關 曉 榮

GUAN
Xiao-rong

# 目　錄

# Contents

# 部長序

攝影，是傳承文化記憶的重要載體。臺灣攝影的風貌多變，沿著歷史的更迭，如透鏡折射出繽紛且多貌的創作樣態。攝影家留下的片刻與瞬間，轉眼成為凝聚在臺灣土地生活的每個人心中，珍貴且共享的資產。

文化部自104年以來，推動「國家攝影資產搶救及建置攝影文化中心計畫」，將搶救及保存攝影資產視為重要的文化工程，透過全臺攝影資產及資源調查之保存、修復、典藏、口述紀錄、出版、藏品研究等工作項目，致力奠定臺灣攝影研究、推廣之基礎資料，以擴大臺灣攝影資產應用價值，並構築臺灣攝影文化之主體性。

《臺灣攝影家》系列叢書，是計畫執行的重點項目之一。自105年以來，陸續策畫編印出版，至今已完成四輯共21冊。叢書記述臺灣不同世代的攝影家生命及創作歷程，呈現豐富的題材與內容，交錯出臺灣社會豐富且深刻的時代面貌。攝影家各自記錄不同視野的所思所見，作品在體現攝影家獨特的見解之外，更豐富了臺灣文化與人民記憶。

歲月流轉，時空交替，影像卻能恆久留存，印記歷史的瞬息變遷。期藉由《臺灣攝影家》系列叢書之影像脈絡，呈現臺灣文化及社會發展的珍貴記憶與土地認同。

文化部 部長

李永得

# Foreword from the Minister of Culture

Photography is an important medium for transmitting culture. In Taiwan, photography's many styles can be seen by the diverse range of creative images captured throughout the annals of history. The brief moments in time that photographers record become precious, shared treasures that preserve memories of life on this land.

Since 2015, the Ministry of Culture has promoted the "National Photographic Asset Rescue and Development of a Photographic Cultural Center Project." The project emphasizes the importance of preserving photographic assets. It names preservation, restoration, collection, oral records, publications, and research as tasks to be included in a comprehensive survey of Taiwan's photographic resources. As it gathers information for research and promotion, it expands related uses and value, thus building a foundation for Taiwanese photographic culture to prosper.

Another project milestone is the *Photographers of Taiwan* series. Since 2016, we have already compiled and published a total of 21 books spread across four collections. Each book includes an account of the life and creative process of a photographer who is closely connected to Taiwan's history. Rich themes and content paint profound portraits of society at different ages. Since the different photographers each had a distinct point of view that influenced their work, their photographs offer insights into diverse ways of thinking while also enriching both Taiwan's culture and the memories of its people.

As time passes by and changes occur, photographs preserve the imprints of history. The *Photographers of Taiwan* series uses photography to present an account of Taiwanese culture and social development, bringing to mind treasured memories that enhance recognition of this land.

Minister of Culture

# 館長序

回顧《臺灣攝影家》系列叢書出版計畫，自105年執行以來，迄今邁入第四個年度。為擴大臺灣攝影家之研究及詮釋視野，國美館進行叢書規格及內容的調整，透過專家學者的分析觀點，匯聚攝影研究與攝影家生命史的書寫方式，以更宏觀的面向來思考臺灣攝影發展的內涵轉變。

今年《臺灣攝影家》系列叢書，將前三輯以人物傳記的線性書寫方式，轉型為「專文論述」、「精選作品」、「口述訪談」以及「傳記式年表」四個單元，以呈現多元的攝影研究成果，期望讀者在領略攝影家生命歷程及賞析經典作品之際，更能認識臺灣攝影文化發展的軌跡及特色。

本次出版以臺灣三個世代具代表性的攝影家——莊靈（1938- ）、關曉榮（1949- ）、游本寬（1956- ）為主題，邀請三位視覺領域的學者專家，擔任各冊專輯的研究主編，分別針對攝影家的創作實踐，深入發展具有分析觀點的專文，並收錄精選的攝影圖集，展現創作者精神淬鍊的影像成果。專輯亦藉由主編與攝影家的親身訪談，建立攝影家闡述影像理念的對話空間，為讀者另闢一道理解攝影家的取徑；而傳記式年表，由編年體方式梳理攝影家的生命軌跡，鑿刻出他們清晰且深刻的時代輪廓。

希冀藉此叢書的嶄新格局，能為臺灣攝影及視覺研究相關領域，提供更多討論及可運用的研究資源，以厚實臺灣攝影論述的知識積累，並擴展各界對臺灣攝影文化的關注及討論。

國立臺灣美術館 館長

# Foreword from the Director of NTMoFA

Initiated in 2016, the *Photographers of Taiwan* series project has already entered its fourth year. To expand research and interpretation of Taiwan's photographers and their works, the National Taiwan Museum of Fine Arts adjusted the scope and content of the series. Expert analysis, photography research and compiling of biographies together offer a holistic view of the meaning and changes behind Taiwan's photography development.

After using a linear, biographical style to introduce photographers in the previous three collections, this year the *Photographers of Taiwan* series conveys the results of wide-ranging photography research through four sections: essays, selected works, interviews, and biographical timelines. As readers come to appreciate the life story of professional photographers and admire their classic photographs, they gain an understanding of how this important cultural field developed in Taiwan and what makes it special.

This collection features three photographers who are excellent representatives of the ages they practiced in: Chuang Ling (1938- ), Guan Xiao-rong (1949- ), and Ben-Kuan Yu (1956- ). Three experts in the visual arts field served as research editors-in-chief. They examined the creative practices of each of the photographers, wrote analytical features, and compiled collections of photographs. Together, these elements showed the results of a lifetime of practice by each photographer. Also included are interviews between the editors-in-chief and the photographers they researched. As the photographers elaborate on their visual image theories, readers better understand the photography process. The biographical timelines, meanwhile, offer chronological accounts of the photographers' life stories and meaningful descriptions of the ages in which they lived.

We hope that the new layout of this year's collection provides greater opportunity for discourse and more resources to Taiwanese photography and visual researchers. Offering a rich discourse on Taiwanese photography and additional related knowledge will bring more attention and discussion to Taiwan's photography and culture fields.

Director, National Taiwan Museum of Fine Arts

*Liang*

# 肉身有時，紀錄不朽

大約兩年前，出版計畫小組執行了許多次訪談，數月後接到通知，原定計畫喊停撤案，本以為白忙一場就此作罷也算一種了結。想不到隔了將近一年又接通知；此番新書改由國美館接案出版，又再打起精神花時間訪談討論，以便本書得以完成出版。近月以來酷暑難當俗務纏身，勉強提筆受命為此書作序深感難為，不如說是給此書出版，寫點可以當作多餘的後記來得允當。

苦惱中，叢書編輯來電，說原定600字文稿，對攝影家而言可能字數限額太少難發揮，可以超過一千字。我私下裡覺得兩者皆好，但我若能在600字以內完稿，倒是值得慶幸的樂事。

最近隨興閱讀了許多已成歷史的攝影紀錄，有知名的攝影家，有不那麼知名的攝影家，更有數量龐大攝影者佚名的靜照。有舉世聞名的巨作，更多的是沒有姓名沒有身分沒有片言隻字關於個人的註記，但絕非虛構的平凡人物平凡人生的紀錄。若從攝影名利場的紅塵中出走，以平凡同理平等對視的角度去看，這些被歸類於不起眼不驚豔的人、事、物紀錄，總是散發著曖曖含光歷久不衰的生死人氣。讓人安靜、屏息，彷彿聽得見草本生長的聲音，也聽得見一片樹葉不理會人之聞向的飄落。

1984年在八尺門工作時照顧我的阿春的父親，於2014年我重返八尺門的專書出版後過世，前幾天阿春的母親過世。1987年在蘭嶼工作，認識並記錄的老一代朋友也多半過世，而紀錄者也已老去。思前想後，只得到一句結論：「肉身有時，紀錄不朽」。

## The Flesh May Be Frail, But These Photographs Will Endure

A couple of years ago, the publishing team for this book conducted a number of interviews, but then, several months later, I was notified that their original plan was being put on hold. It seemed that a period of fruitless work might have reached a conclusion. I never thought that, almost a year later, they would further notify me that the National Taiwan Museum of Fine Arts was now handling publication. So it was time to get energized again, to spend time on the interviews and discussions needed to finish the book and get it published. These last couple of months, tied up with mundane business in the midst of this intensely hot weather, it's been really difficult to make myself put pen to paper as instructed and give this book a preface. It might be better to think that I write this as a kind of redundant "afterword" for its publication.

The editor for this series was worried and gave me a call, saying that perhaps the original 600-word limit for this preface might be too short for a photographer, and that it was fine if I wrote over 1,000 words. Privately, I thought either way was fine, but that it would be a great thing if I could keep it under 600 words.

Recently I was looking through a number of historical photographs, some from well-known photographers and others not so well-known; in addition, I saw a large quantity of still photos by photographers whose names are now lost to us. Among the photos I viewed were some world-famous masterpieces, but many more that completely lacked any name, or identity, or even a single word noting anything about the individual involved—yet they were utterly real, non-fictional records of ordinary people and ordinary lives. Let us leave behind the photographer's vain desire for fame and view these photos with some empathy, from the perspective of ordinary people. Then we find that these records of people, things, and events, seemingly insignificant and unexceptional, exude a kind of strong and silent appeal, an appeal that grows from the enduring meanings of human life. Viewing them, we grow quiet and hold our breath, so quiet we can almost hear the grasses growing, or the sound of leaves as they fall with so little concern for the world around them.

In 1984, when I was living in Bachimen and doing my photographic work, it was Ah-Chun's father who took care of me. In 2014, after the book on my return to Bachimen was published, he passed away; just a few days ago, Ah-Chun's mother also passed. Most of my friends from the older generation that I met working in Lanyu in 1987 have also passed away, and I, who recorded all those scenes, am old now too. Thinking over all these things, contemplating the past and the future, I can come to only one conclusion: "The flesh may be frail, but these photographs will endure."

Guan Xiao-rong

專文
Essays

# 左派影像的肉身
## 論關曉榮的攝影實踐

文／沈柏逸

關曉榮的攝影實踐與同時代追求紀實或美學的攝影家不同——他不只旁觀社會運動，更同時親身參與、付諸行動。他不拍攝明媚風光，而是揭露底層的真實場景；他不是浮光掠影地拍攝，而是花費長久時間深入結構與歷史地探究原住民處境；他不只是位含飴弄孫的爺爺，更是一位至今仍然激進反骨的社會行動者。

他至今依然有慢跑習慣，回顧拍攝八尺門期間於和平島海邊慢跑時，看到人工又醜陋的「消波塊」遍布岸邊，關曉榮深刻意識到相較「美景」，自己更偏好「醜又真實的風景」。人們喜歡拍攝療癒感的夕陽、或美麗自然風光，關曉榮則更關注「真實」——這真實儘管不符合傳統美感，卻充滿繁複的思考。換言之，他不急於簡化現實，而是試圖揭露現實的複雜面向。

### 現實主義的歷史穿透力

關曉榮介入現實的工具，主要透過文字書寫與攝影影像。早期在藝專唸書時，關曉榮大量閱讀翻譯文學作品，這些經驗成為他文字書寫的基礎。同時，他也透過朋友的介紹，接觸美國《人類一家》攝影集，從中看到攝影有別於繪畫的歷史穿透力。

尤金‧史密斯（W. Eugene Smith, 1918-1978）等人的經典攝影書籍於1980年代被引介入臺，他接觸到尤金·史密斯透過拍照介入社會實踐的作品後，開始意識到攝影跟社會之間的關係，開始想仿效西方執行攝影專題的方式，在臺灣耕耘屬於自己的紀實花朵。我們可以注意到「書籍」（無論是西方攝影家叢書或翻譯文學等）啟動了他開始思考攝影能穿透歷史、並且連結社會的現實特性。

談到臺灣的現實主義脈絡，不能忽略陳映真於1985年創辦的《人間》雜誌。《人間》在當初結合了報導文學與攝影，深刻地在社會動盪、矛盾急劇的80年代挖掘了底層的狀況。關曉榮拍攝八尺門阿美族青年的黑白照片被《人間》選為創刊號的封面，這期封面的選用奠定《人間》未來的調性，而關曉榮也接連在這本關注現實的雜誌刊載八尺門與蘭嶼的專題報告。

《人間》對臺灣底層社會的關照，以及對消費文化的抵抗，可說是出版界中具代表性的政治實踐，同時影響了許多身懷理想的報導工作者。誠如張照堂所說：「80年代，在臺北充斥著消費、逸樂、宣傳或專橫的出版品中，《人間》的見證與反省，它嚴謹的人文探索和落實的社會關懷，足以激勵懷有理想與責任心的報導攝影工作者，往現實的深淵中奮進。」[1]

《人間》的社會實踐中蘊含著強烈左傾的理想性，儘管面對著當時的政治壓抑，他們還是不斷實踐現實主義的精神，而非輕易地跟黨國政宣共謀；而關曉榮渾身沾染著這股左傾的批判氣息。

## 另類的攝影實踐： 八尺門

關曉榮的《八尺門》系列帶領我們看見了被主流社會價值遮蔽的人民。他之所以進入八尺門蹲點拍攝，大致有三個因素或動機。首先，1984年連續發生許多礦災，而傷亡的工人當中，阿美族人超過了一半，也就是臺灣的底層工人泰半為原住民，這成為他主要的問題意識：「為什麼礦災受難者大多是占臺灣人口少數的原住民？」再者，他因與友人雷驤製作電視節目而踏查「八尺門部落」，了解原來「基隆八尺門」的住民是花東地區的阿美族人，離開原生地到基隆漁業求生存而搭建的部落，這成為他實踐專題創作的一個場域。最後，關曉榮為了抵抗在媒體工作時的「噤言」，展開屬於自己、更自由卻也更艱苦的調查計畫。當時仍在戒嚴時期，對媒體的管控較為嚴謹，而這種嚴格的媒體管控也難以承擔日益複雜的現實處境。郭力昕也認為，1980年代臺灣社會的紀實攝影實踐普遍缺乏具有政治性向度的認識。[2]

《人間》雜誌創刊號封面使用關曉榮於八尺門拍攝的阿美族青年肖像 / 1985 年 11 月
The first issue of *Ren Jian* magazine, with Guan's portrait of an Amis youth / November 1985

關曉榮在八尺門分租一間斗室，前房居住著邱松茂一家人 / 關曉榮攝 / 1984
Guan rents a small room in Bachimen; Chiu Sung-mao's family lives at the front / photo by Guan

在媒體噤言與高度缺乏政治性批判的處境下，關曉榮毅然離開媒體業，以600元的月租跟族人分租八尺門三張榻榻米大的斗室，從1984年9月到隔年5月，花了約七個月的時間長期觀察他們的生活。不論是礦災事件，抑或對於媒體管控的抵抗，這些核心動力多出於不滿於既定現實的力量，因此他想用某種「新方式」試著敞開另一種複雜的現實維度。

若說過去攝影家的方式多為使用單張照片或強調美學形式的表現；關曉榮則以照片散文（Photo Essay）的組圖編輯，結合日記散文來組織照片脈絡。換言之，相較過去「一張好照片自己會說話」的傳統思維，關曉榮在八尺門專題中以「多張照片」以及「反省書寫」逼近現實。

此外，相較於「迎面而來，按下快門，揚長而去」的拍攝方式，關曉榮更多是以緩慢步驟融入當地人生活，跟他們一起居住，並且長時間追蹤八尺門後續報導。這種緩慢的工作方式，抵抗快速消費的照片邏輯，他更多是將自己的生命慢慢融入原住民生活，同時進行深刻的批判反省與轉化。

簡言之，關曉榮抵抗了個人英雄主義的美學形式；他花更多時間思考「群跟我的交互關係」以及揭露「被主流社會所排除的雜音」。然而，我們不能忽略攝影具有的排斥邏輯，照片往往截取了現實的某個片段而排除了其他面向。

所以我們在看關曉榮的照片時，不能忽視他「文字書寫」的札記，因為這恰恰彌補照片再現現實的無力性。關於文字書寫搭配圖片的必要性，他在八尺門計畫中呈現的文字並非只有報導紀錄的客觀人類學式研究，更多是以「文學書寫」呈顯自己內在的不安、焦慮以及日常的片段。也就是說，在書寫中可以發現他並非「客觀、中立、理性」記錄八尺門居民生活，而是用許多力氣在反思自己拍攝的位置。

可以注意到，關曉榮的攝影實踐抵抗了攝影「形式的表現性」與「客觀的紀錄性」。面對形式主義，他提出「現實主義態度」——以攝影與書寫直視人們生存的困境；面對客觀紀錄，他則是「反思攝影者位置」——批判性地揭露自己做為攝影家的介入，而不是客觀中立地記錄事件。

臺灣深度報導叢書001　　都市原住民目擊報告

關曉榮 撰文/攝影　　臺原出版 出版

關曉榮的「文字書寫」出版著作之一：《八尺門手札》/ 臺原出版 / 1996
One example of Guan's published writing:
*Letters from Bachimen* / Taiyuan publishing

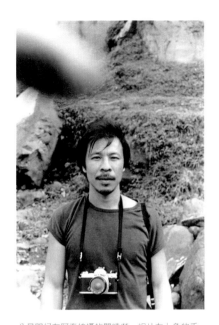

八尺門好友阿春拍攝的關曉榮。相片左上角的手
指是阿春的簽名，也是阿春留給歷史的證言
賴福春攝／基隆八尺門／1984
A photo of Guan Xiao-rong taken by his Bachimen
friend, Ah-Chun. The finger in the upper left is Ah-
Chun's signature, and his testament to history
photo by Lai Fu-chun / Bachimen, Keelung

而關曉榮採實地的田野蹲點，他花長時間追蹤八尺門幫助他的友人阿春；
此外，他也貼近觀察邱松茂的家庭。而透過阿春與邱松茂的個案調查，讓
他有別於一般浮光掠影的攝影家，更深一層進入八尺門原住民的處境。

這種深入參與，也同時回應攝影的倫理問題。當阿春的角色巧妙反轉「被
攝者與拍攝者」的對立角色，亦即阿春在海邊烤肉時反拍關曉榮的照片，
也將關曉榮的專題維度轉化到另個層次。

無論是影像中流露的不屈精神，或是對於拍攝角色的倒轉，或者在關曉榮
肖像上所露出的手指瑕疵，都提醒我們「攝影者—被攝者」關係的流動
性，而不是主客二元對立的僵化關係。這種不可預期的流動性，將攝影提
升到更辯證地動態關係。

透過關曉榮於八尺門長期進行的田野計畫，不僅擴張我們對原住民的複雜
理解，也深刻記錄關曉榮跟原住民的情誼，同時保持著攝影「倫理刀鋒」
的緊張關係。他並非消除緊張界線，恰恰是倫理界線的彰顯，讓人反思紀
實攝影的根本問題。

## 知識解放的戰鬥：蘭嶼報告

結束八尺門的計畫後，關曉榮旋即再次投入原住民議題的研究，而這次的
對象是長期被臺灣忽略的離島蘭嶼。身為蘭嶼的「外來者」，他走進達悟
族的傳統文化，透過影像保留他們傳承已久的祭儀。同時，在核廢料的抗
爭上，也跟達悟族人並肩，站上前線跟政府官僚戰鬥，進一步朝「知識解
放」的方向前進。

關曉榮投身於蘭嶼的拍攝計畫，主要是在從事攝影記者工作時受到兩起事
件影響，這分別跟蘭嶼人的生與死有關。[3]1986年6月土城發生了一起鬥毆
事件，蘭嶼青年蘇光明被砍殺兩刀致死。由於蘇在異地身亡，能幫忙處理
喪事的人不多，他父親遠從蘭嶼飛去臺灣處理兒子後事。在達悟族的習俗
中，亡者多得歸葬故鄉，由於蘇家無法負擔龐大的遺體運輸費用，只好將
其安葬於土城的荒郊墓地。從這個達悟族青年死亡事故中，關曉榮深刻意
識到他們缺乏資源的困境，以及不得不違背傳統習俗的無奈。

關曉榮在報導蘇光明事件過程中，認識了蘭嶼知識青年施努來[4]，同年9月，施的兒子出生，但嬰孩卻罹患先天性腫瘤，施覺得這跟妻子懷孕時，他毫無避諱、前去幫忙蘇的喪事有關，因為在達悟族的傳統觀念裡，這樣做可能招來厄運。上述兩事件都讓關曉榮感受到蘭嶼青年在臺灣生存的不易，但當時在資本主義社會的發展下，無論是生或死，他們為了生存下去，只能脫離本島的傳統習俗，無奈地跟現實社會妥協。

隔年1月，關曉榮在施努來的協助下踏上蘭嶼，此後與蘭嶼結下不解之緣。關曉榮跟當時踏查蘭嶼的攝影家有很大的不同，他沒有在專題中滲入過多浪漫的個人情感，更不是以異國情調的美學化觀看蘭嶼。他宛如握持手術刀般，冷冽地以政治與經濟學的角度頗析蘭嶼，他把蘭嶼「問題化」，考慮宏觀結構中的蘭嶼以及當中人們勞動與生產的關係。

這些都讓他離開拍攝八尺門時的個人直觀情感，更深刻地走進知識結構體系的理性批判。攝影評論者林志明如此評論在蘭嶼的關曉榮：「在文字方面，除了報導文學裡一貫採用的訪談、觀察，政經系統分析、外資狀況調查更加地明確化了，作者自身的介入也較少有自身感情面的描述。更重要的是，關曉榮開始採取歷史的觀點。」[5]

這個歷史觀點包括在書寫中對「漢人中心」提出深刻的反省與批判。攝影評論者陳佳琦指出蘭嶼報告中「充斥著『既……又……』的矛盾交雜，可以象徵原漢之間的長久以來的殖民侵略關係中，關曉榮在身為壓迫者一方中，一種出自個人的、較為自覺的創作態度在作品中展現出向弱勢者認同、試圖貼近的凝視與反省。」[6]

而他也積極於報告中形塑達悟族的主體，進而牽動更廣的原住民意識。這種原住民主體的形塑，可以從他拍攝達悟族的傳統文化中看到；而在其系列影像中，主體高峰則呈現於達悟族青年反抗漢人不合理堆放核廢料的過程。

在《尊嚴與屈辱：國境邊陲──蘭嶼1987》一書中，他同時以圖文揭露了漢化教育、觀光客暴行、蘭嶼青年流落異鄉、蘭嶼醫療衛生資源的缺乏、

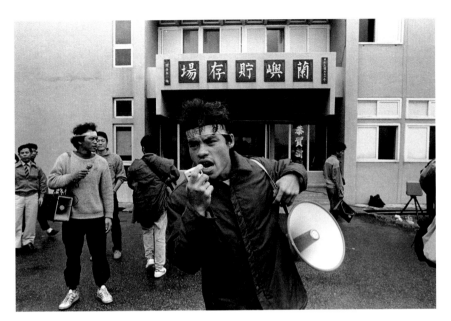

《蘭嶼反核》系列作品，在地青年郭建平在貯存場發聲抗議 / 關曉榮攝 / 蘭嶼 / 1988
From the *Lanyu Anti-nuclear* series: Local youth Kuo Jian-ping speaks in protest at the nuclear waste storage site
photo by Guan / Lanyu

國宅的強行建設、反核廢料運動等問題。從中可以看到關曉榮研究蘭嶼的
各個方面，從兒童教育問題，到青年的勞動發展，最終是蘭嶼嚴峻的生存
處境。

面對族群的欺壓，蘭嶼人在1987年發起機場抗議行動，而關曉榮也帶著攝
影機全程參與。在這場跟政府的對抗中，關曉榮雖做為外人角色，卻不是
在界線之外的冷眼旁觀，他跟當地人併肩對抗政府強權。

相較當地知識青年對蘭嶼土地的認同與維護，關曉榮呈現身分上的矛盾。
做為漢人的他不可能完全融入達悟族，也難以替達悟族代言。但他又批判
漢人中心主義，協助達悟族發聲，同時自省自己的拍攝行為。進一步說，
他不可能成為達悟族人，但在工作處境、思想知識、遭受不公不義的對待
上，卻跟達悟族同一陣線。這種「不同民族的共感」超越了單一血緣、族
裔上的認同，更多是依靠共同經驗觸動彼此。

## 不合時宜的左派影像

從關曉榮的身上與作品中可以感到一種「不合時宜」的力量，他貼近時代地剖析政經結構，但是卻又不被時代所接受。然而，恰恰是這樣的「不合時宜」才蘊含著改變的契機。也就是說，跟時代保持距離，凝視時代的另外一面，不只是看著時代光輝燦爛的表面，而是意識到輝煌表面是透過多少「不可見的人民」支撐著。

這些不被看見的小人物，長期受主流價值忽略、歧視而飽受壓抑。而關曉榮抱著持續戰鬥的精神，與人民共在，更試圖透過影像追求平等與解放的可能。他提到「社會科學的民族平等理論和思想價值面對歧視與壓迫合理化的挑戰，應是歷史性的不容許退卻的沒有間斷的戰鬥。」[7]也就是說，他不只是關注當下，而是把解放的力量投射到未來。

照片物質性的傳承就是最好的載體。他也認為「總覺得那些沒有姓名的一個個人才是人『類』的親人，這廣大的人民在照片裡，在照片的底下、在照片的背後、在照片之外的真實存在給我至深的觸動和感懷。」[8]換言之，照片呈現的不只是私人的感性，更重要的是如同歷史共同體的存在。

弔詭的是，流著外省漢人血統的關曉榮，跟原住民並沒有直接關係。然而，我們不能以血緣本質主義看待他們，而是得透過階級的視角來看待他們之間的認同關係。

相較外省菁英對資本主義與權力的共謀，[9]關曉榮則是透過底層的認同，連結弱勢外省與原住民的關係，進而激起行動的力量。關曉榮在成長過程中，和他們有著共同的弱勢經驗，但是關曉榮卻在拍攝時不斷自省漢人的拍攝主體，以及後設追問攝影者與被攝者之間的倫理刀鋒。

此外，他也並非彰顯自己的攝影行動或藝術成果。而是將自己退後，呈顯他者的生命與尊嚴，[10]並且進一步推進原住民運動。他除了未曾在商業藝廊展示他者肖像之外，書籍銷售的大部分收益也都投入原住民的運動之中。也就是說，他更在意的是行動與實踐本身，而不是自己的影像成就。

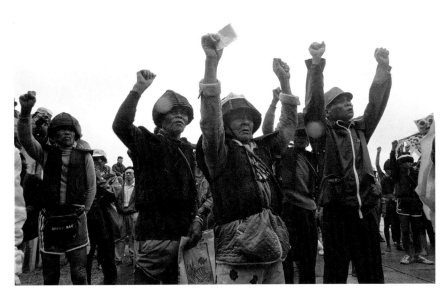

《蘭嶼反核》系列作品：石破天驚的達悟族人吶喊 / 關曉榮攝 / 蘭嶼 / 1988-1989
From the *Lanyu Anti-nuclear* series: The resounding cries of Tao tribesmen / photo by Guan / Lanyu

綜合來看，可以察覺關曉榮實踐紀實的左派影像，蘊含著與民共在、唯物的歷史觀、後設批判自身位置以及行動主義地參與運動。他不甘於輕鬆簡單的現實表面；而是複雜化地看待現實，進入現實層次的肌理，試圖從中煽起抵抗資本秩序的可能。

## 紀實攝影的重估：肉身的實踐

儘管影像呈現了當下情境，紀實攝影卻並非如此的不證自明。攝影評論者蘇珊·桑塔格（Susan Sontag, 1933-2004）對攝影能再現現實的能力倍感懷疑，認為攝影不是讓我們接近現實，反而是將我們推離現實：「攝影的美學化傾向是如此地嚴重，使得傳遞痛苦的媒介最終把痛苦抵銷。相機把經驗微縮化，把歷史變成奇觀。照片創造同情不亞於照片減少同情和疏遠感情。」[11]

儘管紀實攝影擺脫不了再現現實的危機，然而關曉榮的攝影實踐卻透過跨族群的互相連結、反身性的自我反思、以及文字寫作與研究調查等，打開攝影的更多層次。如果說，攝影本身的問題是美學形式終究將框限現實；那關曉榮則是在他肉身的實踐中跨越了攝影自身，跨域地將攝影連結起感性的文學書寫、理性的社科調查與激進的行動主義。

要言之，他的攝影就像是「在之間」的狀態，在跟各領域結合的縫隙中生長而出，而不是回到攝影美學本質的框架。這種「在之間」的攝影，恰恰逃離美學形式的侷限，以及攝影的再現危機。

另一方面，他的攝影作品不只停留在攝影家拍攝原住民的對立關係；而是將自己放在與原住民共在的行動網路之中。這讓人想到哲學家茱蒂·巴特勒（Judith Butler, 1956-）曾提過的協同性主體觀念：「『我』就不是什麼『自我』，而是一個同他人息息相關的存在：我同他人共處在錯綜復雜的依存關係之中，該處境無法改變，我們的生命同樣脆弱，我們彼此唇齒相依。」[12]在關曉榮作品中，我們幾乎看不到攝影者強烈的主體，主體既是回頭檢視自己的位置，同時也向外往他者擴延。

這種既向內又朝外的實踐，也要求觀者產生倫理回應。儘管桑塔格悲觀地批判攝影美學不斷將人們推離現實苦難，然而巴特勒卻樂觀認為攝影還是可以引起人們產生政治的回應：「如果能產生新的框架，展示新的內容，攝影能夠像人們傳遞苦難，也將改變我們看待當前的政治態度。若要達到這目的，攝影作品必須具有感染力，還必須激發我們的倫理回應。」[12]也就是說，透過新的方法，攝影還是能以具有感染的方式要求大家採取政治行動。

關曉榮的攝影實踐是透過不斷自省，同時要求觀者產生倫理回應 / 關曉榮攝 / 新北新店 / 1985
Guan practiced continual self-reflection in his photography, and demanded an ethical response from viewers / photo by Guan / Xindian, New Taipei

重新審視關曉榮作品，仍脫離不了《人間》以來紀實攝影再現現實的危機，然而，我們不能忽略他的「行動本身」，他的現實主義實踐中蘊含著極強的感染力與情動力，而行動精神也可以是新框架的演繹，也是關曉榮「左派」影像的在地實踐。

郭力昕認為關曉榮不只是《人間》人道主義溫情框架，而是運用更加理性與批判的方法在處理現實問題。然而，其實是關曉榮與被壓迫者「共感」的力量支撐著他執行「理性」的分析。我們不該只重視關曉榮的理性方法，而必須回頭觀照他感性又不落入濫情的力量。要言之，本文不是單方面強調其理性克制的方法，而是從「情感轉向」的辯證方式回到關曉榮肉身的攝影實踐。[14]

我們在觀看一張照片時，總是只看到照片所再現的事物，卻往往忽視拍攝者脆弱的肉身。而關曉榮的實踐除了攝影的物質性照片外，包含著自己與原住民的共在關係、參與的政治行動、反思自己的拍攝位置、以及勇敢面對攝影的侷限。

關曉榮在作品中不可見的肉身恰恰抵抗了讓現實無力的形式美學，在行動中也更加立體地將現實以更複雜的面貌呈顯在我們面前。這些曾經存在的左派影像，也將隨著照片與文字的物質性投入歷史長河中不斷繁衍，進而創生革命與解放現實的可能。

1　張照堂，〈光影與腳步──臺灣寫實報導攝影的發展足跡〉，收錄於臺灣省立美術館編輯委員會，《映像與時代──中華民國國際攝影藝術大觀：攝影藝術研討會論文集》（臺中：臺灣省立美術館，1992），頁50。

2　郭力昕，〈紀實攝影典範的昨日與今日〉，《八尺門：再現2％的希望與奮鬥》（臺北：南方家園，2013）。

3　關曉榮，《尊嚴與屈辱：國境邊陲──蘭嶼1987》（臺北：時報，1994），頁158-160。

4　施努來即臺灣原住民達悟族知名作家夏曼‧藍波安。經過反核廢運動的自省，施努來決定為自己正名「夏曼‧藍波安」。

5　林志明、蕭永盛，《台灣現代美術大系：報導紀實攝影》，臺北：藝術家出版社，2004。

6　陳佳琦，《再現他者與反思自我的焦慮──關曉榮的蘭嶼攝影》，國立成功大學藝術研究所碩士論文，2002。

7　關曉榮，〈追究記憶、創造現在──「過境邊陲」十年後出土的思考〉，《藝術觀點》32期（2007.10），頁58。

8　關曉榮，〈想念大陳、再現《人間》〉，《文訊》287期（2009.9），頁73。

9　社會學研究者趙剛在〈這些船不知道消失在哪兒了──讀關曉榮的《國境邊陲》〉中談到：老關對原住民的「認同」，與趙錢孫李、朱王段顧等外省第二代菁英對「臺灣人」的「認同」雖是出自同一個歷史「病灶」，但卻以天地的懸殊面對這樣的病；前者是通過對占臺灣總人口百分之二的絕對底層原住民的「認同」實現自我教育與救贖，後者則是對權力與宰制的跪倒，使自己能夠上得了「吃人的筵席」（魯迅語）；前者是要讓自己與他人站起來，後者則是爭先恐後表效忠當奴才分骨頭。參見：《國際邊緣 名家專欄》（2019.3.22），網址：http://sex.ncu.edu.tw/column/?p=822

10　關曉榮曾撰文提到：「透過發掘被壓迫、長期被視為符號禁忌的底層民眾，⋯⋯這是以底層敘事的精神拍下有關『人』的攝影，發揚被邊緣化、他者化的人民的光彩。」出自：關曉榮，〈留長髮、搖滾樂、反「新生活」規訓體制──《八尺門》社會報告的1980年代〉，《藝術觀點》44（2010.10），頁17-21。

11　蘇珊‧桑塔格著，黃燦然譯，《論攝影》（臺北：麥田，2010），頁171。

12　茱蒂‧巴特勒著，何磊譯，《戰爭的框架》（鄭州：河南大學出版社，2016），頁298。

13　同上註，頁150。

14　郭力昕，〈人道主義攝影：凝視他者的政治意義，並與桑塔格爭辯〉，《製造意義》（臺北：VOP BOOKS，2018），頁93。郭力昕指出：「儘管人道主義、悲憫情懷和社會正義，仍然是關曉榮的一種內在支撐要素，他的紀實作品卻不是人道關懷式的，也並非情感用事，而是政治的，激進的。因此，他的作品並非建立在道德主義和説教腔的基礎上，而是立足於批判的、辯證地分析上。」

# 關曉榮的「人間」之旅
## 報導攝影及八〇年代的攝影文化風潮

文／馬國安

1984年10月，37歲的《人間》雜誌社記者關曉榮第一次背著自己的相機踏入狹小的基隆八尺門租屋處；同年的前一個月，陳映真出版了文集《孤兒的歷史・歷史的孤兒》一書，書中集結收錄他於1977年「鄉土文學論戰」發表的多篇論文；也在同一年，黃春明描寫日治時期被迫賣淫少女的小說《莎喲娜拉・再見》正被改編為電影，由黃春明本人撰寫劇本。當年金馬獎最佳劇情片《老莫的第二個春天》，則是講述一名外省老兵與山地少女共譜的婚姻故事。1980年代中期，如同正從冷戰走出的世界，臺灣的社會氛圍瀰漫著躁動和困惑；為階級不平等的現狀發聲，有識者對國家權力的叩問，開始獲得不同程度的反響。

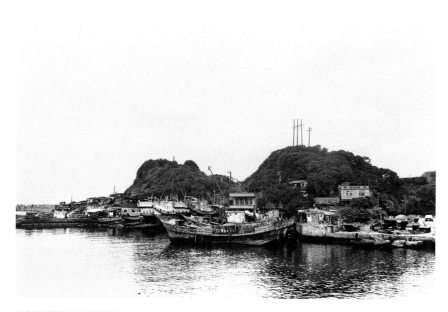

自和平島遙望八尺門聚落所在的兩座小山丘 / 關曉榮攝 / 基隆 / 1987
A view from Heping Island toward the two hills of the Bachimen settlement / photo by Guan / Keelung

1986 年 3 月《人間》雜誌主辦的報導
文學與攝影講座[1]
Lectures on reportage literature
and photography held by *Ren Jian*
magazine in March 1986

1984年是關曉榮做為報導攝影工作者的第一年，也是陳映真計畫出版《人間》雜誌胎動的一年。三年後，臺灣解嚴，衝破禁令的媒體正式進入眾聲喧嘩的年代，「報導文學」與「報導攝影」蔚為流行，但做為臺灣報導攝影先驅的《人間》雜誌，卻再過短短兩年就黯然告別文化界，曾經志同道合的報導人們，只能再度回歸原本孤獨的道路。究竟《人間》雜誌的出現，為像關曉榮這樣機敏發掘議題、初入報導攝影世界的新世代報導者扮演了什麼角色？透過這本見證了解嚴之際、社會轉型階段時深層問題的報導攝影雜誌，我們又能如何對1980年代以前的攝影文化史進行更完整的梳理和理解？

以下，本文將分為三部分探討《人間》雜誌與1980年代的臺灣攝影文化。第一部分，筆者聚焦《人間》雜誌挑起的「報導文學」大旗，從1970年代末的「鄉土文學論戰」談起，同時關照引領關曉榮走上報導工作者之路的文化知識脈絡網；在第二部分，則將從占據《人間》與關曉榮主要關注對象的臺灣「原鄉」與原住民──當時稱為山地同胞出發，反思由報導攝影者挖掘出的1980年代族群議題；最後，從對族群議題的討論，延伸到「國族認同」──這個始終未曾被解答，卻由《人間》雜誌以報導攝影專題「老兵回家」深刻挑戰的問題。

## 深入人心的「報導文學」

收錄此書的訪談中，關曉榮將自己報導方法中現實主義式的關注歸因於《夏潮》雜誌與陳映真的影響，同時也特別提到奚淞做為他少時文藝觀和世界觀引路人的地位。在1980年代關曉榮世界的知識圖景中，於1978年發行中文版的《漢聲》雜誌（英文版《ECHO》自1971年起發行），應該鮮少被拿來與《人間》甚或《夏潮》這樣立場鮮明的雜誌相提並論，但這份奚淞參與編輯的經典中文民俗雜誌，其養分的土壤實與《人間》共享，也就是1970年代以降，深植臺灣文藝界的重要命題──對「鄉土」的困惑、追尋與探求。在政治立場指導意識形態的時代，評論者往往會忘記，「鄉土文學」在臺灣文壇的誕生，除了承載文人們對文化霸權、傳統與認同的反思，同時也融會了對社會底層與邊緣人的關懷、以及對現代性的批判等等複雜的視野。也正是在這樣的文化脈絡中，做為1970年代末期論戰「鄉土文學」的參與者，陳映真和黃春明雖然立場並非完全一致，但他們卻可以一起轉身，成為1970-80年代之交鼓吹「報導文學」的先驅。

當然，報導文學在《人間》問世前，已有相當的發展，在臺灣媒體界也早有前例，《人間》的誕生，見證的是報導文學與攝影報導的發揚光大時期。自許要從現實生活、尤其是底層小人物的生活出發，檢視現代化的過程中，位在冷戰大國勢力邊緣的臺灣島民們究竟面臨的是何種文化及精神上的轉變；《人間》的作者們無疑開始面臨各種「報導文學」方法論的問題。與此同時，做為面向大眾的月刊雜誌，《人間》更重要的任務，更落在將報導攝影和文學這樣的媒介深入讀者的日常生活。一方面，嫻熟西方現代理論與概念的這群新世代文化人，大多與奚淞有著類似的體驗：在替《漢聲》雜誌採訪大甲媽祖遠境時，奚淞第一次體會到「不能用一些概念與觀念去生活，必須實際地去體會生活。」[2]另一方面，其實「鄉土文學」在1970年代文壇的出現與流行，也和早在1930年代以降就已席捲臺灣文壇一次的文學論戰遙相呼應，在那時，臺、日文人除了論辯語言的使用（臺灣話／北京話／日本話），也逐漸將焦點轉移到文學與現實的關係；這些對寫實主義文學的關注，到戰後的1970年代，再次回歸文壇。而1970年代的臺灣文人與1930年代的前輩們，幾乎遭逢了類似的命運：被當權者質疑，甚至噤聲。也就是說，繼承報導文學與鄉土運動的《人間》成為一種文化人的抵抗，同時也繼續扮演臺灣報導文學的實驗場。而做為背景的「鄉土」概念，與其說是一種實存的地理空間，不如說是指涉家鄉，一種對心靈歸屬感的文化認同建構。

也就是說，肩負普及臺灣報導攝影與文學雜誌使命的《人間》傳承來自文化界的文學運動，也脫胎自剛剛開始扎根的鄉土與紀實攝影。早在1950年代，臺灣北部以鄧南光為中心的「自由影展」與之後的「臺灣省攝影學會」就已延續發展日治後期以來的紀實攝影風潮，在1960-70年代也大量投入紀實攝影的南部攝影家們則更被稱為「鄉土攝影家」。有別於官方主流認可的「畫意攝影」，這些以作品反映社會真實面貌的紀實攝影，常常在主流評論中被認為拍攝主題都是「破破爛爛」。[3]雖然「報導攝影」與「紀實攝影」並不完全相同，但向讀者們示範如何真正「實際地去體會生活」的《人間》記者，早已將鄉土與紀實攝影的精神內化傳承。《人間》的發刊詞是這麼寫著：「我們抵死不肯相信，有能力創造當前臺灣這樣一個豐厚物質生活的中國人，他們的精神面貌一定要平庸、低俗。」對現代人精神面貌的觀察與關注，貫徹《人間》的選題與報導方式。幾乎每期都有的

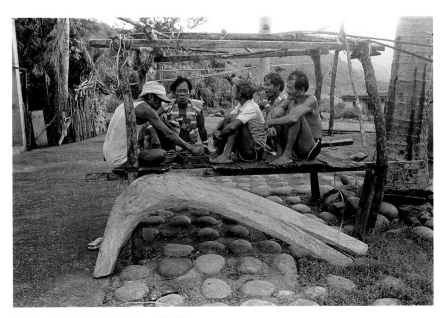

〈蘭嶼紀事〉專題呈現達悟族人日常 / 關曉榮攝 / 1988

The "Lanyu Chronicle" presented the daily life of the Tao people / photo by Guan

人物專題，訪問對象都是主流報刊絕無興趣、看似平庸甚至窮困的「小人物」，如計程車司機、在平地都市掙扎求生的「山地」勞工等等。透過文字與圖像重現這些人們的日常、甚至是類似鄉土攝影家拍攝的「破破爛爛」生活場景，《人間》引領讀者看見現代社會邊緣人物的內心世界與人生故事。可以說，由《人間》建構起的報導攝影與文學典範，植基於寫作者的社會責任感，傳遞的是報導者堅信的理念與價值。[4]而這些價值，則往往透過「原鄉」的家國認同議題得到最深刻的討論。[5]

## 關曉榮與《人間》折射的八〇年代族群圖像

《人間》所收錄的報導攝影與文學作品中，關曉榮的八尺門與蘭嶼專題，為其中持續性最長、也最完整者。不論從報導攝影及文學的方法論、或雜誌編輯取材的角度，關曉榮的作品都含括了《人間》深入人心、極具代表性的一面：即「民族誌」式的報導方法，以及對「原住民」與「原鄉」同時做為族群和社會議題的深入探討。姑且不論「民族誌」在人類學界田野實踐過程中的美麗與哀愁，對於報導文學在臺灣的引介與深化，研究者曾提出，其實「報導文學」做為一種介於新聞學與文學之間的文類，長期以

來一直缺乏充分的相關理論基礎和分析，更遑論報導文學的方法論。[6]但由於其發展的歷史文化脈絡，早期的臺灣報導文學經常是與人類學——或者就是人類學者——分享田野採訪與報導的方法，這種借重報導者在報導地，或對報導對象長期追蹤、進行田野工作、取得對報導對象言說以外資訊的「整體式」調查研究，仍為報導文學提供了較具方法論根基的實踐方式。

另一方面，做為早期報導文學的重要母題，關於「原鄉」或原住民族群議題的報導，也成為《人間》的聚焦方向：「人間少數民族」的系列報導，雖然與關曉榮的系列專題往往並無直接的關聯性，卻與關的作品共同構成《人間》的報導攝影風格，記錄了當時臺灣報導攝影界「原鄉」報導的幾種重要面向。最突出的範例，應該見於《人間》第20期。「『要滅絕一個民族、必先滅絕他的文化』臺灣少數民族面臨結構性崩潰的命運，無疑是這一說法最佳的註解。」——這是當期的編輯室手札內容。在這一期雜誌中，《人間》報導了鄒族（當時稱為曹族）少年湯英伸被執行死刑的悲劇，當時，由《人間》以兩期雜誌專題報導的「湯英伸事件」轟動全臺學術界與文化界，幾乎定義了《人間》深入原鄉、關注原住民議題的報導重點。在這期雜誌中，關曉榮的〈蘭嶼紀事〉攝影專題系列也正連載中，與死在平地看守所槍下的鄒族少年故事恰成互補。

第20期雜誌的湯英伸專題文章主照片，是少年在棺木中的遺體，狹小的棺中，還放著一本《人間》雜誌。而同一期中，〈蘭嶼紀事〉則有一個這樣的文題：「文明，在仄窄的樊籠中潰決……」相較於題為「我把痛苦獻給您們」、戲劇化的湯英伸報導，關曉榮在這期〈蘭嶼紀事〉的照片散文則從蘭嶼紅頭村青年駕舟捕魚的日常，娓娓道來達悟（當時稱「雅美」，以下使用當時稱呼）文明與古老信仰，搭配族人搭建傳統木屋的系列照片，引領讀者反思政府在此地興建國宅的政策，進一步想像「文明」如何可以不屬於所謂「現代人」或現代社會，卻來自遵守古來儀式與生活方式的原鄉族群。無疑地，1970-80年代以來的「報導攝影」所建構的臺灣族群圖像多種多樣，而透過觀察收錄於《人間》的報導，可以發覺的是，在這些報導攝影工作方法底層，仍然持續在進行拉鋸的，可說是新聞故事的「戲劇性」（或可說是一種「非日常性」）與「寫實性」這兩端：湯英伸專題中的少年遺體肖像，雖然極具震撼力，但照片本身，幾乎直接成為「指導」

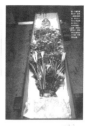

《人間》特別報導湯英伸被槍斃之頁面'，右頁為湯英伸遺體相
The *Ren Jian* magazine page reporting on the death penalty of Tang Ying-shen; his remains are shown on the right

——而非引導——讀者價值觀與同情反應的依據。透過對少年遺體的視覺性呈現，「報導攝影」成為文字所建構價值判斷的延伸，而報導湯英伸案的兩篇專題報導，基本上都是透過攝影作品視覺性的渲染，來達到傳達「死刑少年家庭之慘」與「被害家庭之苦」的效果。反觀〈蘭嶼紀事〉專題的報導圖像，則圖與文呈現截然不同的關係：照片散文中被選取、集合的攝影作品，大多是已經承載豐富資訊的獨立圖像，讀者不會看到帶有「雅美人傳統祭儀」或「紅頭村傳統家屋」這樣定義式圖說的照片來強化某種「原始他者」的刻板印象，而是在觀看一系列與文字互相映照、記錄了生活在當代時空的雅美人不同生活面向的過程中，思考報導專題呈現的是蘭嶼雅美人怎樣的「現實」生活。也就是說，關曉榮的報導攝影方法，雖然是從民族誌式的記錄出發，但他其實是帶著更具批判性的視野，隱隱牽引著讀者在閱讀影像的同時，建構屬於自己對「現實」或「何為寫實」方式的獨立思考。

同樣是在為本書進行的訪問中，關曉榮引用了東海大學社會系教授趙剛關於社會學方法的闡述，強調在學術研究中，「我」是應該可以被從現實抽離、由主體變身客體的概念。在報導原住民議題時，相較於「戲劇性」的

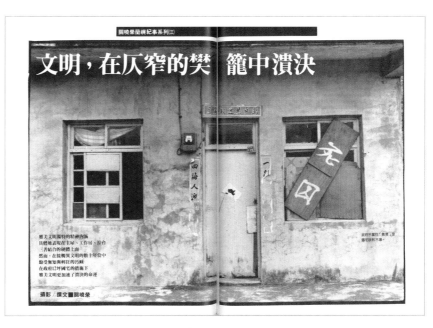

關曉榮在《人間》的〈蘭嶼紀事〉系列專文頁面[8]

A page from Guan's "Lanyu Chronicles" feature in *Ren Jian* magazine

報導攝影方法：刻意地模糊讀者與報導者之間的界線，將讀者的「我」代入被報導者的情景中，關曉榮自覺地觀察到做為讀者的「我」以及身為報導者的「我」可能有的預設立場和理解方式，也因此在《人間》的原鄉報導中呈現了不同的寫實面向。但從另一個角度來說，無論是關曉榮或《人間》的記者與編輯群，都必須定義何為「寫實」，同時也必須對不同身分認同者的預設立場有所解讀。《人間》的報導作品，其實也就是在戲劇性與寫實性之間取得平衡的各種探索。以下，本文聚焦《人間》自25期以來陸陸續續報導的「老兵回家」專題，探討《人間》如何在作品中檢視與呈現自身對族群與認同關係的報導方式和立場。

## 國族認同之外、報導攝影的「寫實」

1988年1月，由一群外省老兵與熱血友人組織的「外省人返鄉權利促進會」終於在兩岸分隔四十年後，首次踏入對岸的故土，返鄉省親。當年3月出版的29期《人間》專題報導了他們的返鄉之旅，但其實早在前一年的11月，「返鄉權利促進會」還在街頭抗議的階段，《人間》25期就製作了題為「海峽隔離後遺症」的專題，記者橫跨海峽，分別報導了彼岸福建南安的霞宅鄉，和此岸臺北城中的榮民家庭。類似《人間》其他期數中報導大陸民情風土的專文，描繪「彼岸」的報導以色彩飽滿的彩色照片為主，相片裡的福建故鄉質樸恬靜，老井和老人依舊，田間小路上也只散見幾名村婦村夫。這樣的報導風格與「此岸」文章中採訪的老榮民家族圖像正好成

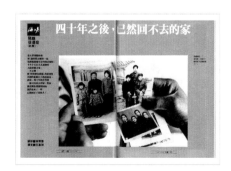

《人間》「海峽隔離後遺症：此岸」專文頁面 [9]
*Ren Jian* magazine feature, "The Post-Taiwan Strait Separation Syndrome: This Shore"

《人間》「海峽隔離後遺症：彼岸」專文頁面。右頁為福建南安霞宅村全景 [10]
*Ren Jian* magazine feature, "The Post-Taiwan Strait Separation Syndrome: The Far Shore." Photo at right shows Xiazhai Township, Nan'an, Fujian.

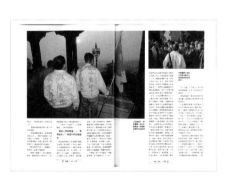

《人間》跟拍返鄉會報導，標題為「我還活者，我沒有死啊！」。左圖為返鄉團傍晚登上煤山俯瞰北京紫禁城情景 [11]
*Ren Jian* magazine follows a group returning to their hometowns in China. The caption reads, "I'm not dead, I'm alive!" Photo at left shows the group on "Coal Hill," looking down on Beijing's Forbidden City.

為對比：在標題「四十年之後，已然回不去的家」大字下，是黑白家族照的相中相。而29期《人間》記者跟拍「返鄉會」所製作的報導，也延續了「此岸」的風格：「想家」的外省人們衣服背上的題字在黑白報導照中顯得益發鮮明。雖然強調並幫助他們定義自己的訴求，但在與故鄉的家人團聚時，鏡頭所收入的背上題字，卻也同時將他們與彼岸鄉人的身分區隔開來。什麼是家鄉？是旅遊風景畫般的古老村莊？還是都市一角的半違章建築？報導者記錄了採訪對象面對的現實，請觀者自行解讀。

從聚焦現代的國族權力體制如何粗暴入侵古老在地聚落來討論原民部落，關曉榮的《蘭嶼報告》與《八尺門》系列成為《人間》收錄的重要報導作品，一路走來，已形成《人間》報導風格的標竿。但關曉榮逐漸開展確立的報導攝影方法，包括類似人類學者田野調查的報導作業，其實並未成為《人間》一般的報導手法。在攝影報導作品中，報導者所標舉的「寫實」，究竟是不是經過對自身預設立場的檢視，仍繼續挑戰《人間》之後的報導者。然而，從原民部落議題延伸到「家鄉」、「故鄉」、「原鄉」、「彼岸」、「此岸」，或者是成為1970、80年代流行論述詞的「鄉土」，透過《人間》的作品，讀者們第一次有機會把所有這些或指空間、或指時間，甚至隱含意識形態的詞語和符號，同時對照、一起思考。關曉榮的「人間之旅」，見證了紀實攝影在臺灣的重要一頁，而他自己的紀實攝影生涯，也由此走出一條不一樣的路。

---

1   《人間》第 5 期（1986.3），頁 91。
2   奚淞，〈我的生活與藝術〉，《姆媽，看這片繁花！》（臺北：爾雅，1996）附錄，頁 255。
3   有關 1950-60 年代紀實與寫實攝影的相關評論，可見：陳德馨，〈光明與真情的瞬間：鄧南光與《台灣攝影》雜誌〉，《藝術學研究》第 20 期（2017.6），頁 93-154。
4   報導文學由於兼有文學的特質，常必須在「主觀」與「客觀」之間取得困難的平衡，有研究者認為報導者必須秉持嚴格的社會責任感，報導文學的「主觀性」與「目的性」才可以被合理化，見：須文蔚，〈報導文學在臺灣〉，《新聞學研究》第 51 期（1995.7），頁 129-130。
5   「原鄉」一稱在本文主要為「原住民故鄉」或「原住民之鄉」之意，一方面可指臺灣原住民在日本殖民者、甚至漢人族群來到島上前的居住地；另一方面，也可意指原住民族群在政權（漢人及／或日人）威逼下，不得不遷徙後的新居地，同時也帶有住民們對於原居地鄉愁式的情緒，因此該詞本身指涉的不只空間，也是歷史變遷中對「故鄉」此一空間與地方的認知。
6   須文蔚，〈報導文學在臺灣〉，《新聞學研究》第 51 期，頁 121-142。
7   《人間》第 20 期（1987.6）「人間少數民族」，頁 18-19。
8   《人間》第 20 期（1987.6）「關曉榮蘭嶼紀事系列三」，頁 86-87。
9   《人間》第 25 期（1987.11）「海峽隔離後遺症：此岸」，頁 42-43。
10  《人間》第 25 期（1987.11）「海峽隔離後遺症：彼岸」，頁 26-27。
11  《人間》第 29 期（1988.3）「王拓大陸探遊筆記之一」，頁 30-31。

# The Body of Leftist Images
## On Guan Xiao-rong's Practice of Photography

Shen Bo-yi

Guan Xiao-rong practiced photography differently than many of his contemporaries: Rather than merely observing social movements, he participated; instead of shooting lovely scenery, he preferred to reveal the circumstances of the lower classes; and rather than capturing superficial images, he spent long periods investigating the structural and historical reasons for the plight of indigenous people. Even today, as a grandfather who enjoys playing with his grandchildren, he remains a radical social activist.

## The Historical Impact of Realism

Guan Xiao-rong's principal tools for intervening in reality were the written word and the photograph. As a youth in art college, he read a great deal of literature in translation, forming a foundation for his own writing. At the same time, a friend introduced him to the American photography collection, *The Family of Man*, helping him understand how photography's historical impact differed from that of painting.

In the 1980s, Guan discovered books about photographer Eugene Smith and his involvement in social issues, sparking his awareness of photography's relationship to society. He hoped to follow Western methods in photographic feature stories and to develop his own documentaries in Taiwan. Guan's habit of reading, whether collections of important Western photographers or literature in translation, stimulated his thinking on the realistic aspects of photography that give it lasting historical value and connection to society.

The influence of *Ren Jian* magazine, founded by Chen Ying-zhen in 1985, cannot be overlooked when discussing the development of realism in Taiwan. *Ren Jian* combined reportage and photography, delving deeply into conditions underlying the social turbulence and conflicts of the 1980s. Guan's black-and-white photos of young Amis tribespeople at Bachimen were chosen for the magazine's inaugural edition, setting the tone for its future issues. With its focus on reality, *Ren Jian* also continued to publish a series of Guan's special features on Bachimen and Lanyu.

*Ren Jian* magazine's concern for the lower strata of society and its resistance to consumer culture made it a kind of political actor in the publishing world, and it influenced many idealistic reporters. As Chang Chao-tang said, "In 1980s Taiwan, with publications full of consumerism, entertainment, propaganda, and strongly slanted views, *Ren Jian* offered testimony and reflection; with its rigorous humanistic exploration and active concern for society, it inspired idealistic, responsible reporters and photographers to forge ahead into the deep abyss of reality."

*Ren Jian's* social practice embodied strong, left-leaning ideals. Despite the political repression of the time, it continued to operate in a spirit of realism, avoiding easy conspiracy with the messages of party and state, and its critical, left-leaning spirit deeply influenced Guan Xiao-rong.

## An Alternative Practice of Photography: Bachimen

Through the alternative approach to photography in his *Bachimen* series, Guan Xiao-rong bore witness to the way mainstream society sidelined an entire group of people. Earlier photographers might have just chosen one representative photo, or tried to emphasize aesthetic expression. Guan instead chose a suite of photos for his photo-essays, with context provided by his personal journal entries and prose. By contrast with the traditional idea that "a good photograph speaks for itself," Guan approached reality more closely in his Bachimen features with multiple photos and reflective commentary.

Earlier photographers would usually "meet the subject head on, press the shutter, and walk away." Guan Xiao-rong, however, moved slowly into the lives of the local people, lived with them, and continued with long-term follow-ups on his subjects at Bachimen. This slower approach ran counter to the logic of quickly consumed photographic images, and he gradually integrated his life with the life of the indigenous people, while engaging in deep criticism, reflection, and change.

In short, Guan Xiao-rong resisted the aesthetics of individual heroism; instead, he spent time thinking about his interactions with the group and exposing "the noise banned from mainstream society." Yet we cannot ignore the fact that photography possesses an exclusionary logic, in which photos isolate one aspect of reality while excluding others.

Consequently, we must consider Guan Xiao-rong's accompanying notes when we view his photos, since they supplement those areas where photos cannot represent reality. Given the necessity for such corresponding texts, the writing that appears in Guan's Bachimen project is less an objective, anthropological style of reporting and more a kind of literature that reveals his inner uneasiness and anxiety, along with fragments of daily experiences. Through his writing we discover that he is not an "objective, neutral, rational" observer of the people in Bachimen, but instead, that much of his energy is focused on considering his own position as a photographer.

We should note that Guan's photographic approach resists both formal expressiveness and objective documentation. His reaction to formalism was to propose a realistic approach—a direct examination of his subject's existential plight through photography and writing. With respect to the notion of objective documentation, he instead reflects on the photographer's position, that is, he critically exposes himself as an intervening photographer rather than an objective and neutral recorder of events.

Guan Xiao-rong's field experience also differed from that of other photographers. He spent a long period of time tracking events on Bachimen and helping his local friend Ah-Chun, and he closely observed the family of Chiu Sung-mao. His investigations of these individual cases distinguished him from photographers with a more superficial approach, as he delved deep into the circumstances of Bachimen's indigenous peoples.

Guan's in-depth participation was also a response to ethical issues in photography. When Ah-Chun cleverly reversed the opposing roles of photographer and subject, which he did by taking a photo of Guan himself as they were barbequing meat at the seaside, Guan Xiao-rong's feature took on a new level of meaning.

Whether in the unyielding spirit that his images reveal, or in the reversal of roles between photographer and subject, or in the hand injury we see in Guan's portrait of Ah-Chun, we are reminded that the photographer-subject relationship is a fluid one, not an ossified relationship of binary opposites. This kind of unpredictable fluidity elevated Guan's work, giving it a more dynamic and dialectical character.

Guan's long-term project at Bachimen expanded our complex understanding of indigenous peoples, and vividly documented his friendship with them. At the same time, he maintained a tense relationship at the "ethical knife's edge" of photography. Guan did not eradicate the tensions of these ethical boundaries, but on the contrary exposed them in a way that caused people to reflect on the fundamental problems behind documentary photography.

## The Battle to Liberate Knowledge: The Lanyu Report

After finishing his Bachimen project, Guan immediately began researching indigenous peoples' issues. His subject this time was the island of Lanyu, long ignored by Taiwan. As an outsider, he entered into the traditional culture of the Tao people, preserving their time-honored ceremonies in his photographs. When they protested against nuclear waste storage, he stood side-by-side with them in their struggle against government bureaucrats, advancing further toward his goal of "liberating knowledge."

Guan Xiao-rong differed greatly from other photographers investigating Lanyu at that time. His stories were not colored by personal, romantic feelings, nor did they reflect an aesthetic viewpoint based on the island's exotic appeal. Rather than indulging in nostalgia, Guan analyzed the island's political economy with a sharp eye: he "problematized" Lanyu, considering it within the larger macrostructure and the labor and production relationships within it.

This approach allowed Guan to set aside his own direct, personal reactions as he photographed Bachimen, to engage in a more intellectually structured, rational critique. Photography critic Lin Chi-ming describes Guan's Lanyu work this way:

"His writings, in addition to the interviews and observa-tions typical of reportage literature, possessed great clarity in their political and economic analysis and their investigations into foreign investment. There were fewer personal interventions in terms of describing his own feelings, and more importantly, he began to adopt a historical perspective."

The historical perspective in Guan's writing included a critique of Han Chinese-centric attitudes. Photography critic Chen Chia-chi pointed out that Guan's Lanyu reports "were full of contradictory, 'both this…and that' statements, symbolizing the long-standing, invasive colonial relationship between the Han Chinese and indigenous peoples. Guan Xiao-rong, coming from the side of the oppressor, adopt-ed a more personal and self-aware creative approach. His reflective gaze displayed his recognition of the disadvantaged and an attempt to get closer to them."

Guan also actively shaped the identity of the Tao people through his reportage, helping spur formation of a broader indigenous consciousness. Guan's shaping of Tao identity can be seen in his photos showing Tao traditional culture, and is best represented in the series showing Tao youth resisting the unreasonable storage of nuclear waste on their island.

In his book, *Dignity and Humiliation: At the National Frontier — Lanyu 1987,* Guan exposed, through photos and text, issues such as Sinicized education, the atrocities of tourism, Tao youth forced to live abroad, shortages of medical resources, the forced building of public housing, and the anti-nuclear waste movement. We can see how he studied all aspects of Lanyu, from children's education to the development of youth labor, and ultimately, the harsh living circumstances there.

Faced with the oppression of their ethnic group, the people of Lanyu launched an airport protest in 1987; Guan, with his camera, participated in the entire event. Despite being an outsider in this consfrontation with the government, he was not merely observing coolly from the sidelines, but stood should-to-shoulder with the locals against governmental power.

Relative to the educated youth of Lanyu and the way they identified with and safeguarded their land, Guan evinced a contradiction in identity. Being Han Chinese, he was unable to completely integrate into the Tao tribe or to speak for them. But he did offer a critique of Han-centrism, and he helped the Tao people speak out while even as he reflected on how he was photographing them. Though unable to become a tribe member, Guan felt aligned with them due to his own working conditions, his knowledge, and his experience of unjust treatment. The sympathy between different ethnic groups transcended ties of blood or ethnicity, being based more on experiences common to both.

## Anachronistic Leftist Imagery

One senses a kind of "anachronistic" force both in Guan Xiao-rong's work and in his person. He analyzed the political and economic structures of his era, yet was not accepted by it. Such "anachronism," however, was a source of political possibilities. Keeping a distance from the times and seeing them from another angle, he was able to see beyond their brilliant surface and to realize how that surface was supported by countless "invisible people."

Mainstream societal values had long overlooked these faceless, invisible people, who became victims of oppression and discrimination. But Guan Xiao-rong always maintained a fighting spirit, standing with the people and pursuing the possibility of equality and liberation. He said that "A ceaseless, un-compromising historical battle must be waged, because the social sciences, with their ideas of equality among ethnic groups and the value of their worldviews, are constantly challenged by attempts to rationalize discrimination and oppression." Concerned not just with the present, he hoped to project a liberating power into the future.

The lasting, physical legacy of photos was what made them Guan's best vehicle. He said, "I always feel that those nameless individuals belong to the family of human 'kind.' It is the real existence of those individuals in such great numbers in, beneath, behind, and outside my photos that gives me a deep sense of connection and caring." Guan's photos display not just personal sentiment, but more importantly, the historical coexistence of communities.

It may seem strange that Guan, with his mainland Chinese Han bloodline, had no direct relationship to any of the indigenous people he depicted. But rather than an essentialist view based on bloodlines, it is a class-based perspective than may help clarify their mutual sense of recognition.

By contrast with the mainland elites and their conspiratorial grasp of capitalism and power, Guan's identification with the lower tiers of society allowed him to connect marginalized mainlanders and indigenous peoples, and to generate the power for action. Even though they all shared the experience of being disadvantaged, Guan continued to reflect on his stance as a Han person while shooting, and to engage in meta-criticism regarding the ethical tension between photographer and subject.

Guan further made no special show of the artistic talent evident in his photography. Instead, he took a step back to let the lives and the dignity of others come to the fore, while also promoting the indigenous peoples' movement. He did not show his portraits in commercial art galleries, and he donated most of the proceeds from his books to the indigenous movement. Put another way, he cared more about taking action than achieving artistic success.

Taken together, the leftist images in Guan's documentary practice show him standing with the people, taking a materialist view of history, engaging in meta-

criticism regarding his own stance, and participating in movements as an activist. Guan penetrated beyond the easy, simple surface and took a more complex view of reality, working himself into its deeper layers, attempting to incite the possibility of resisting the capitalist order.

## A Reassessment of Documentary Photography: A Physical Practice

Documentary photography is not always as self-evident and straightforward as it seems. Photography critic Susan Sontag had strong doubts about photography's ability to represent reality. She believed that rather than bringing us closer to reality, it pushes us away from it: "...the aestheticizing tendency of photography is such that the medium which conveys distress ends by neutralizing it. Cameras miniaturize experience, transform history into spectacle. As much as they create sympathy, photographs cut sympathy, distance the emotions."

Documentary photography, it is true, cannot escape these critical questions about representing reali-ty. But Guan Xiao-rong's practice of the art opened up new levels with his cross-ethnic connection, his reflexive self-examination, his writing, and his research. If we acknowledge that the problem with photography is that its aesthetic form ultimately places a limiting frame around reality, then Guan Xiao-rong pushed beyond photography itself through his physical practice of it. In a cross-disciplinary manner, he linked the sensibility of literary writing and the rationality of social science with a kind of radical activism.

Guan's photography, in other words, was in an "in-between" state, growing from the interstices of various other disciplines rather than returning to the basic confines of photographic aesthetics. It was this kind of "in-between" photography that allowed him to escape the limitations of the medium's aesthetic form and its crisis of representation.

In other respects, Guan's photographic works did not stop at the opposing relationship between the photographer and indigenous people; instead, he placed himself in a network of action along with them. This is reminiscent of philosopher Judy Butler's concept of the collaborative subject, in which the "I" is not just some "self," but is an existence closely bound up with others. For her, the "I" coexists with others in a complex interrelationship, and that is something that cannot be changed, since our lives are equally fragile and we are dependent on each other. In Guan's work, we are hardly aware of the photographer as a strong, separate subject, since that subject is one who turns and looks back at his own position even as he extends his view outward towards others.

This kind of practice, extending both inward and outward, also requires an ethical response from viewers. While Sontag pessimistically criticizes photographic aesthetics for distancing us from the reality of suffering, Butler is more optimistic, as she believes that photography can generate political responses. She contends that if we can create new frames, within which to display new content, that photography can transmit to us the reality of suffering and change our outlook

on the current political situation—but that to achieve this, photography must be infectious and must arouse an ethical response. That is to say, with new methods, photography can still use its appeal to urge people to political action.

In a cursory look at Guan Xiaorong's works, it seems that since the *Ren Jian* period his documentary photography has been unable to escape the crisis of the representation of reality. Yet we cannot ignore his idea of "action in itself." His practice of realism had tremendous appeal and emotional power, and his spirit of action represents the derivation of a new kind of photographic frame.

Kuo Li-hsin posits that Guan Xiao-rong, beyond working within the warmhearted, humanistic framework of *Ren Jian* magazine, also employed a more rational and critical approach to dealing with real problems. The power of Guan's sympathy for the oppressed, however, was what supported him in his rational analyses. We should not value just Guan's rational approach; we should also look back and recognize the power of his emotional but never overly sentimental responses. Thus, while this essay emphasizes his rationality and restraint, it also recognizes the dialectic of this "affective turn" as it looks back at Guan's physical practice of photography.

As we look at any photograph, we always see only the subject that it represents, even as we typically overlook the frail physical existence of the photographer. In fact, beyond the physical photographs he produced, Guan's practice also involved his relationship with indigenous people, the political movements in which he participated, his reflections on the position of the photographer, and his brave acknowledgement of his medium's limitations.

It was Guan Xiao-rong's physical presence, despite not being manifested in his own photographs, that served as an exact counterweight to the formalist aesthetics that rob reality of its power. Through his actions, he presented reality to us in an even more three-dimensional and complex form. By virtue of the physical continuity of Guan's photographs and writings, these leftist images, of things which once existed, will continue to multiply and spread in the long stream of history, creating new possibilities for revolution and the emancipation of reality.

# Guan Xiao-rong's "Ren Jian" Journey:
## Reportage Photography and the Photographic Culture Craze of the 1980s

Ma Kuo-an

A new era of media activity began with the lifting of Taiwan's martial law and related restrictions in 1987. Reportage literature and photography became popular, yet just two years later, *Ren Jian* magazine, Taiwan's pioneer in the field, had departed the cultural scene, and reporters with shared ideals were forced to resume their isolated journeys. What role did the emergence of *Ren Jian* play for someone like Guan Xiao-rong, a young reporter entering the new sphere of reportage photography and intelligently exploring current issues? Given that *Ren Jian* witnessed the lifting of martial law and the resulting societal transformation, can it help us better understand the history of photographic culture in Taiwan before the 1980s?

This three-part essay explores *Ren Jian* magazine and Taiwan's photographic culture in the 1980s. It begins with the nativist literary debate in the late 1970s, discussing how *Ren Jian* raised the banner of reportage literature, and the cultural and intellectual milieu in which Guan's career began. Second, it reflects on ethnic issues raised by reportage photographers in the 1980s, which, for Guan and *Ren Jian*, were mainly the questions of Taiwan's "homeland" and its indigenous peoples (then often called "mountain compatriots"). Lastly, it touches on the question of national identity—a question that remains unresolved, and one powerfully posed by *Ren Jian* in its photo essays on "Veterans Returning Home."

## The Deep Impact of Reportage Literature

In an interview included in this book, Guan Xiao-rong attributes his concern for realism in reporting to the influence of *China Tide* magazine and Chen Ying-zhen, while noting how Shi Song shaped his early literary outlook and worldview. Issues rooted deeply in Taiwan's literature and art were part of its intellectual world in the 1980s: confusion, searching, and exploration around the "native land" issue. Commentators often forget that, with political affiliation shaped by ideology, the birth of nativist literature in Taiwan reflected a complex outlook. Such literature dealt with cultural hegemony, tradition, and identity; it embraced a concern for the marginalized and the lower strata of society; and it offered a critique of modernity. It was in such a cultural context that participants in the nativist literary debates in the late 1970s such as Chen Ying-zhen and Huang Chun-ming, despite their differing stances, could still join hands to pioneer the reportage literature of the late 1970s and early '80s.

Reportage literature and photography at that time were already developing, and early examples appeared in Taiwan's media, but only *Ren Jian* witnessed the real flowering of the genre. Its avowed purpose was to begin from real life, especially the lower levels of society, as it examined the process of modernization and the cultural and spiritual shifts it brought to Taiwan, which lay just outside the spheres of influence of the great Cold War powers. *Ren Jian* encountered methodological problems with reportage literature, but its mission, as a monthly magazine for a general readership, was to bring reportage literature and photography into its readers' daily lives. Members of the new, culturally aware generation familiar with modern Western ideas had certainly had experiences similar to those of Shi Song: Reporting on the Dajia Mazu Pilgrimage for *Echo* magazine, he realized for the first time that "you cannot approach life through certain concepts or ideas; you have to understand it through actual experience." The nativist literature movement of the 1970s also echoed a debate prevalent in Taiwan's literary circles since the 1930s, when concerns were shifting from the choice of language (Taiwanese, Mandarin, or Japanese) to literature's relationship to reality. The concern for literary realism returned in the post-war 1970s, and the literati of that era, as in the 1930s, were often either questioned, or silenced, by the authorities. *Ren Jian*, inheriting the trends of reportage literature and the nativist movement, became a theater of experimentation for reportage literature and the cultured person's voice of resistance. The concept of "native land," always in the background, referred less to a real, geographical area than to the idea of a homeland, a construct for cultural identity that provided a sense of spiritual belonging.

Thus *Ren Jian*, intent on popularizing reportage photography and literature, inherited a literary movement, and grew out of the nativist and documentary styles of photography that were then taking root in Taiwan. As early as the 1950s, the Free Film Festival, centered around Deng Nan-guang in the north of Taiwan, and later, the Taiwan Provincial Photographic Association (today, the Photographic Society of Taiwan), continued the development of documentary photography begun late in the Japanese occupation. The many southern photographers involved in documentary photography in the 1960s-70s were called "native photographers." In contrast with the officially accepted "pictorial photography," photographs documenting society's true face were often deemed "rubbish" by reviewers. While "reportage photography" and "documentary photography" may differ, the *Ren Jian* reporters who showed readers how to "actually experience life" had internalized the spirit of both nativist and documentary photography. The publisher's note in *Ren Jian* magazine read: "We refuse to believe that the Chinese people who can create a Taiwan with such great material wealth must have a spiritual outlook so common and vulgar." Its topics were aimed at the modern person's spiritual life, and almost every issue had a profile piece on subjects disdained by the mainstream media. The subjects of those pieces were common, even poor—"little people" such as taxi drivers or "mountain" laborers struggling to survive in lowland cities. Through texts and images that reproduced their daily lives, and even the "rubbish" of their surroundings, as in the photos of nativist photographers, *Ren Jian* directed its readers toward the inner worlds and

the life stories of society's marginalized figures. Thus, the paradigms of reportage photography and literature established by *Ren Jian* were based on their writers' sense of social responsibility. The magazine conveyed their ideas and their values, which were often discussed most deeply through questions surrounding the idea of "homeland" and national identity.

## The Image of Ethnicity Reflected by Guan Xiao-rong and *Ren Jian* in the 1980s

Guan Xiao-rong's stories on Bachimen and Lanyu were among the most long-running, thorough pieces of reportage literature and photography published by *Ren Jian*. Whether as a result of his methodology or the magazine's editing and selection of content, Guan's stories were poignant and highly representative of *Ren Jian*: that is, they used an "ethnographic" approach to reporting, while discussing Taiwan's indigenous peoples and "the homeland" from both ethnic and social perspectives. While such ethnographic fieldwork might be revealing, researchers have suggested that as reportage literature, with a status somewhere between journalism and literature, began to spread in Taiwan, it lacked both an adequate theoretical basis and a clear methodology. But its historical and cultural contexts meant that early Taiwanese reportage literature nevertheless shared field interview and reporting methods with anthropology. And in fact its more global approach to reporting, which involved on-site, long-term investigation of the subject, along with field work and information beyond the subject's own responses, did provide a fairly sound methodology for reportage literature.

"The homeland" and indigenous ethnic groups were important motifs in early reportage literature, and they became a focus for *Ren Jian* as well. A series of reports, "The Minorities Among Us," while not directly related to Guan's own features, nevertheless joined with them to shape the character of reportage photography at *Ren Jian*. They document important aspects of Taiwan's reportage photography at the time, as seen most notably in the 20th issue of *Ren Jian*. A note from the editing room at the time reads: "'To exterminate a people, first exterminate their culture.' The fact that Taiwan's minorities today face structural collapse offers the best commentary on this statement." In the 20th issue, *Ren Jian* reported on the tragic execution of Tang Yingshen, a youth of the Tsou tribe (known then as the Cao). Two issues ran features on the "Tang Yingshen Incident," which caused a furor in Taiwan's academic and cultural circles, and they virtually defined the magazine's in-depth focus on the homeland and indigenous peoples' issues. In that same issue, Guan's "Lanyu Chronicles" series was also in serialization, complementing the story of the Tsou youth who was shot to death at a lowland detention center.

The cover photo for the 20th issue showed young Tang Yingshen's body in a narrow coffin, an issue of *Ren Jian* placed alongside him. A subtitle in Guan's "Lanyu Chronicles" in the same issue read: "Civilization collapses in a narrow cell…" In contrast with the dramatic "I dedicate my suffering to you" in the report on Tang Yingshen, the photo essay of Guan's "Chronicles" featured daily scenes of youth in

the fishing boats of Hong Tou Village, and described the Yami tribe's culture and ancient beliefs. Photos showing the Yami building traditional wooden dwellings spurred readers to reflect on the government policy of erecting public housing there, and to consider the idea that "civilization" is not the property of "modern people" or modern society, but that it derives from ethnic groups in their original homelands, following their ancient rituals and ways of life. The image of Taiwanese ethnic groups that emerged from the reportage photography of the 1970s and '80s was a diverse one, and a look at *Ren Jian*'s reportage reveals a seesaw battle in the background—a conflict between the opposing poles of "dramatic" (or non-routine) news reporting on the one hand, and simple realism on the other. The portrait of Tang's body was hugely impactful, and the photograph tended to "direct"—not merely suggest—values and sympathetic responses for the readers. The photographic presentation of the young man's remains extended the value judgments built up in the text. The visual and emotional impact of the Tang Yingshen photos conveyed "the cruel tragedy befalling the family of the executed youth" and "the pain of the victim's family." But, returning to the images in the "Lanyu Chronicles," we find a radically different relationship between text and image. Most of the shots selected for the photo essays were independent images, richly loaded with information, but were not accompanied by definitive captions such as "A traditional Yami ritual" or "A traditional Hong Tou Village house," which would only further ingrain stereotyped impressions of "the primitive other." Instead, photos and text augmented each other to document various aspects of Yami life in a particular time and place, urging the reader to reflect on the essay's presentation of how the Yami actually lived. In other words, though Guan's reportage photography was based on ethnographic documentation, he adopted a more critical perspective, subtly guiding the reader toward thinking independently about "reality" or "what is realism?"

In an interview conducted for this book, Guan quotes Chao Kang, Professor of Sociology at Tunghai University, who says that during research, the "I" can be detached from reality to become object rather than subject. In reporting on indigenous peoples, then, rather than the "dramatic" approach of reportage photography, the line between reader and reporter was deliberately blurred, bringing the reader's "I" into the circumstances of the reporter. Guan consciously noted how both the reporter's "I" and the reader's "I" may have pre-set viewpoints or modes of understanding, and various kinds of "realism" appeared in his reports on the homeland in *Ren Jian*. Both Guan and the reporters and editors at *Ren Jian* had to define what was meant by "realism," while also interpreting the predetermined positions of different identities. Reportage in *Ren Jian*, in fact, was a series of explorations in balancing drama with realism. Below, this essay focuses on the "Veterans Returning Home" series that began in the magazine's 25th issue, showing how *Ren Jian* examined and presented its methods of reporting and its stance toward the relationship between ethnic groups and identity.

## Beyond National Identity, and "Realism" in Reportage Photography

In January of 1988, a group of veterans and their friends formed the Association for the Right of Mainlanders to Return Home, so that, 40 years after the separation across the Taiwan Strait, those veterans could return to their homeland and visit their families. The 29th issue of *Ren Jian*, published in March of that year, reported on their journey back home. In fact, in November of the previous year, while the Association was still demonstrating in the streets, *Ren Jian* had already published a feature report in its 25th issue entitled "The Post-Taiwan Strait Separation Syndrome." For that report the journalist traveled across the Taiwan Strait, reporting on both Xiazhai Township in Nan'an, Fujian, and on a veteran's family in Taipei, Taiwan. Other issues of *Ren Jian* featured mainland folkways and customs: The story describing "The Far Shore" was based around richly colored photographs depicting Fujian as rustic and peaceful, its old wells and elderly neighbors still in place, with only a scattering of village men and women in the fields. That style contrasted strongly with the images in "This Shore," in which an old veteran's family was interviewed. Under the title "After 40 Years, A Home to Which He Still Cannot Return," the magazine's photo image shows some old black-and-white family photos. In the 29th issue, the reporter's photos accompanied a report, produced by the Association, that continued in the style of "This Shore": Messages written on the backs of clothing worn by "homesick" Taiwanese of mainland ancestry seemed especially vivid in black and white; those messages both emphasized and defined their needs. Yet, when reunited with their families in their mainland hometowns, those same words in the camera lens only further emphasized their separate identities. What is one's hometown? Is it an ancient village that looks like a scenic tourist destination? Or just a semi-legal building in some corner of a city? The reporter documented the reality his subjects faced, and asked readers to make their own interpretation.

Guan Xiao-rong's reporting on indigenous tribes for *Ren Jian* focused on the invasion of their ancient local settlements by a modern national power system. His pieces on Lanyu and Bachimen were important works of reportage that set a benchmark for the magazine's style. Even so, the methods he gradually established, including those borrowed from anthropology, did not become a standard there, yet the "realism" he espoused in his photojournalism, in particular the question of whether reporters should examine their own preexisting viewpoints, continued to challenge reporters after *Ren Jian* ceased publication. The issues addressed in *Ren Jian* included indigenous tribes, questions surrounding the concepts of "hometown," "old hometown," "homeland," "far shore," and "this shore," and the term "nativist" that had become popular in the 1970s and '80s. Readers for the first time could compare all these terms and symbols as they appeared in *Ren Jian*, with their references to eras or regions, or their allusions to ideology, and consider them all at once. Guan Xiao-rong's "Ren Jian journey" is a testament to an important page in Taiwan's reportage photography, and once it ended, Guan's own career in that field would ultimately follow a new path.

作品

Works ————————

# 散文與攝影：〈女兒的胞衣〉、早期攝影

## Prose and Photography: "Daughter's Afterbirth" and Early Photographic Works

文／沈柏逸

關曉榮就讀藝專時大量接觸文學作品，從中體會到人孤獨的存在以及荒涼的自由。從他1977年開始的街頭攝影中，可以觀察到臺灣錢淹腳目的時代並不是如此光鮮亮麗。本系列收錄他用第一台相機拍攝的家庭生活，開計程車為生時街拍的路上老人，還有當攝影記者時的魚塭專題，這些人物都在那個光彩時代流露出悵惘的氛圍。

關曉榮不只能拍，還同時能寫。在〈女兒的胞衣〉一文中可以觀察到他書寫的風格接近寫實，而他也挖掘自身的生命經驗，從自我反思中找到抵抗現實的力道。雖然傾向寫實風格，但他不是虛偽的客觀立場，而是透過主觀的觀察以及同情的理解，感受自我真實的體驗。綜觀而言，無論是早期攝影或散文寫作，在在凸顯關曉榮強烈「主觀」的位置，同時流露個人生命經驗的真實。

Guan Xiao-rong read a lot of literature in art school; it taught him about the existence of loneliness and the freedom found in desolation. From the street photography he began doing in 1977, we see that the era when Taiwan was "ankle-deep in money" may not have been such a glamorous time. This series includes photos depicting family life, taken with his first camera, elderly people on the street that he photographed while driving a taxi, as well as features on fish farming that he produced as a photojournalist. The subjects of his photos, during that brilliant era, all evince an air of frustration.

Guan was a writer as well as a photographer. In his book of prose works, "Daughter's Afterbirth," we see him mining his own experience, finding the strength to resist unpleasant realities through self-reflection. His style is generally realistic, but rather than a false objectivity, he gains understanding through sympathetic observation and finds his genuine self. Overall, his early photographic and written works both exhibit a strong "subjective" stance while still revealing the truth of his individual life and experience.

散文〈女兒的胞衣〉章名頁，時報出版 / 1993
Chapter title page from Guan's book, "Daughter's Afterbirth" (China Times publishing)

散文〈女兒的胞衣〉內頁 30-31
Pages 30-31 of Guan's book, "Daughter's Afterbirth"

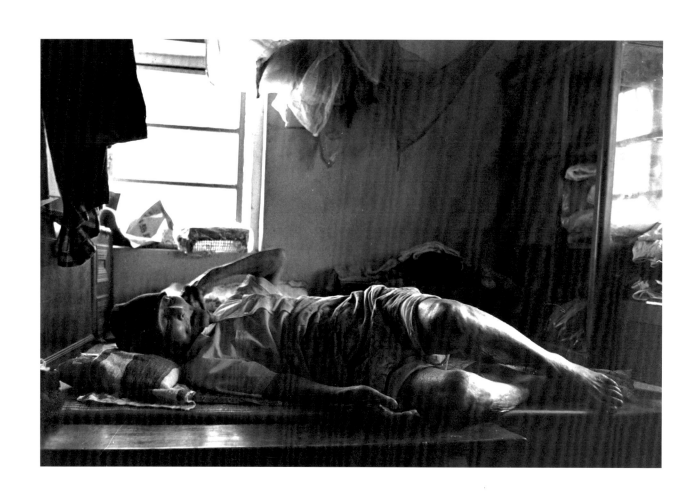

關曉榮的阿公 / 屏東恆春 / 1979
Guan Xiao-rong's Grandfather / Hengchun, Pingtung

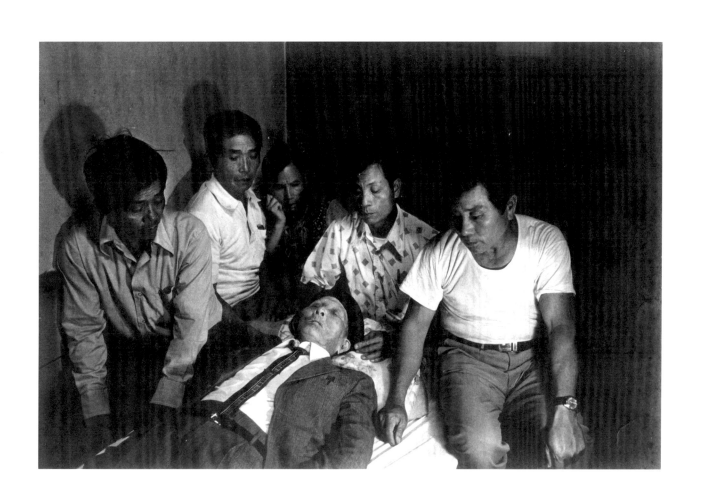

關曉榮岳父（右）與彌留的阿公 / 屏東恆春 / 1979
Guan's father-in-law (right) with his dying grandfather / Hengchun, Pingtung

恆春古城東門外崩塌的城垣 / 屏東 / 1978-1979
Collapsed city wall outside the East Gate / Hengchun, Pingtung

恆春核三廠建廠用地外 / 屏東 / 1978-1979
Outside the Maanshan Nuclear Power Plant building site / Hengchun, Pingtung

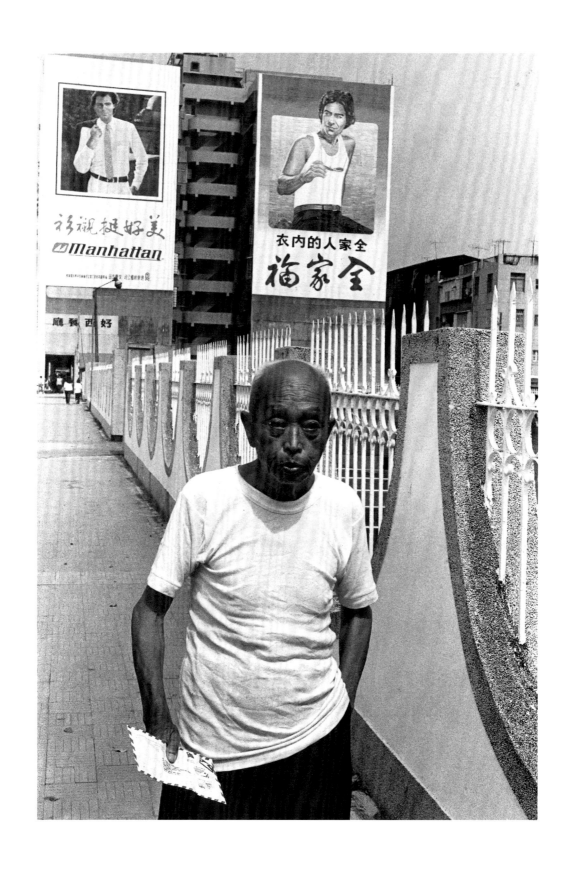

臺北南京東路 / 1981-1982
Nanjing E. Rd., Taipei

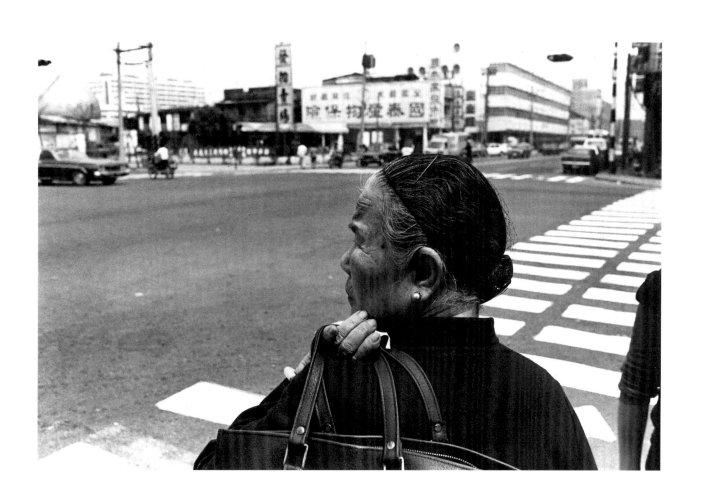

昔日麥克阿瑟公路南松山路橋下 / 臺北南京東路四段 / 1981
Beneath the South Songshan Bridge on the former MacArthur Thruway / Sec.4, Nanjing E. Rd., Taipei

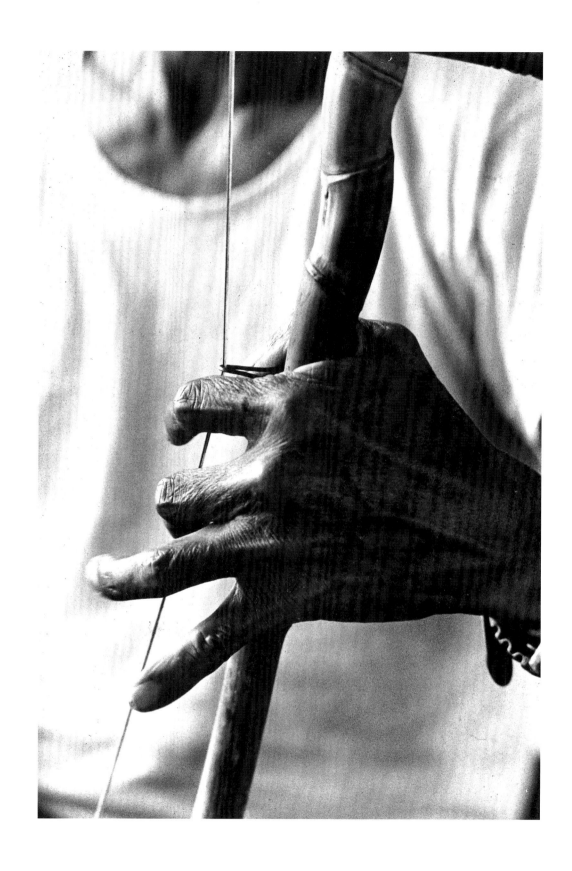

街頭演奏者 / 彰化 / 1983
A street musician / Changhua

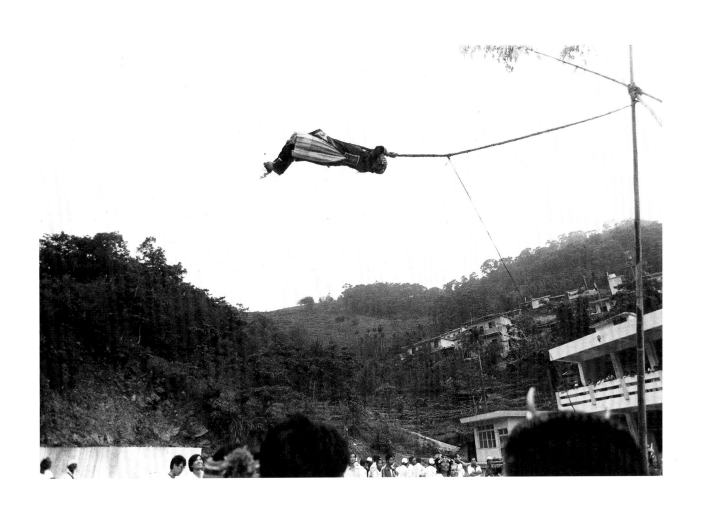

魯凱族豐年祭及運動會 / 屏東霧台 / 1983
A Rukai Tribe bamboo swing competition / Wutai, Pingtung

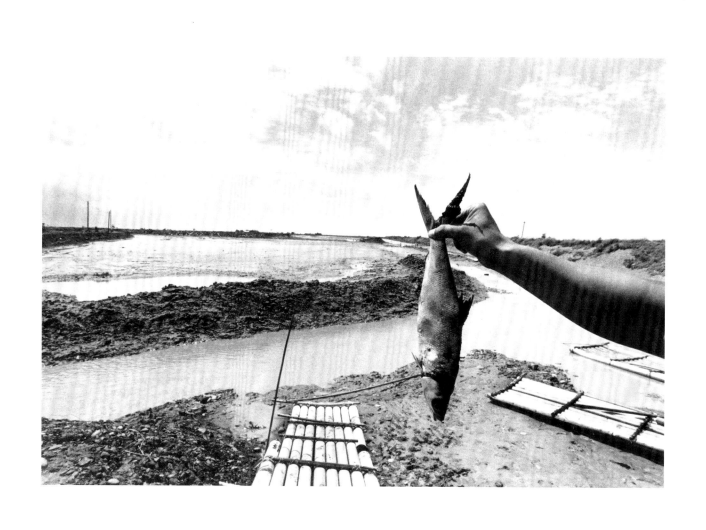

九三大水災後的魚塭 / 臺南 / 1981
A fish pond after the great flood / Tainan

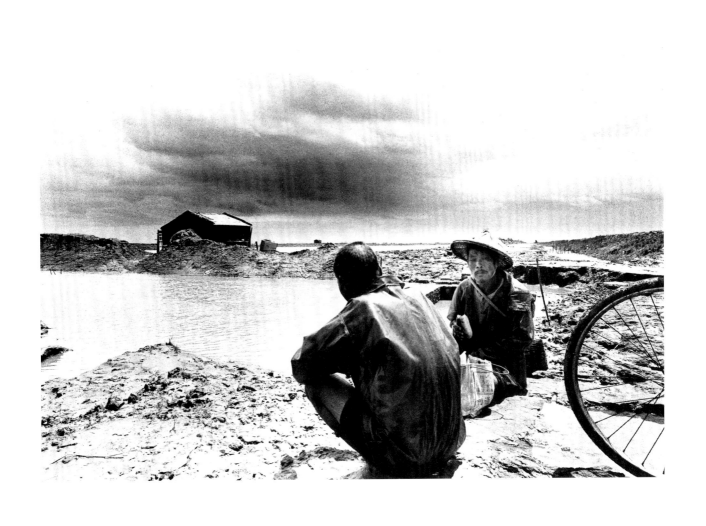

九三大水災後的魚塭 / 臺南 / 1981
A fish pond after the great flood / Tainan

# 沉浸的田野調查：《八尺門》

## Immersive Fieldwork: *Bachimen*

文／沈柏逸

1984年開啟的《八尺門》報告中，關曉榮轉向不同於早期街拍或短暫專題的拍攝方法，開始運用長期蹲點的田野調查，沉浸於居住在基隆八尺門阿美族社群，並且鎖定追蹤個案勞動者阿春的生命歷程。在此系列中，可以看到早期八尺門中族人既疏離又協作的氛圍。無論是慌恐的孩子、守家的婦女以及漂泊的青年都流露出疏離的感受；也顯現族人們互助的傳統，以及他們身處艱辛環境仍不屈不撓的精神。

關曉榮也再三回訪八尺門，見證阿春與八尺門的變與不變。或許肉體會經過時間的流逝而衰老，過往討海工作的人變成了板模工，違建的部落屋子被改建成現代化的公寓。然而，經歷風霜的阿春沒有被艱苦的現實擊倒，而阿美族不屈的永恆精神也將透過這些影像，不斷傳遞下去。

In 1984, as he began reporting on Bachimen, Guan adopted methods different from his earlier street photography and short feature stories: He conducted long-term fieldwork, immersed himself in Amis tribal society, and tracked the life story of Amis laborer Ah-Chun. The series makes apparent the atmosphere of both alienation and collaboration early on among the tribes in Bachimen. His photos all reveal this sense of alienation, whether in the face of a panicked child, a woman performing her household duties, or a wandering youth. At the same time, however, they display the Amis tradition of mutual assistance and their resolute spirit in the face of a difficult environment.

Guan visited Bachimen time and again to see Ah-Chun and to witness what changes may or may not have occurred. Perhaps, as a person's body weakens with time, the man who once made his living on the sea would later become a construction worker, or an illegal tribal house would be converted into a modern apartment building. Hardship, however, was not new to Ah-Chun. He remained unbowed by reality, and in Guan's images, that indomitable spirit of the Amis will live on.

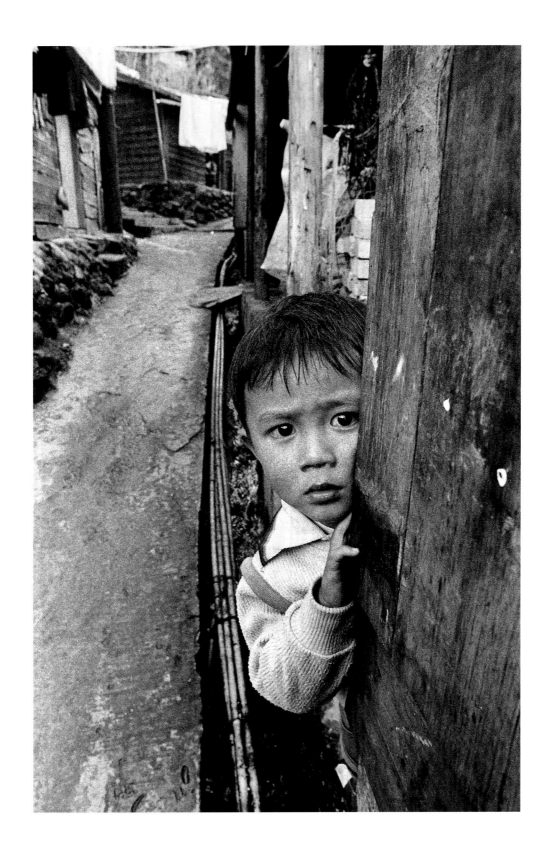

母親外出交代看家的男孩 / 1984
A little boy looks after the home while mother is away

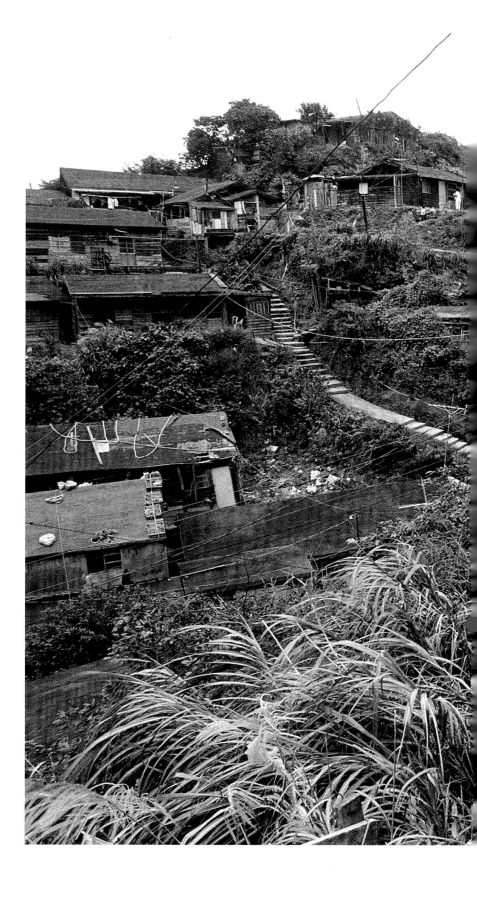

兩座小山向東的一個山坡頂最高的住戶 / 1984
The highest residence on the eastern-facing
slopes of two hills

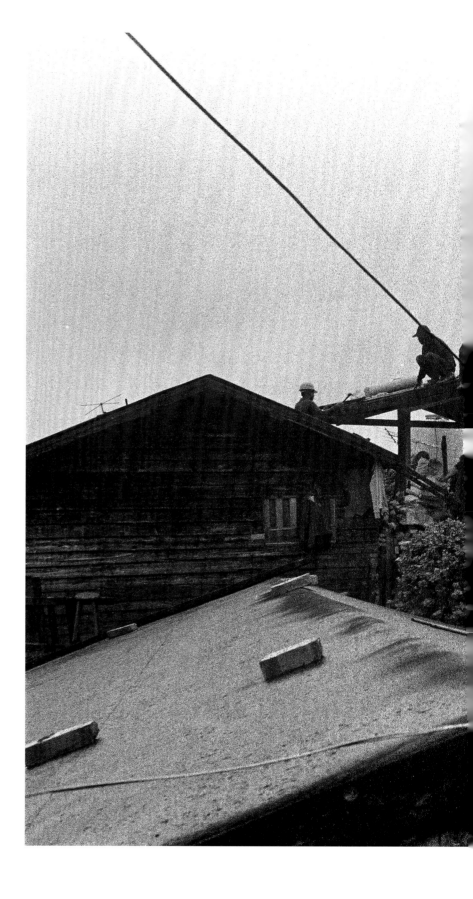

阿美族人在移居地求生存保留了傳統助工、
換工的社會凝聚力 / 1984
Amis tribe members in a new settlement retain social
cohesion, helping and exchanging labor

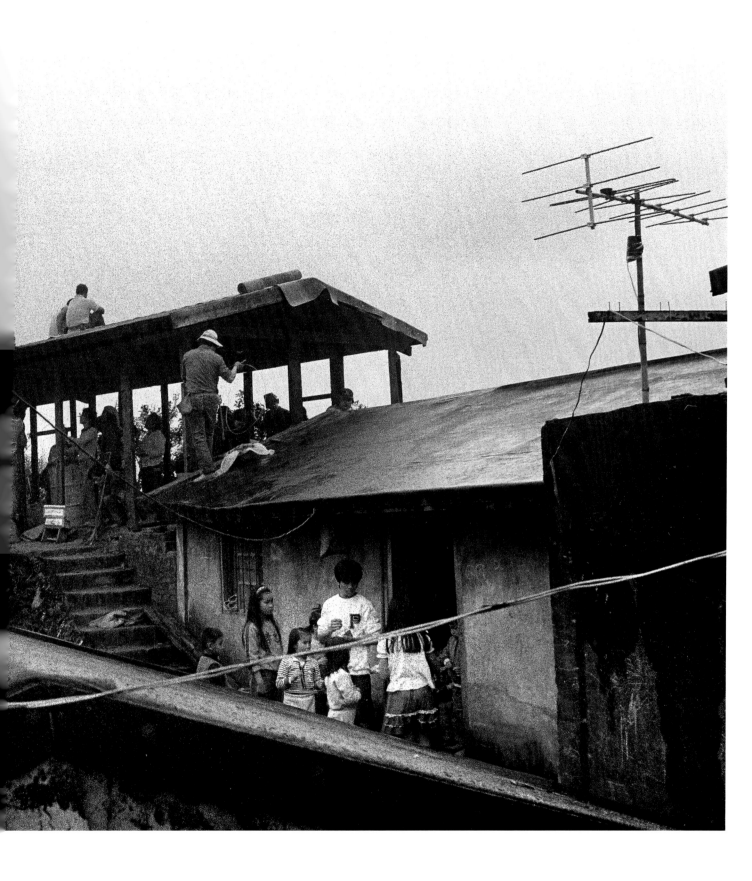

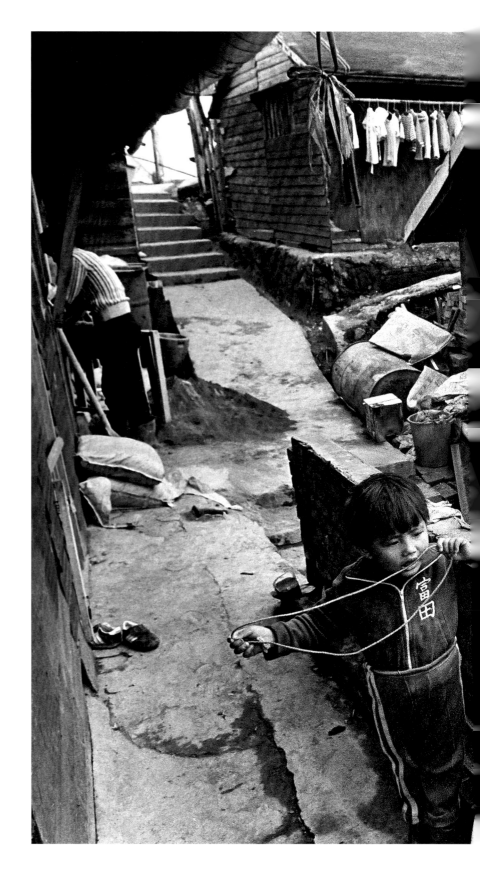

丈夫出海未歸的婦女 / 1984
A wife waits for her husband at sea

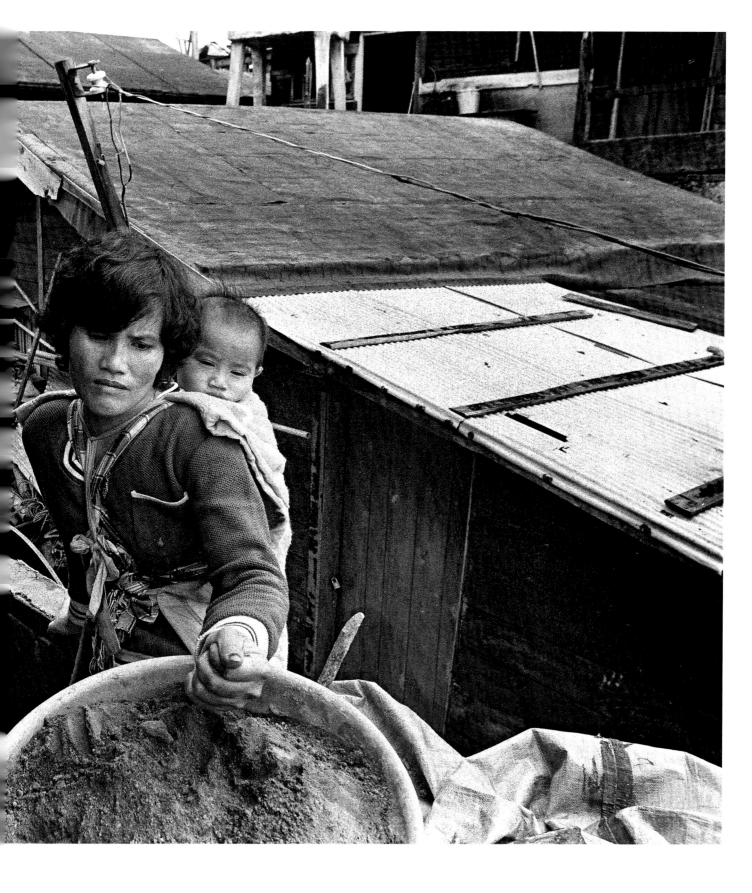

被捕獲帶回飼養的小山豬 / 1984

A small boar captured to be raised at home

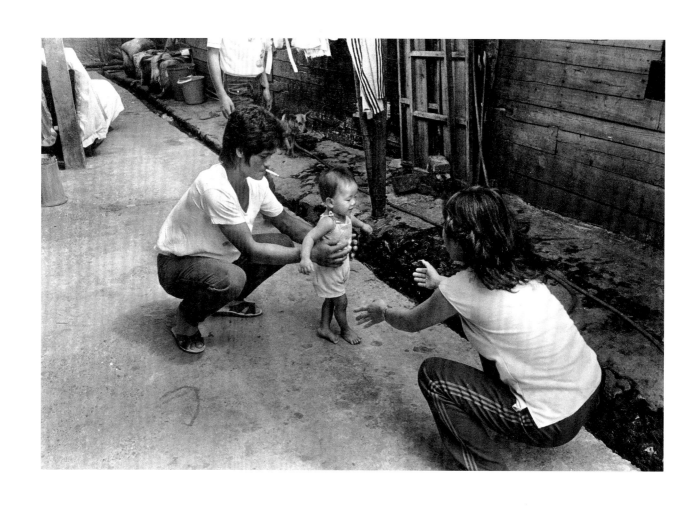

剛學走路的孩子 / 1984
A child taking his first steps

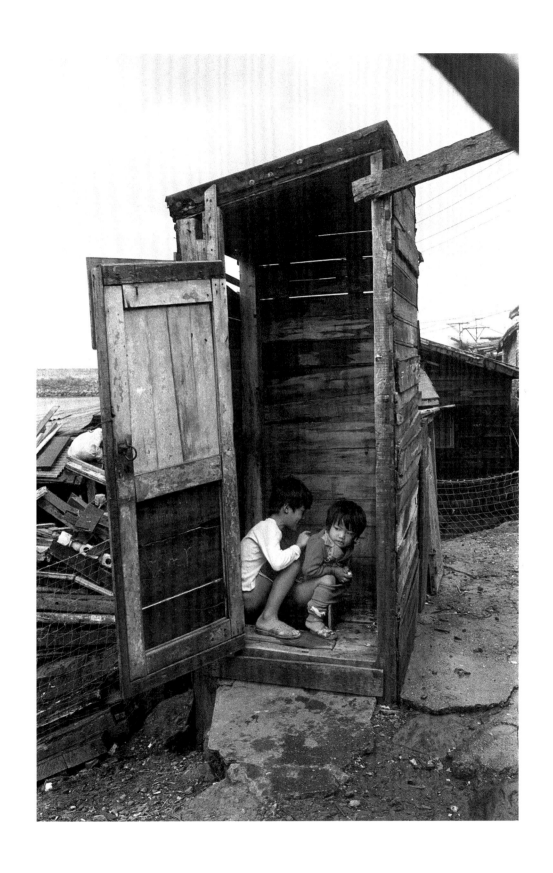

哨所般的小公廁 / 1984
A watchhouse-style public toilet

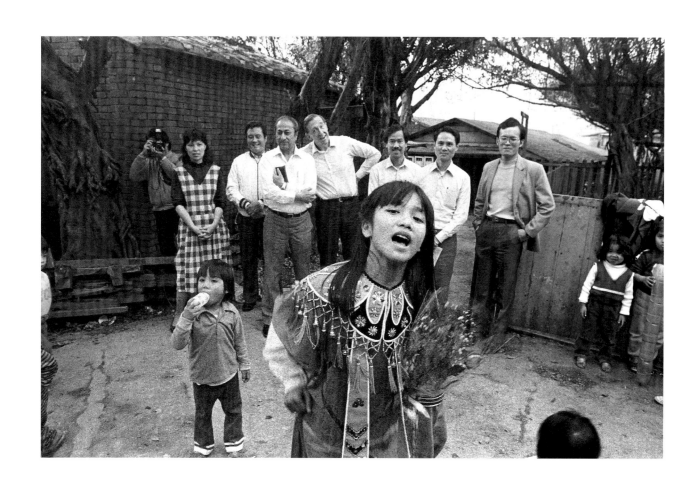

國外參訪者到來，學童從學校被叫回來跳迎賓舞。中央為領唱的女孩李惠美 / 1984
Children called out from school sing a greeting song for a foreigner. At center is lead singer Lee Hui-mei

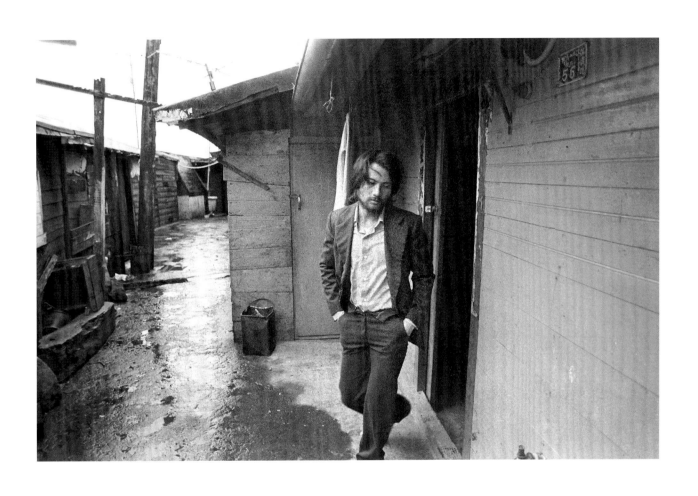

往朋友家借錢未果的青年 / 1984
A youth after failing to get a loan from a friend

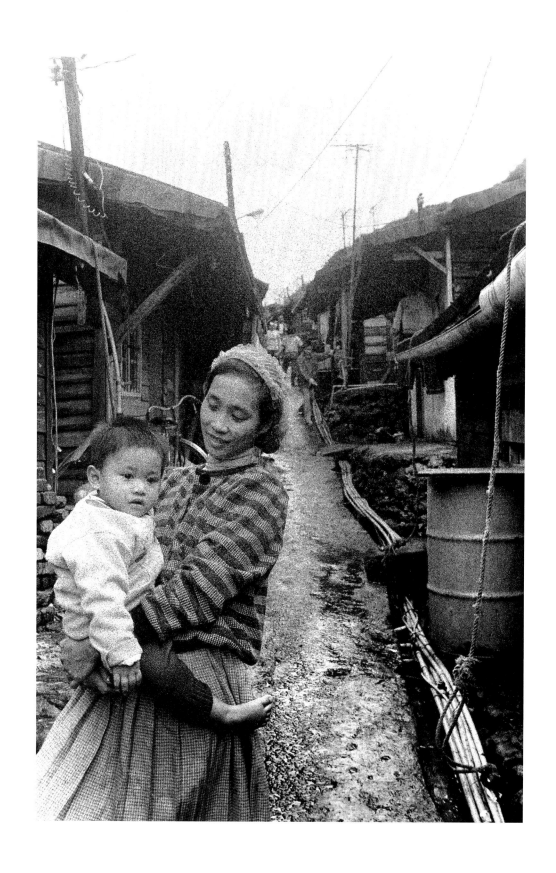

年輕的母與子 / 1984
A young mother and child

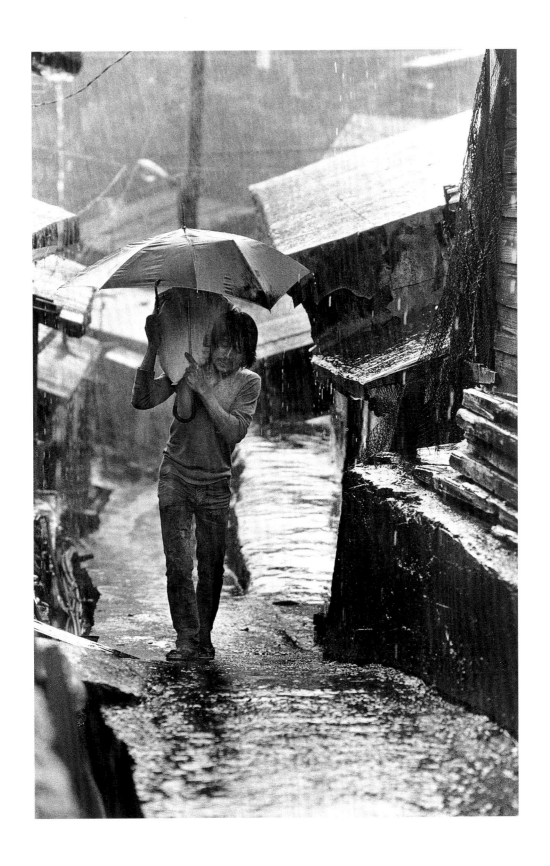

林明發扛著故鄉臺東的米袋 / 1984
Lin Ming-fa carries a bag of rice from his hometown of Taitung

高昌隆，1985 年《人間》雜誌封面人物 / 1984
Gao Chang-long, cover photo subject for 1985 *Ren Jian* magazine

阿杉出海前 / 1984
Ah-Shan before going to sea

照顧弟弟、同時育養三個小孩的阿杉大姊 / 1984
Eldest sister of Ah-Shan, caring for her younger brother while raising three children

來找邱松茂的朋友向關曉榮吐露心事 / 1984
A friend, coming to see Chiu Sung-mao, shares his troubles with Guan Xiao-rong

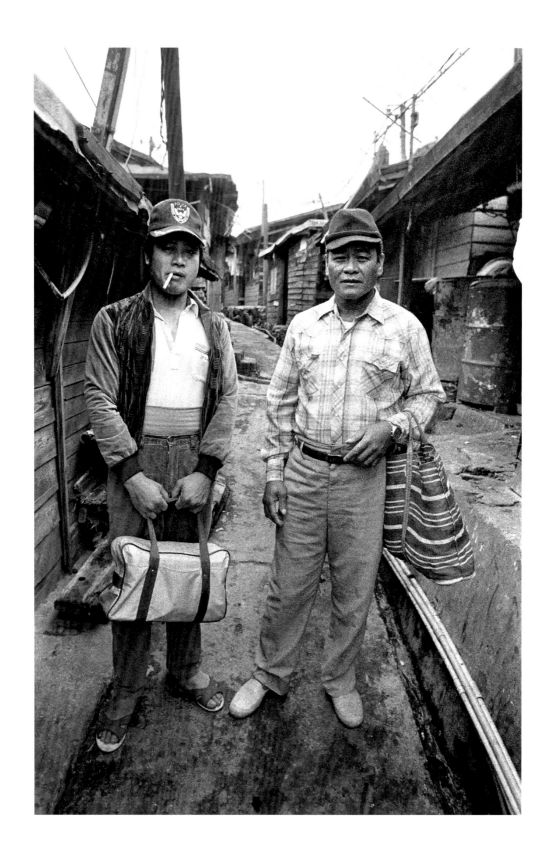

阿春與父親出港前在家門口 / 1984
Ah-Chun and his father at the door of their home before heading to the harbor

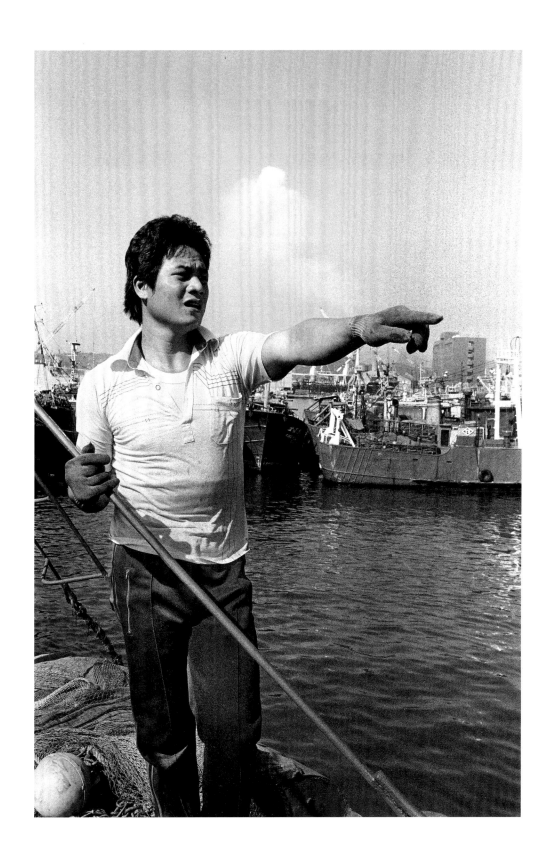

這一趟出海，阿春擔任大副 / 1984
On this trip, Ah-Chun is first mate

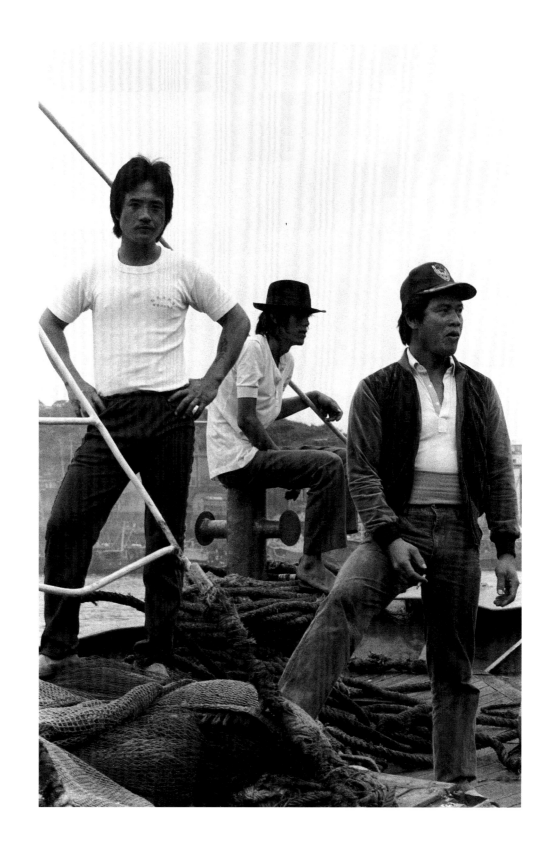

阿春、阿杉與馬各 / 1984
Ah-Chun, Ah-Shan and Ma Ge

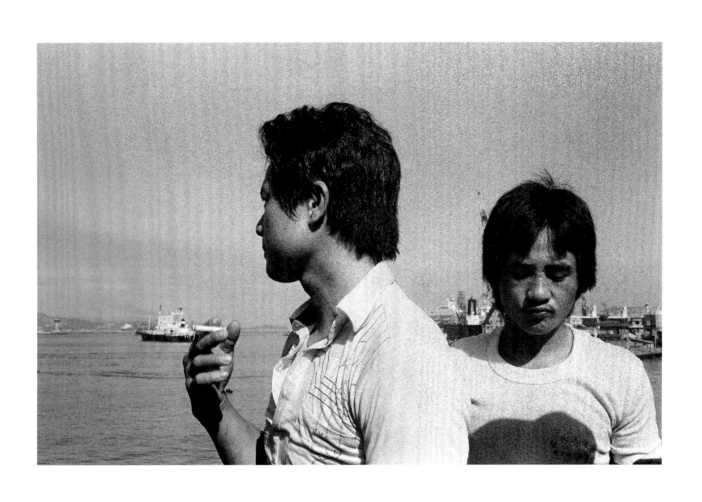

阿春與馬各（右）即將出港 / 1984
Ah-Chun and Ma Ge (right) about to leave the harbor

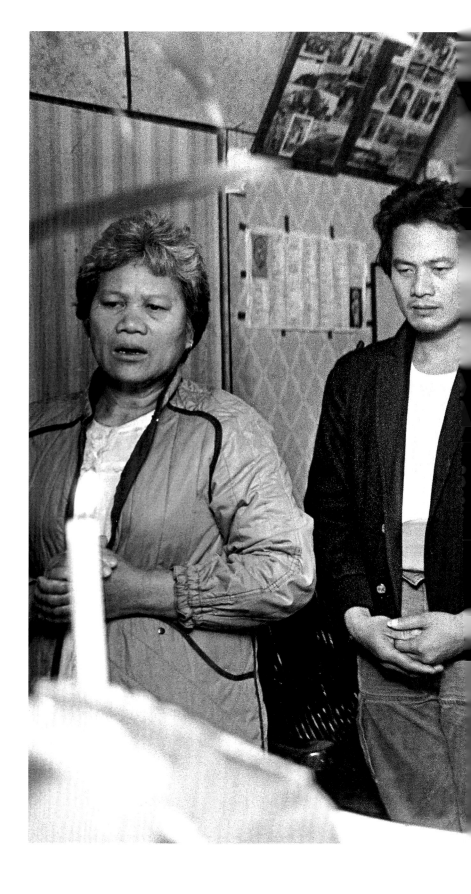

斷指歸來後，阿春母親與教友在家裡禱告 / 1984
After Ah-Chun loses his finger, his mother prays at home
with church members

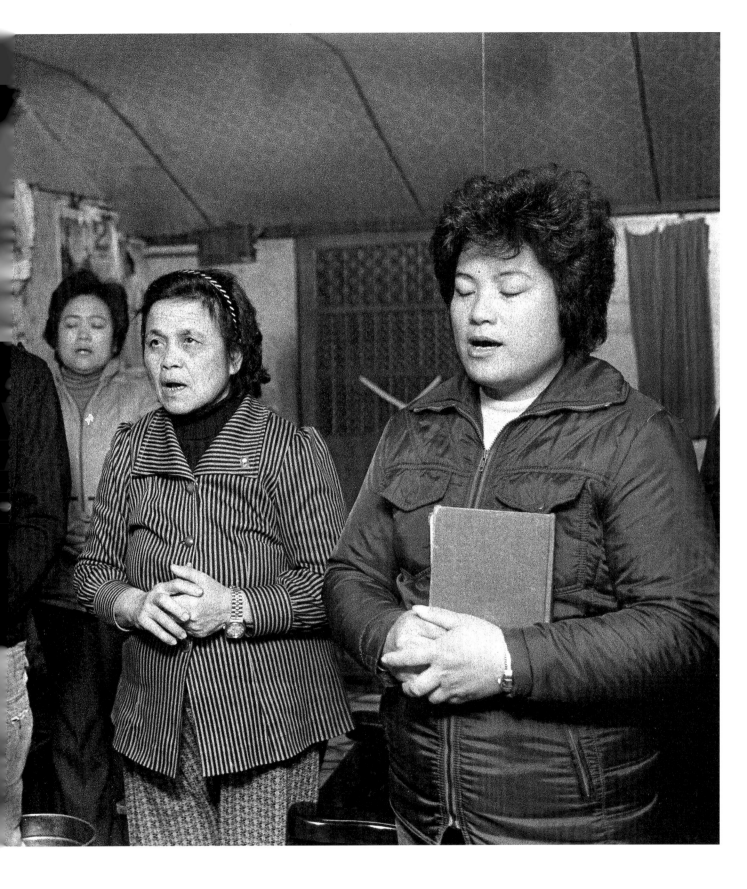

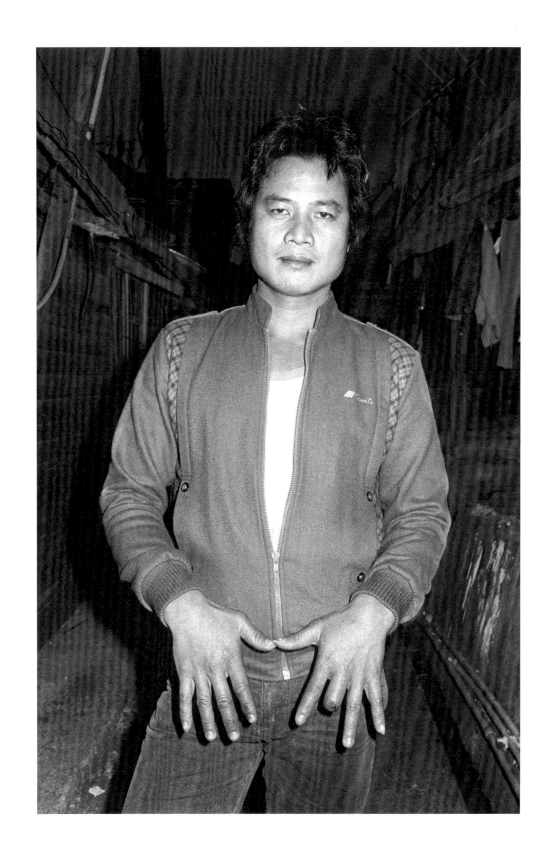

阿春在作業中被繩索絞斷中指 / 1984
Ah-Chun loses his middle finger, catching it in a rope while working

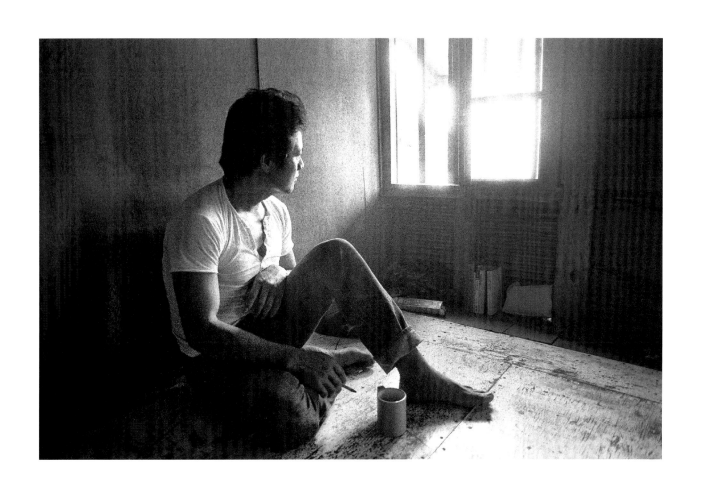

受傷斷指前，在關曉榮房裡的阿春 / 1984
Ah-Chun in Guan Xiao-rong's room before his injury

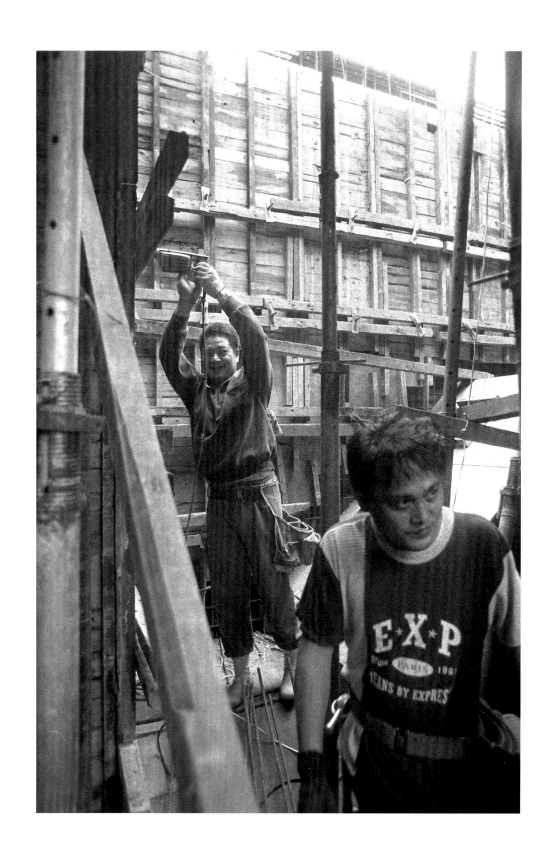

八尺門的阿美族漁工都已下船，在建築工地做板模工 / 1996
The Amis fishermen of Bachimen, no longer on their boats, now work setting construction forms

阿春已婚，有了兩個兒子，一家人在國宅 / 1996
Ah-Chun, married with two sons, and family in their apartment

阿春工傷斷指出院前 / 基隆長庚醫院 / 2011
Ah-Chun prior to leaving hospital after second hand injury / Keelung Chang Gung Memorial Hospital

阿春工傷斷指出院前 / 基隆長庚醫院 / 2011
Ah-Chun prior to leaving hospital after second hand injury / Keelung Chang Gung Memorial Hospital

母親來醫院接阿春出院 / 基隆長庚醫院 / 2011
Ah-Chun's mother comes to take him home from the
hospital / Keelung Chang Gung Memorial Hospital

54 歲的阿春看 24 歲海上勞動斷指的自己
基隆原住民會館 / 2011
54-year old Ah-Chun, after losing a finger at sea,
gazes at his 24-year-old self
Keelung Indigenous Cultural Hall

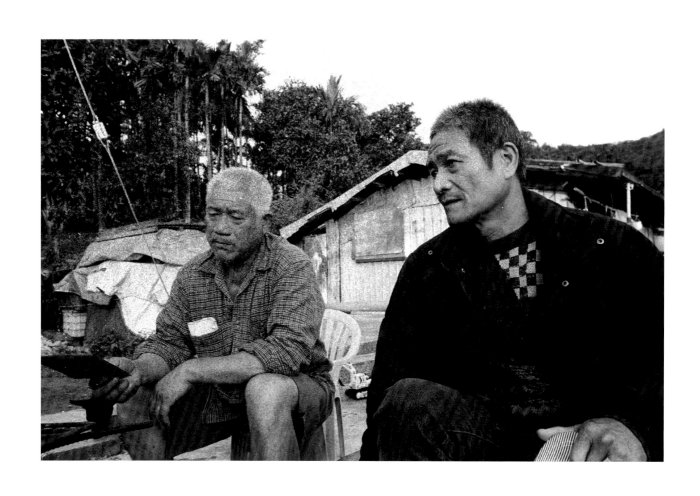

剛收到喜帖的邱顯德（左）與阿春 / 2011
Chiu Xian-de (left), with Ah-Chun, has just received a wedding invitation

不作態不迴避不言語的賴福春 / 2011
Lai Fu-chun (Ah-Chun) – direct, unaffected, quiet

# 影像與知識構成：《蘭嶼報告》

## Structuring Images and Knowledge:
*Lanyu Report*

文／沈柏逸

關曉榮跨越大時間維度的《蘭嶼報告》系列，同樣運用長期田野的方式，見證蘭嶼達悟族人的生存處境。相較《八尺門》的生活感觸，他在《蘭嶼報告》中運用知識性的方法，剖析蘭嶼的歷史、結構、政治經濟等問題，以強烈的政治批判意識，凸顯漢人教育的壓迫、反核廢料的政治抗爭、傳統民俗儀式的存亡等議題。這些影像與知識，也進一步抵抗著漢人意識形態所塑造的現實。

如果說《反核》系列（1987-）像是手術刀般冷冽分析遭受漢人壓迫的結構問題；那麼《造舟》系列（1987-1988）則客觀記錄了達悟族的傳統智慧。他鉅細靡遺地運用民族誌方式記錄傳統造舟的過程。這種如建檔般的攝影方式，更加全面地關照傳統，同時彰顯了達悟族人敬畏天地、與自然共存的生活態度。

Guan also employed fieldwork research methods in his long-running *Lanyu Report* series, in which he witnessed the living conditions of the Tao people on Lanyu. His more intellectual approach there contrasted with his impressions of life in Bachimen, as he set about analyzing Lanyu's history, structure, and political economy. Guan's highlighting of certain issues, such as its oppressive, Han Chinese-centered education, the anti-nuclear waste protests against the government, and the question of the survival of traditional folk ceremonies, all implied a strong political critique. The resulting images and information served to further counter the realities shaped by Han Chinese ideology.

In the *Anti-Nuclear* series (1987-2007), Guan analyzes with a sharp, keen eye the structural problems associated with the Han Chinese oppression suffered on Lanyu, while in the *Boat Building* series (1987-1988), he makes an objective record of the traditional wisdom of the Tao tribe. His ethnographic approach results in a detailed record of their boat-building process. Through this approach, like building a photographic dossier, Guan highlights their veneration for the land and their attitude toward living in harmony with nature.

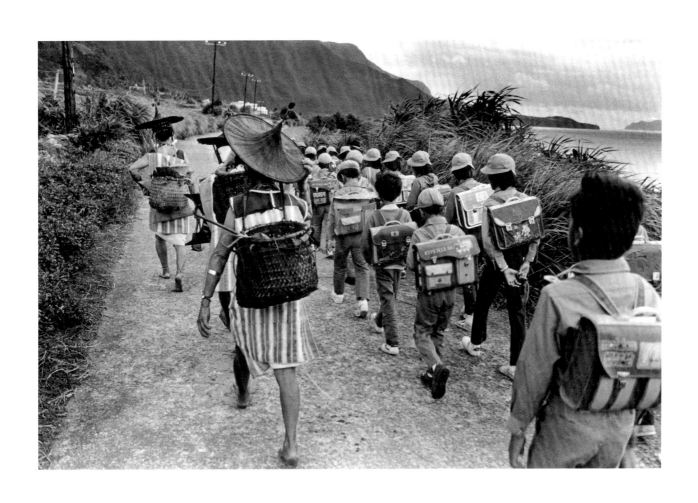

清晨前往田園工作的婦女與上學的孩童 / 1987
Women leaving for the fields and children going to school early in the morning

國旗下的漢化學校教育 / 1987
Sinicized education at school under the Republic of China (ROC) flag

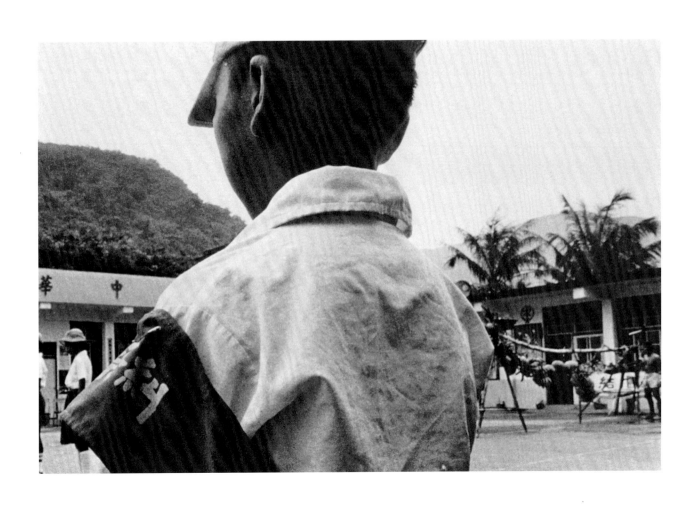

紅頭國小校園裡的糾察隊 / 1987
Hongtou Elementary School class monitor

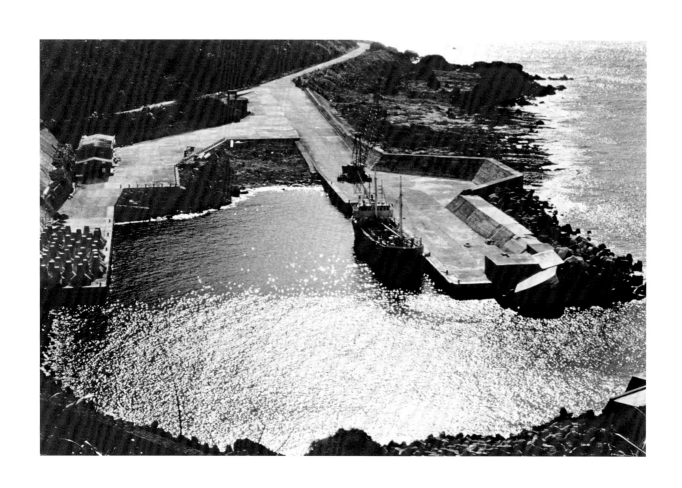

蘭嶼的核電廢料卸運碼頭 / 1987
Lanyu nuclear waste unloading dock

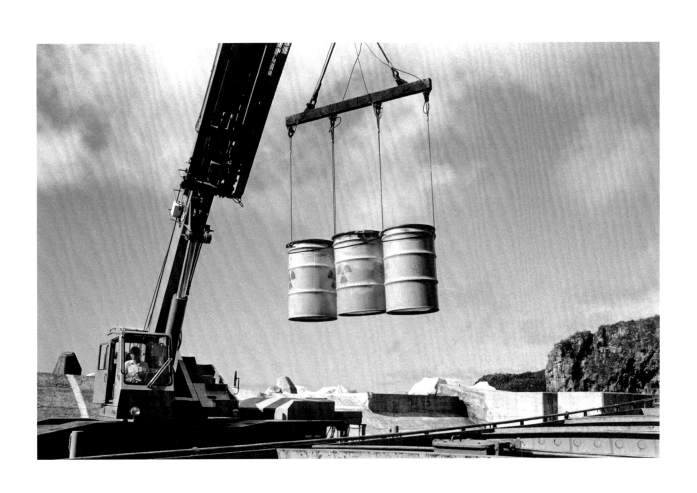

在蘭嶼龍門碼頭裝卸的核電廢料 / 1987
Unloading nuclear waste at Longmen Wharf, Lanyu

蘭嶼反核行動「機場抗議事件」/ 1987
"Airport protest event" during Lanyu anti-nuclear campaign

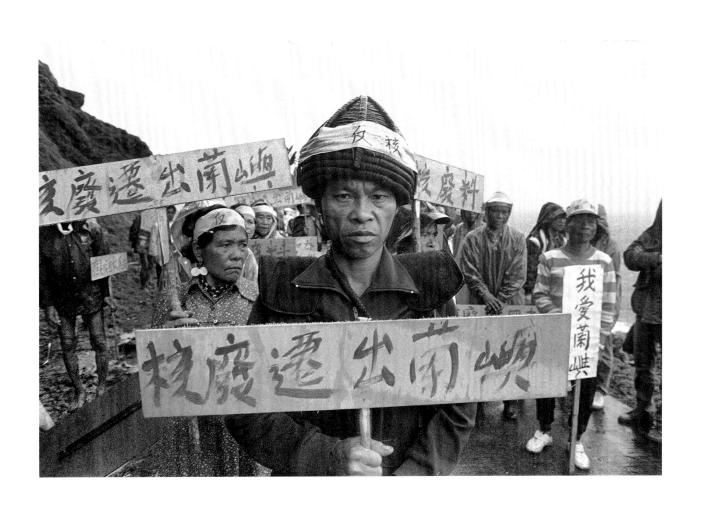

反核廢料抗議隊伍集結 / 1988
The anti-nuclear protest group gathers

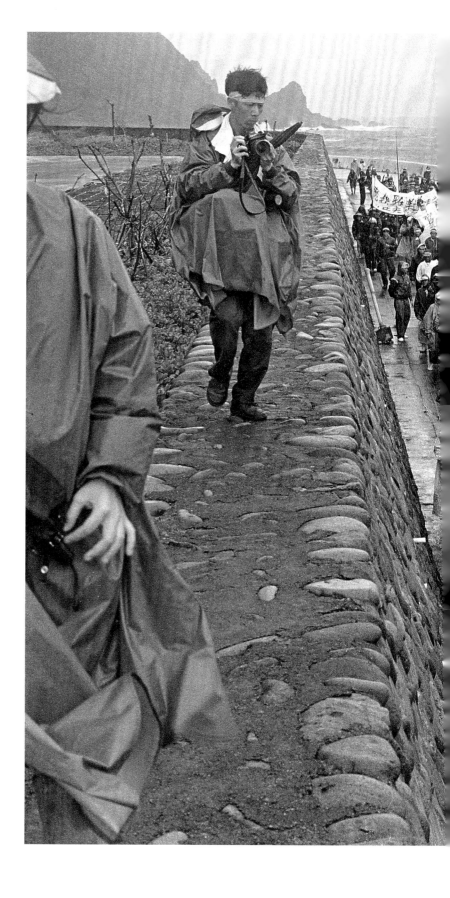

反核隊伍行經「蘭嶼核廢料貯存場」圍牆外 / 1991
Anti-nuclear protesters march around perimeter wall of
the Lanyu Nuclear Waste Storage Site

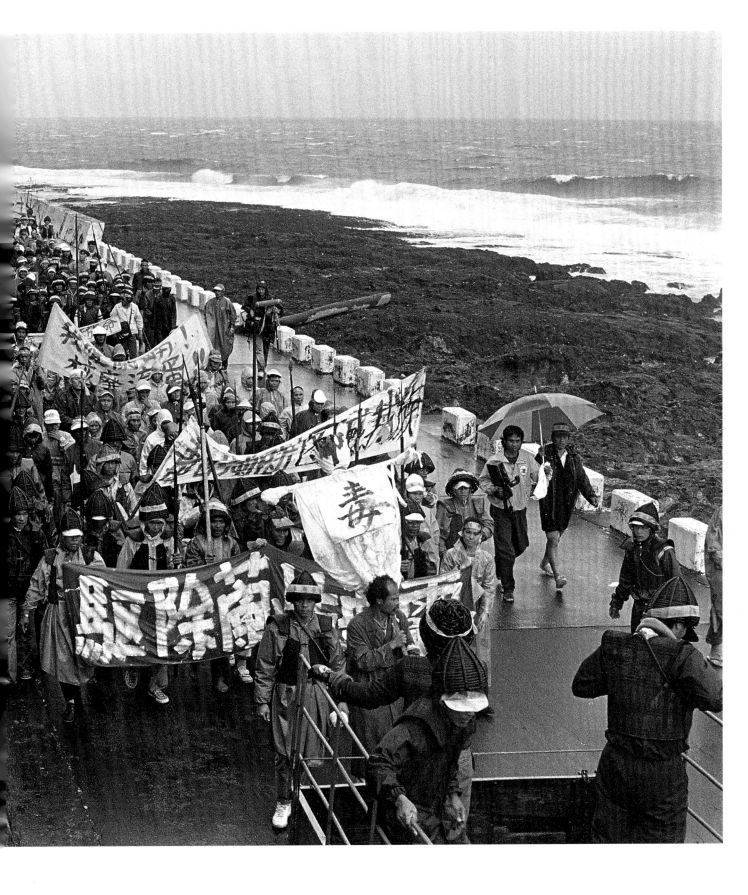

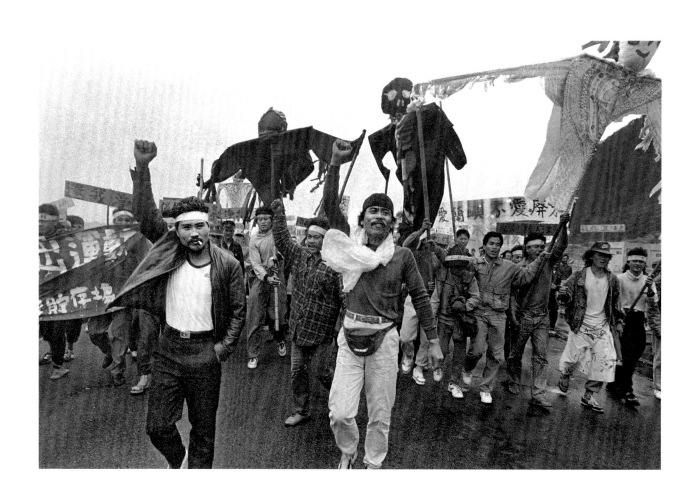

遊行隊伍進入核廢料貯存場 / 1988
Marching protesters enter the nuclear waste storage site

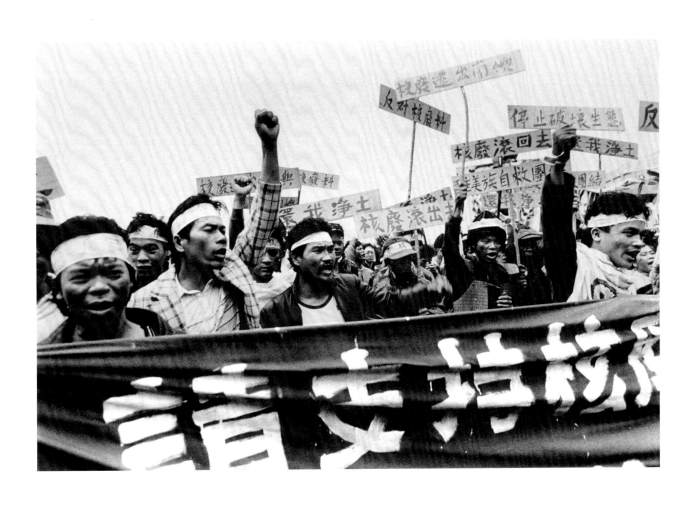

核廢料滾出蘭嶼 / 1988
"Nuclear waste out of Lanyu!"

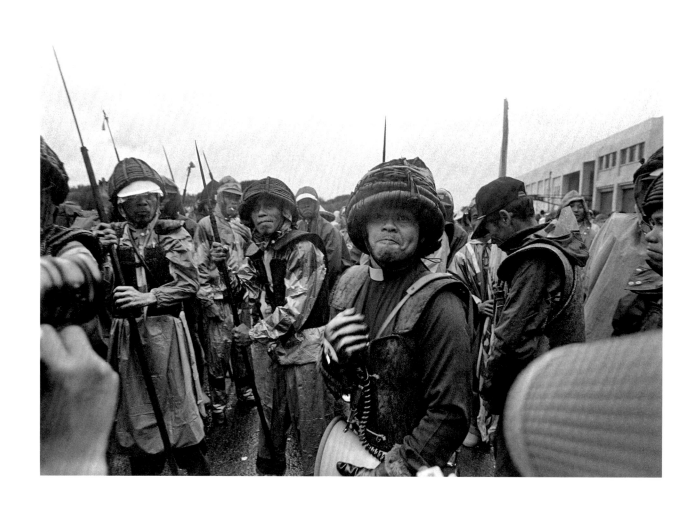

「驅逐惡靈」的長老們 / 1991
Elders "expelling evil spirits"

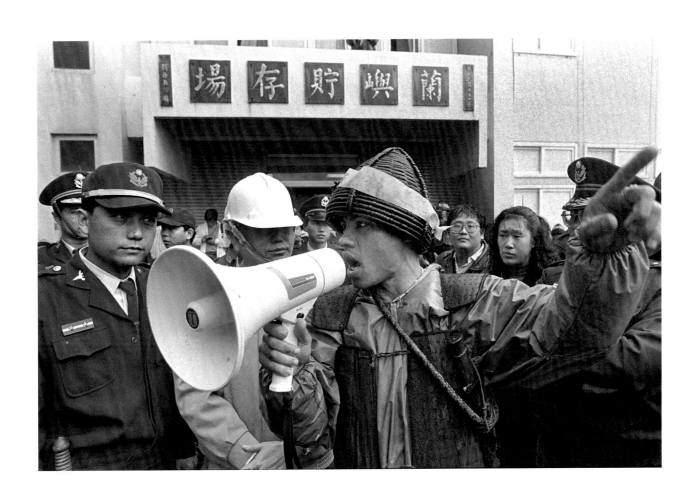

核廢料貯存場轉給台電後，抗議行動中的郭建平 / 1991
Kuo Jian-ping during protest movement, after nuclear waste site is turned over to Taiwan Power Company

反核廢料運動青年領袖郭建平
質問核廢料貯存場場長 / 1988
Young protest leader Kuo Jian-ping confronts head of
nuclear waste storage site

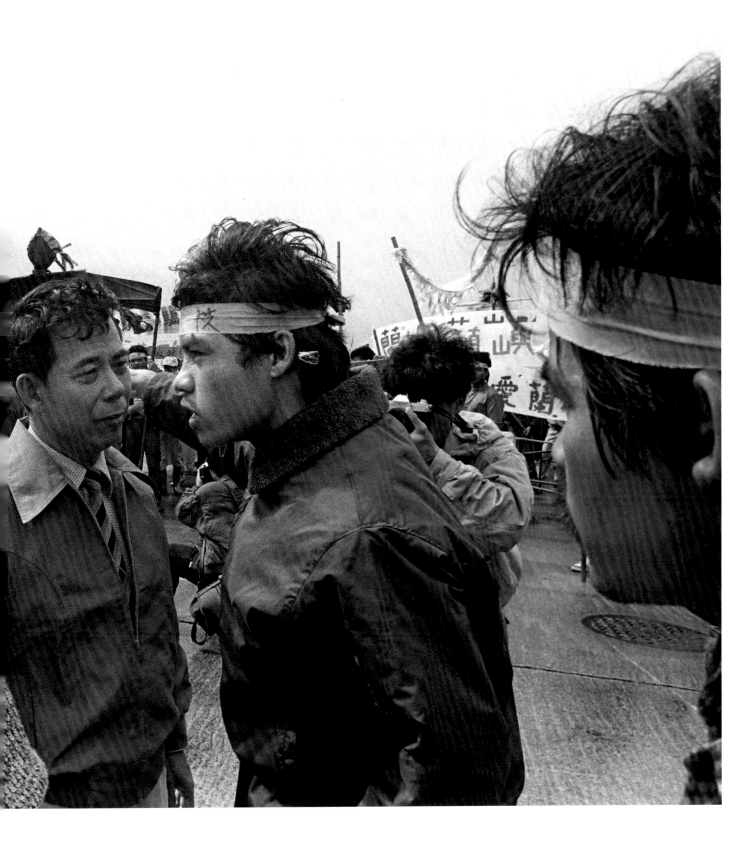

剛進入國小一年級的達悟男孩農農，在「機場抗議事件」現場 / 1987
Nong-nong, Tao tribe boy just entering first grade, at the "airport protest event"

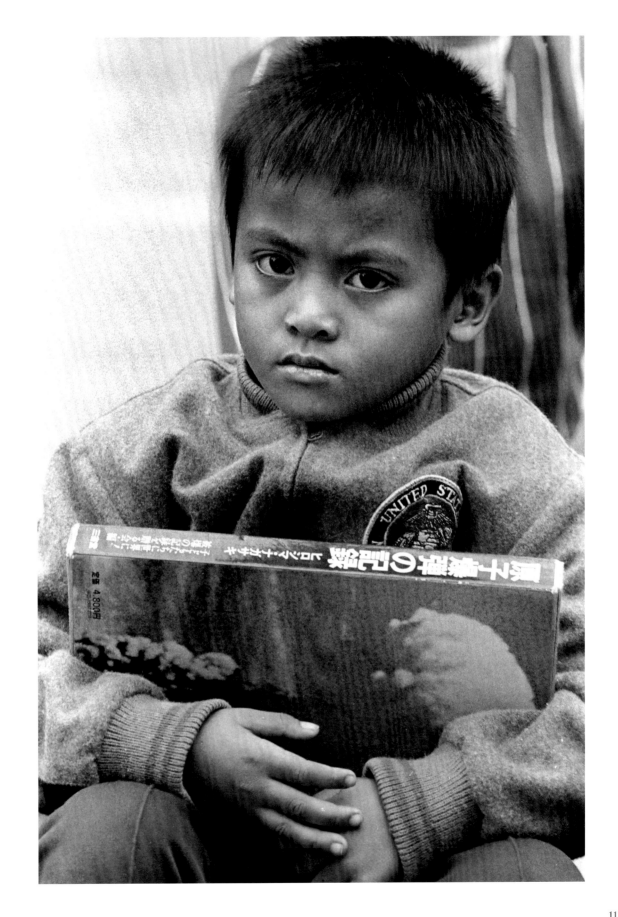

漁人部落造舟出發前的清晨 / 1987
Early morning, before the fishing tribe sets out to build a boat

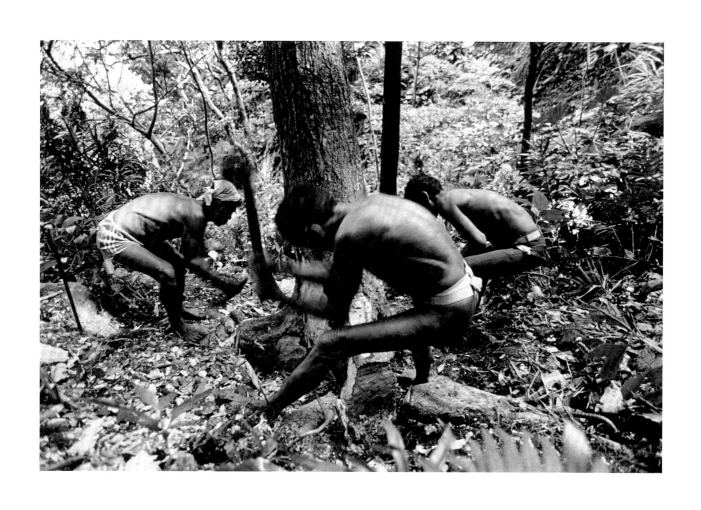

利用熱帶雨林樹木的板根，取製龍骨彎曲部分的材料 / 1987
Taking the lateral buttress root of a tropical rainforest tree to make the curved keel of the boat

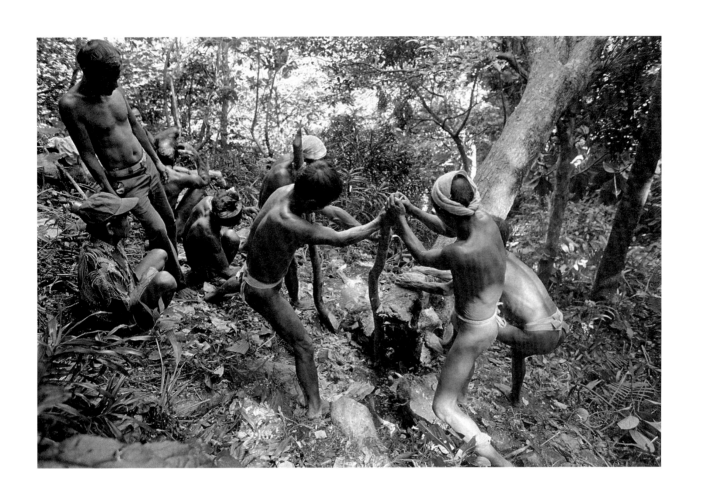

樹木連根挖起 / 1987
Tree and root are dug out together

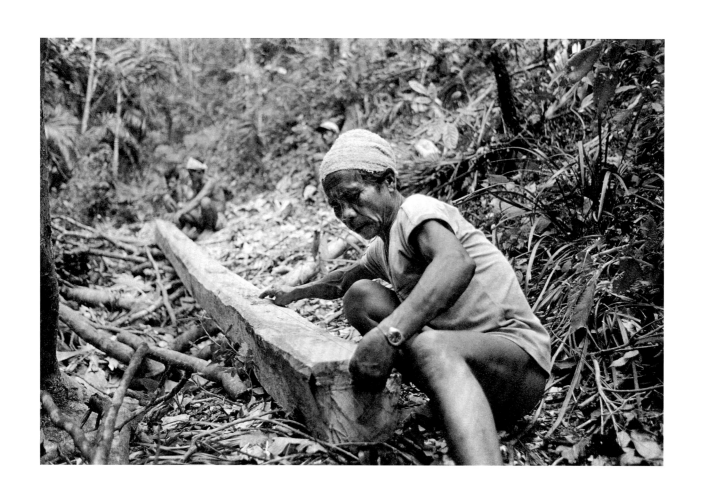

龍骨中段直幹的製材工作 / 1987
Cutting the straight plank for the keel

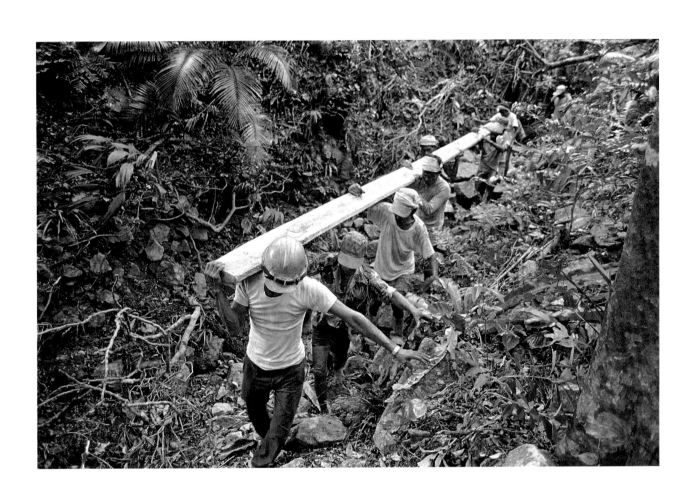

扛運沉重的龍骨中段直幹 / 1987
Carrying the heavy straight plank for the keel

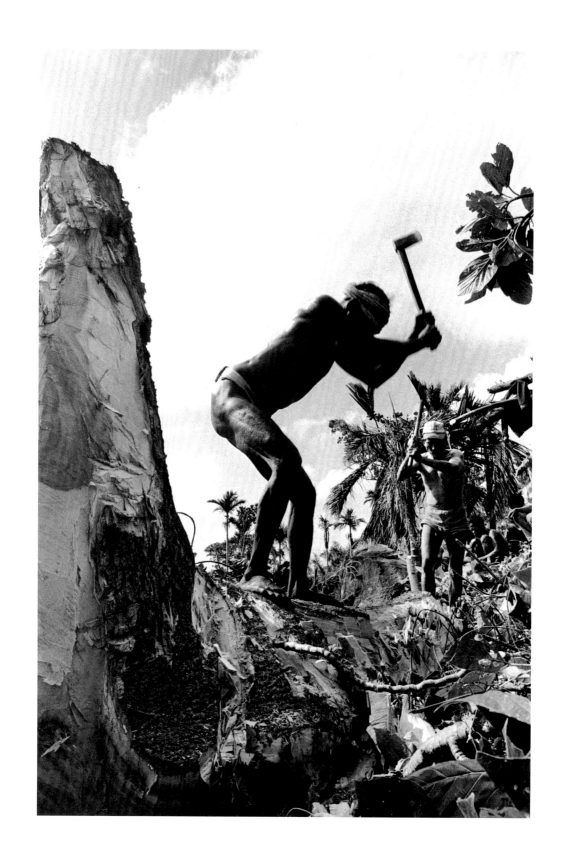

造舟是民族智慧和藝能的傳承積累，也是生產工具製作的團結勞動 / 1987
Boat-building requires both knowledge and energy

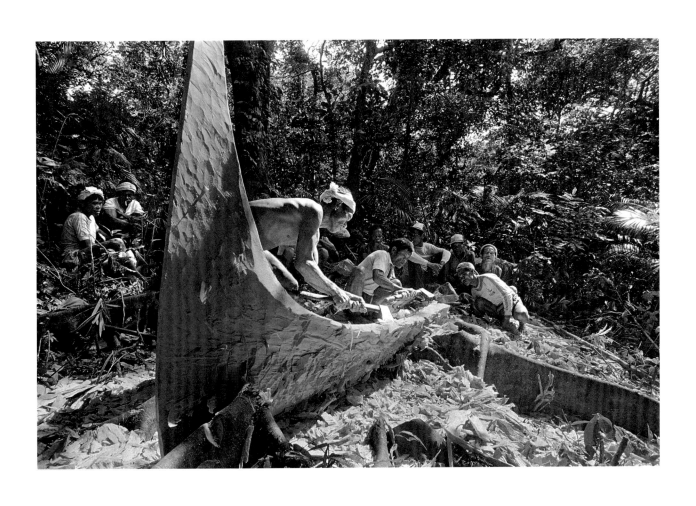

助工族人展現技能與體力 / 1987
Workers demonstrate skill and strength

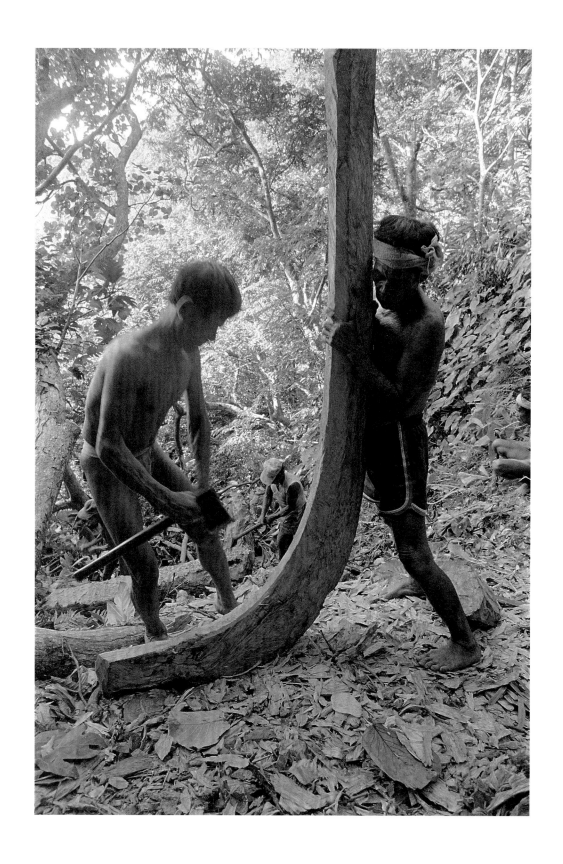

伐木現場完成曲狀龍骨結構 / 1987
Completing the curved keel plank at the logging site

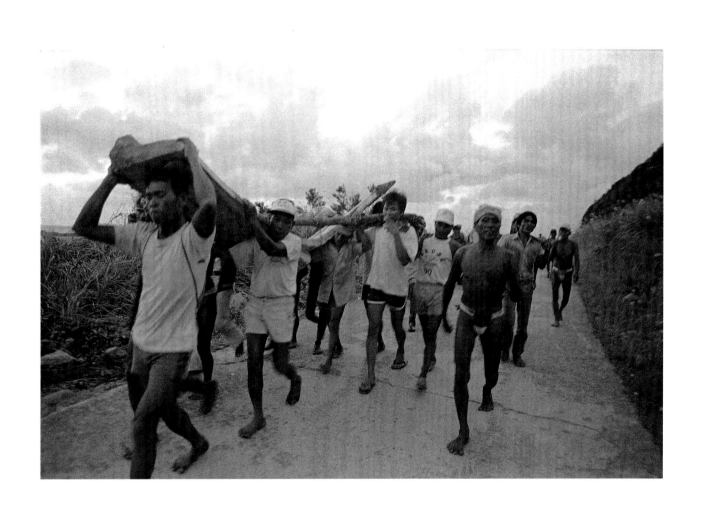

薄暮時分搬運船板下山 / 1987
Keel planks come down the mountain at sunset

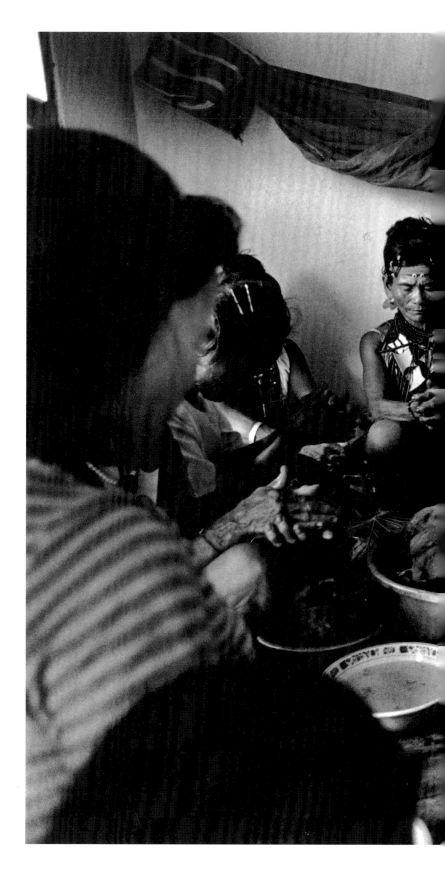

漁團成員的妻子們祈禱神祇庇佑 / 1987-1988
Wives of the fishing expedition pray to the gods for divine
protection

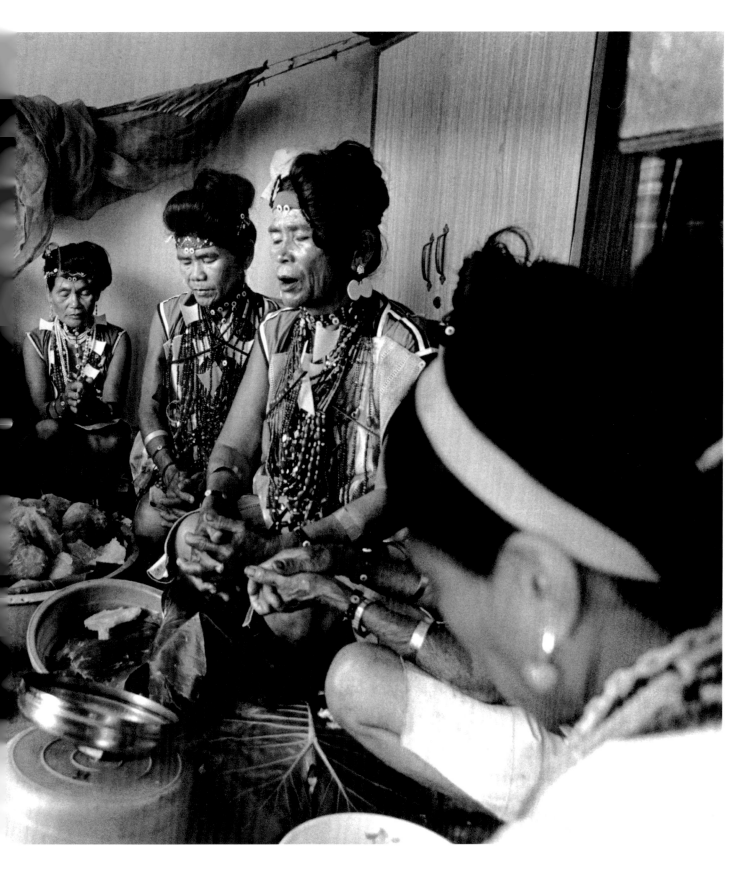

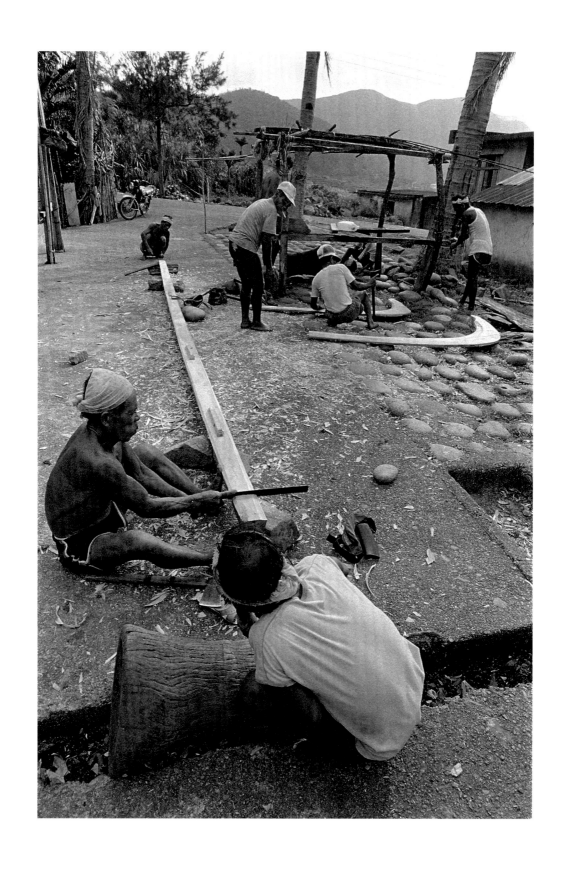

在龍骨中段直幹兩端鋸出凹槽 / 1987-1988
Notching the ends of the straight keel piece

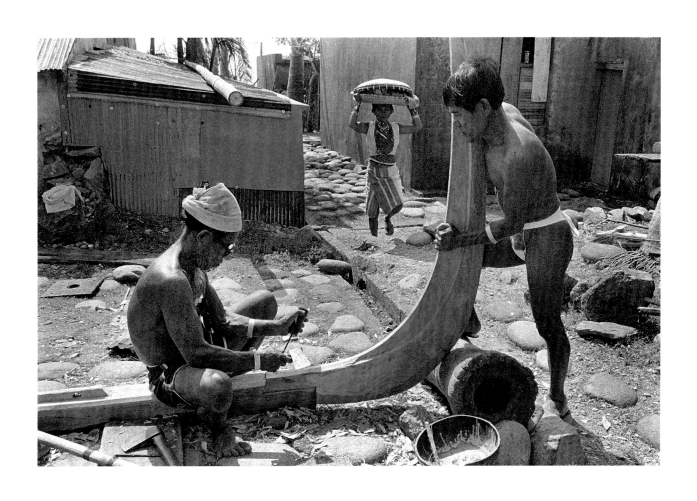

在龍骨的結合處打鑿榫洞 / 1987-1988
Chiseling a mortise where the keel sections meet

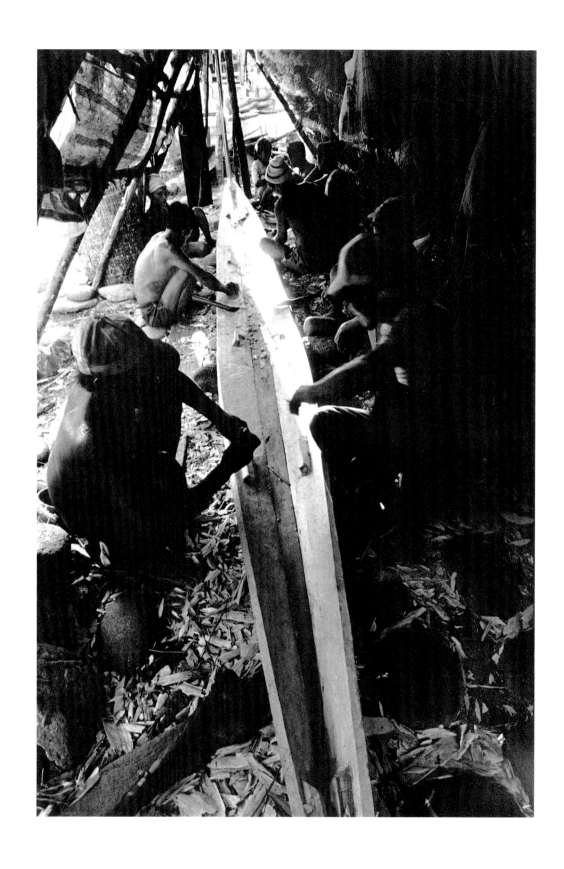

緊接龍骨的第一層船板完成接合 / 1987-1988
The first set of hull plates being attached to the keel

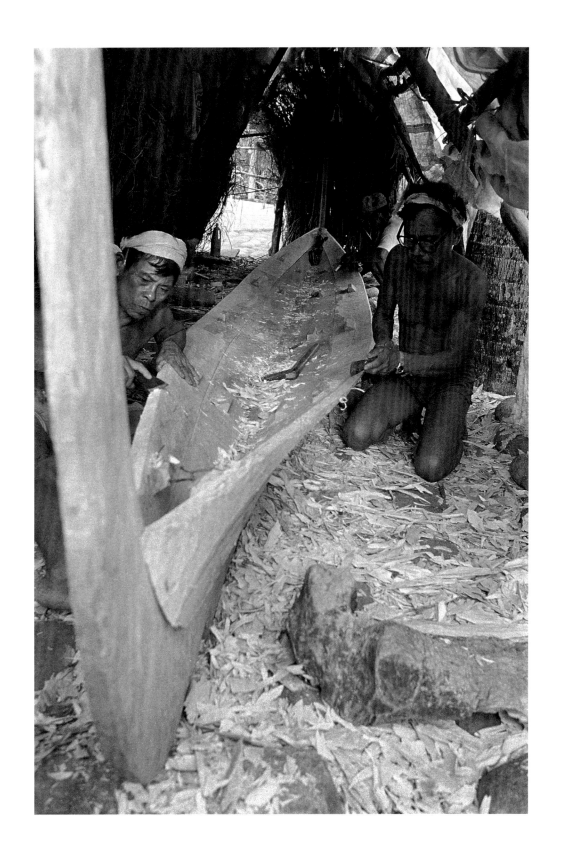

第二層船板結合前的修整 / 1987-1988
Preparing to attach the second set of hull plates

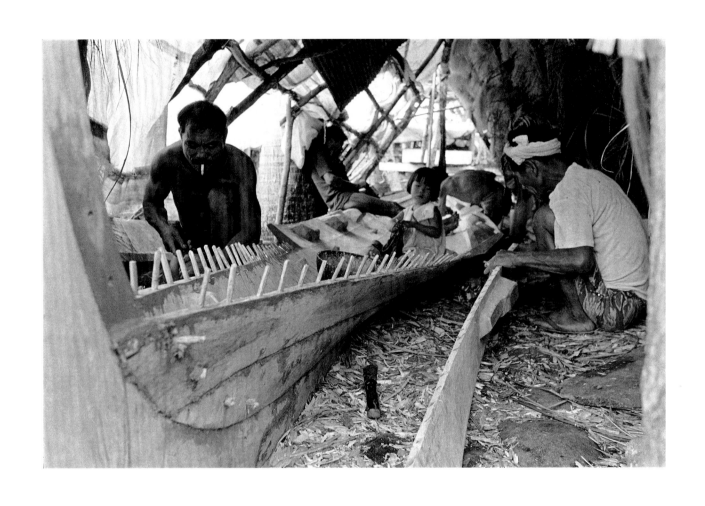

第三層船板結合前的修整 / 1987-1988
Preparing to attach the third set of hull plates

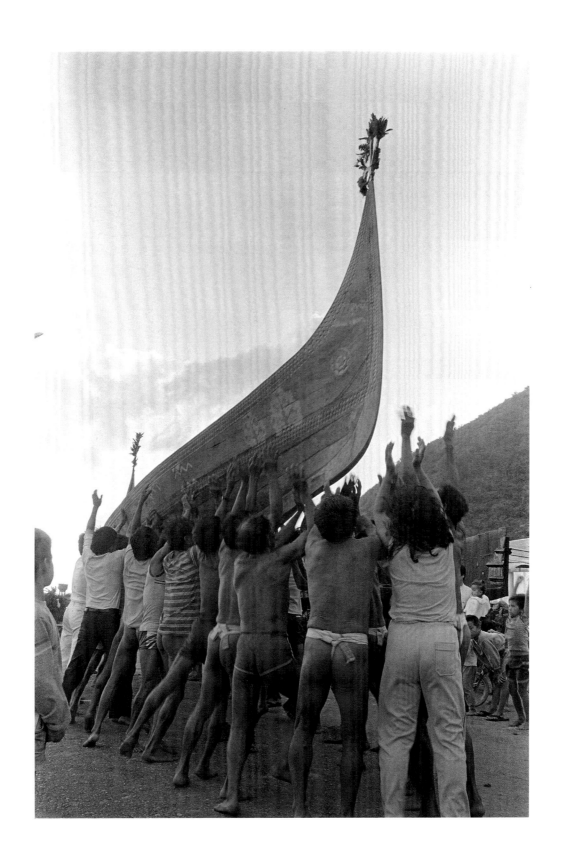

雕刻彩繪前眾人練習拋舟 / 1987-1988
Practicing tossing the boat prior to carving and painting

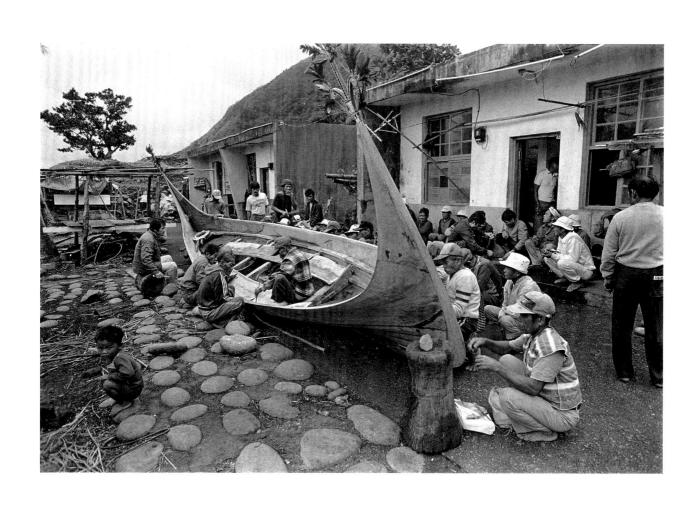

雕刻與彩繪舟體 / 1987-1988
Carving and painting the body of the boat

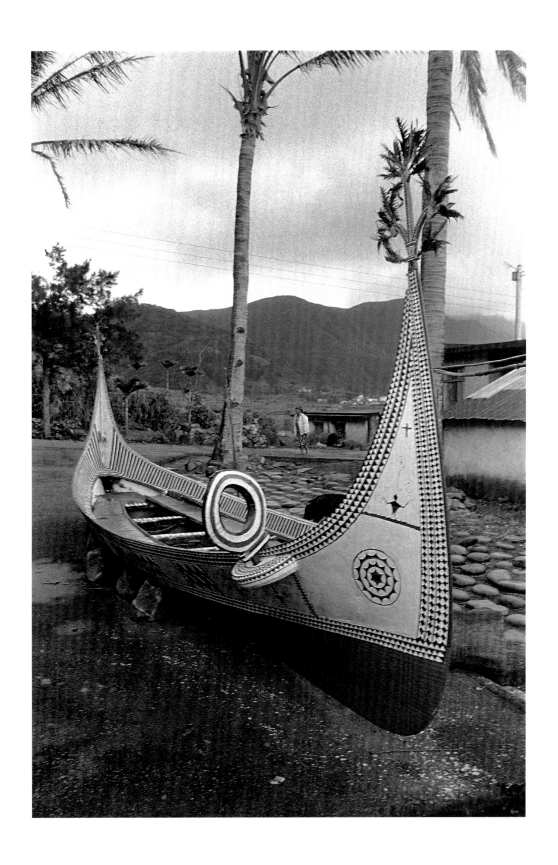

雕刻彩繪完成的十人舟 / 1987-1988
The 10-man boat after carving and painting

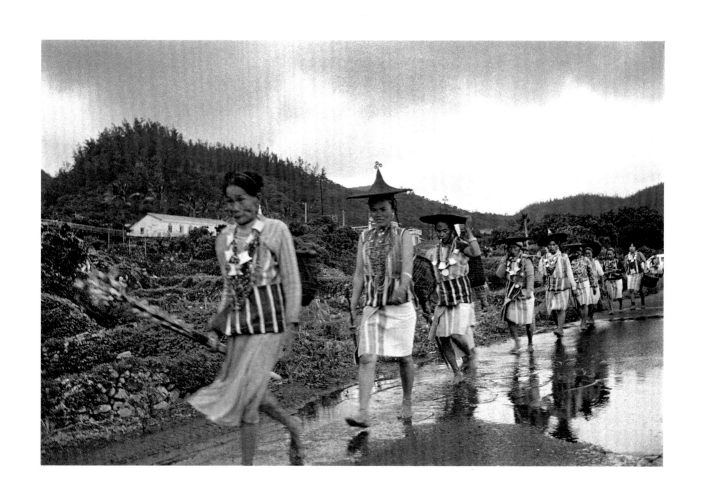

漁團成員個別家庭的婦女前往芋田採收禮芋 / 1987-1988
Women representing individual families of the fishing expedition going to harvest ceremonial taro

採收禮芋前婦女在田邊禱告驅邪 / 1987-1988
Women pray beside the fields to expel demons prior to harvesting ceremonial taro

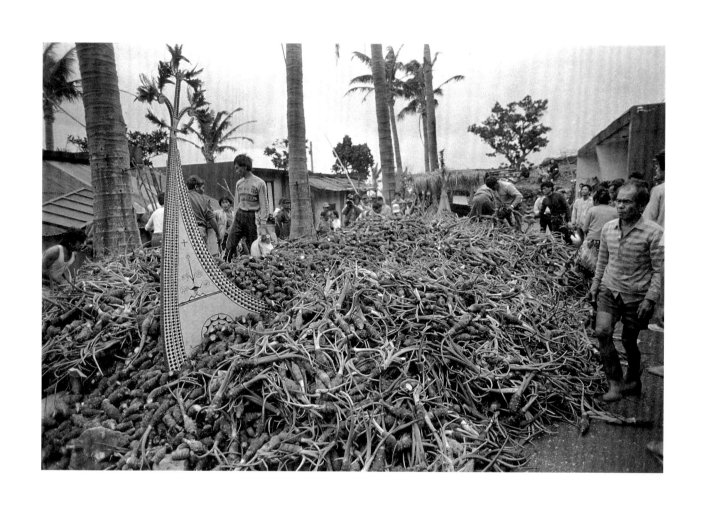

十人舟下水祭典前，帶梗的禮芋覆蓋在無梗的禮芋上面 / 1988
Before the launching ceremony for the 10-man boat, taro, with stalks, are placed on top of ceremonial taro roots

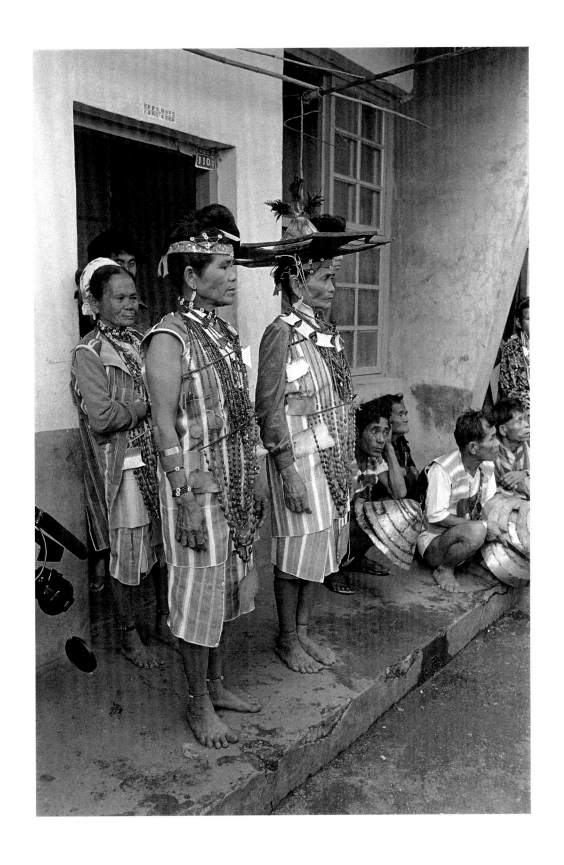

盛裝參與十人舟下水祭典的婦女 / 1988
Women dressed in special attire for the 10-man boat launch ceremony

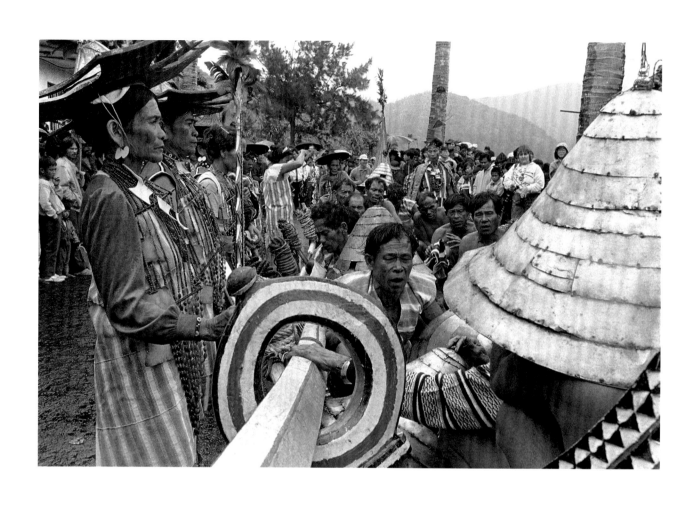

漁團成員男子坐在舟內，女子立於舟側，繼續與來客對唱 / 1988
The men of the fishing expedition sit in the boat while the women stand at the side and sing with guests

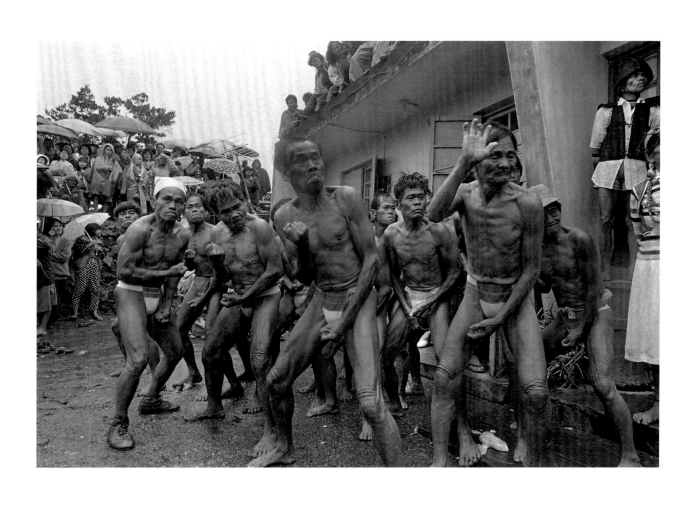

驅除 anito 惡靈儀式 / 1988
Ceremony to expel evil "anito" spirits

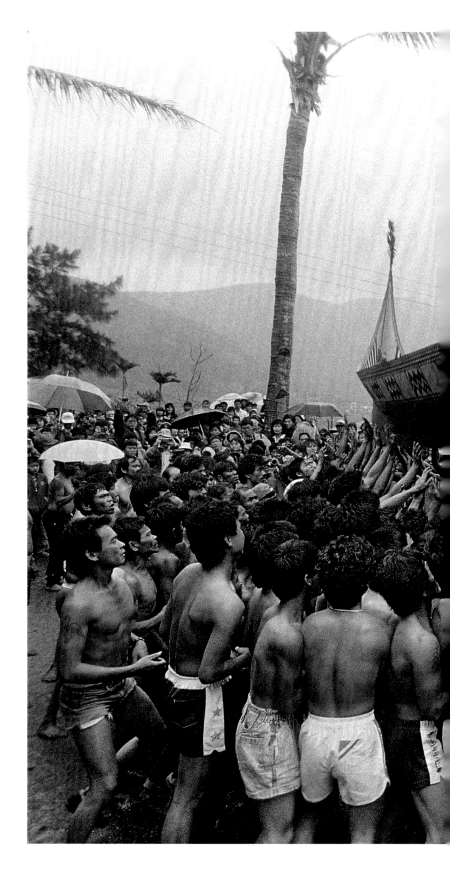

群眾將十人舟拋向空中 / 1988
A crowd tosses the 10-man boat into the air

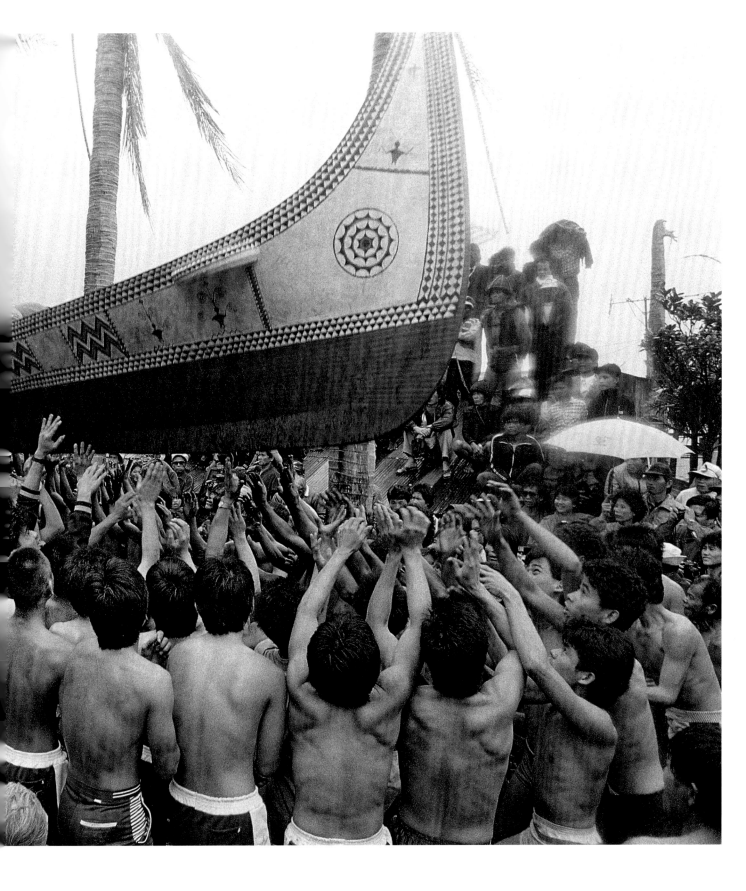

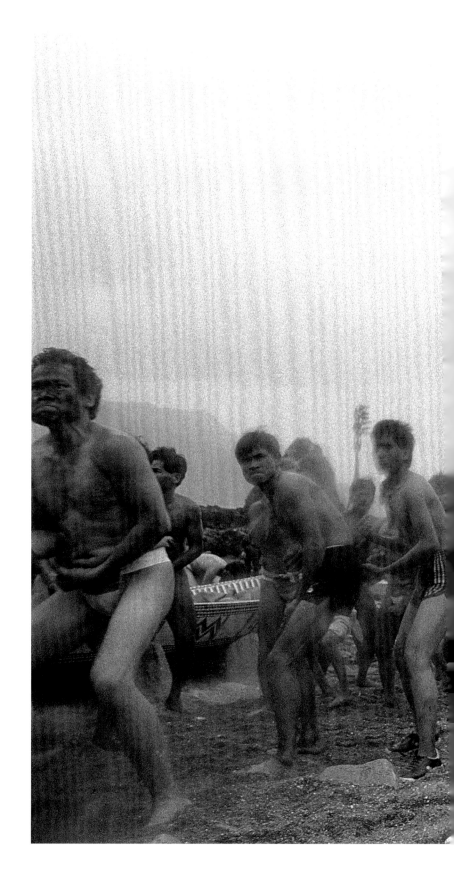

青年們在灘頭驅除 anito 惡靈 / 1988
Young men on the shore, expelling evil "anito" spirits

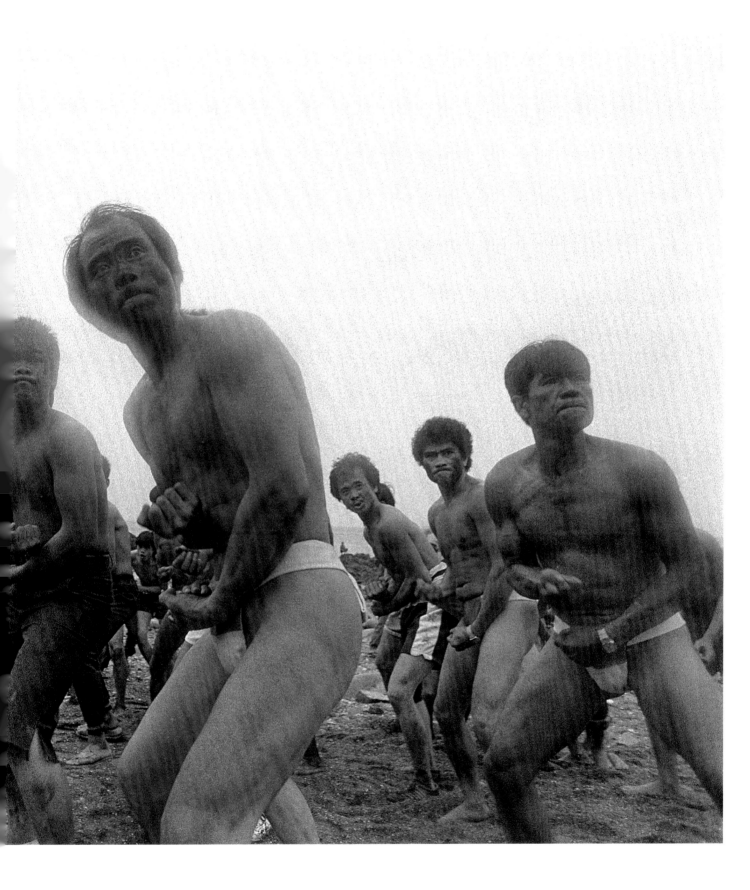

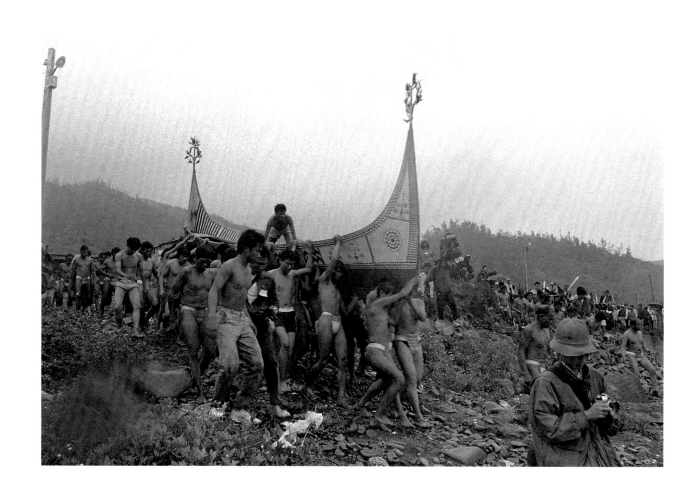

協力舉舟即將到達漁人部落灘頭 / 1988
Working together to carry the boat to the shore

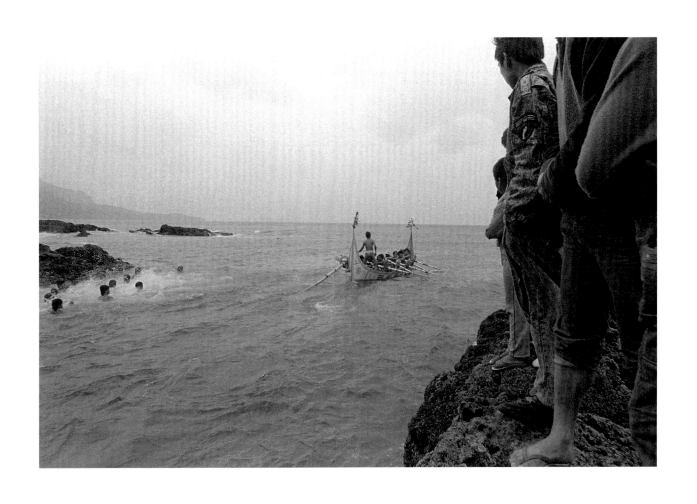

十人舟下水祭典首航歸來 / 1988
Returning from the maiden voyage after the boat launching ceremony

# 口述訪談

Interviews ——————————

# 關曉榮訪談紀錄 [1]

## 生命經驗的碰撞：藝文的啟蒙

沈柏逸（以下簡稱沈）：老師拍攝與書寫蘭嶼、八尺門關於原住民的狀態，這些作品跟後代的人產生了許多的對話與啟發。您是何時開始意識到，這種關於他者處在邊緣狀態所散發的尊嚴與力量？

關曉榮（以下簡稱關）：1970年代，我在恆春國民中學教書的時候，臺灣民謠歌手陳達開始為人所知，撞擊了社會上許多迷茫的心靈。當時大家都不知道自己是誰，因為大部分的人只聽西方古典音樂或流行音樂。

我教書時，聽過陳達在學校大禮堂演唱，我雖是廣東省人母語是廣東話，但陳達吟唱的臺語民謠深沉地蘊含中華文化的固有精神，深深打動我，跟我產生共鳴。不僅是歌詞，主要還是吟唱的聲音。雖然很多與他同時代的人唱臺灣民謠，但都是相較活潑、輕柔、歡喜的樂音，沒人像他一樣給人深刻的感動。

陳達唱的內容像是吟遊詩人的詞，訴說生命經歷的人間疾苦，有別於當時的國語流行歌曲或西方的搖滾樂、藍調等。他一生的坎坷不只鍛鍊了詞，同時把自己的身體鍛造成一把絕無僅有的樂器，和他的月琴合為一體。從他的聲音可以感受到官方宣傳的新生活運動中的「社會和諧」並不確切、更不真實。相較來說，陳達民謠的真實性穿透歷史、也穿透了戒嚴時期新生活運動的美學。

因為我在眷村經歷過匱乏的生活，所以更能體會。過去眷村子弟大都自生自滅，幼時的我根本不清楚「被壓抑的匱乏」是什麼，但當我聽到陳達故事敘説的民謠吟唱，這種物質匱乏的經驗便直接跟他訴説的民間疾苦連結在一起。

《女兒的胞衣》書影 / 時報出版 / 1993
Cover of *Daughter's Afterbirth* / China Times Publishing

沈：老師在國中教書時，寫了許多散文，之後也持續書寫並集結出版《女
　　兒的胞衣》，您的寫作與文學素養是如何養成？這些文學素養又是怎
　　麼跟攝影報導的工作產生關係？

關：我的文學啟蒙者是奚淞。我跟奚淞的淵源，要從就讀國立藝專（今國
　　立臺灣藝術大學）一年級的時候說起，那時臺北西門町的「天琴廳」²
　　咖啡店聚集了五花八門各領域的年輕人，我常常逃課到那裡瞎混，店
　　裡也有來自美國學校的小孩。

　　我們在那邊讀書、交朋友、聊天、瞎扯、鬼混，我就是在那邊認識奚
　　淞。我的思想與審美的啟蒙是來自於文學，奚淞鼓勵我閱讀魯迅、沈
　　從文或翻譯的西方文學經典，因為學生時代讀了很多小說，我在教書
　　時開始塗塗寫寫。戒嚴時期藝專的校風還是相當保守，曾有不成文規
　　定：紅色代表共產主義不能畫，灰色代表虛無不能畫，黑色不能畫因
　　為代表無政府主義。相較來說在天琴廳那群人是叛逆的，但當初的叛
　　逆不像現在是走上街頭反抗，而是虛無與自我放逐。

　　不只知識分子才有絕對疏離的時代感受。比方說文學家傳達出精神上
　　的困境、流亡與掙扎，大眾也有這種感受。特別是在第二次世界大戰
　　之後，人類常常要面對生死以及生命脆弱的現實。卡繆、沙特這些文
　　學家的作品之所以在歐洲吸引大眾，我相信是因為跟大眾產生精神上
　　的共鳴。因為在二戰中犧牲的不只是知識分子，一般家庭的破碎與流
　　離失所大有人在，這是他們文學的精神土壤。

　　年輕時讀過的文學作品對我有相當大的影響。我過去拍攝的紀錄片或
　　報導攝影中所謂的人文關懷，其實跟我早期閱讀的小說人物被汙辱與
　　被損害的經驗有關，基本上我跟這些受創的人有一種來自於中國內戰
　　離亂的童年生活的連帶感——有人說是同情心、同理心，但是我常常
　　把它倒過來，是先有同理心才會產生同情心。我對於受苦的人那種感
　　受力，和個人經驗是連結在一起的。

## 現實主義的關注

沈：老師提到的「虛無與自我放逐」似乎跟當時流行的存在主義有關，然而您之後的作品卻特別關注現實主義。如果說存在主義關注個人的精神狀態，那政治經濟學批判的現實主義則更關注社會結構。您怎麼看自己從存在主義到左派現實主義的思想轉變？

關：關注現實主義是受到《人間》雜誌創辦者陳映真先生的影響。1984年我住進基隆八尺門的時候，帶的書不多，其中有一本是俄國無政府主義者克魯泡特金（P. Kropotkin）的《我的自傳》。八尺門報告工作結束後，接觸《夏潮》雜誌，這在黨外時期是一份左翼思想、理論與社會調查報告的刊物，我才打開另一扇思想的窗——政治經濟學。你提到的轉變，主要是在那時候，我開始接觸馬克思的思想理論，雖然不是很用功地學習，但也還能理解到馬克思思想裡有關政治經濟學的理論分析是具有歷史穿透性的。

在八尺門蹲點攝影時，我的問題意識來自於煤礦災難：為什麼這種工殤率很高的職業，從業人員大部分都是原住民？這種問題意識來自我對生產者的階級位置在結構社會中的覺悟，我認為一名工人不只是「個別的人」，他可能是個人罹難，但是更重要的是礦工做為「被剝削的階級」，背後更關乎總體階級的問題。

其實每一代都有虛無疏離的問題。但是別忘記，你有一天也會老去；年輕的時候，你要靠知識去瞭解：產生這種社會性的疏離感，原因可能來自一個重要的生產領域。在馬克思理論中，人是生產方式與生產關係的總和，疏離感發生於生產方式，生產方式又產生於生產關係，像是我同時也是被資本家視線凝視之下的一個我——工人。所以說「疏離」必須進入一個知識狀態去理解，只是感受到噩夢般的困局是不夠的；如果要為自己的處境負責，想走出這個困境的話，那就要找到一個方法。

我很敬佩一位社會學家——東海大學的趙剛教授，他提到社會學在做學術研究的時候，可以把「我」對象化。「我」可能很難逃脫自我

（Ego）的遺失狀態，但在研究方法上可以把「我」變成一個社會與時代變遷的結果。也就是從現實中抽離出來探討：我，為什麼會變成這樣的我？為何如此思考？為何情感投射是這種狀態？為何我的價值觀是這樣？

當我把知識做為方法，把自己分離出來後，我便可以用一個比較客觀的角度看待我自己；也能瞭解我會犯這樣的錯、走這條路，其實背後有社會的因素、歷史的因素，不只是做為一個純粹的自然人的遭遇。

沈：**雖說政治經濟學的階級結構分析策略非常重要，可是假如我們都以階級來看個體，是否會化約個人複雜的生命經驗？**

關：這是個思想理論的重大課題，但我們不能因為個體的差異，而抹煞被壓迫階級的社會事實。手工業生產的時代跟工業化大生產的時代不一樣，在工業化的大生產中，勞動者只能出賣他的勞力，這是政治經濟學的理論觀點。我並不是要否定結構中個人的特徵，但是個別特徵中往往有統計上的一致性，比方說一個人學歷不高、社會資本不高，那麼他的文化資本肯定不夠。個人的存在往往是個人與社會結構交織出來的狀況。

群跟我之間的關係是動態的，當我們以階級結構的方式去思考人的時候，可能化約了個人；以民族學、社會學以及戰後依賴性發展政治經濟學來看，真相卻比較具體。這些學問都是強調人在社會、歷史、結構之間的關係，從這角度切入，社會發展中所犧牲的都是生產勞動階級，而在臺灣戰後現代化發展的年代，這些勞動階級中，原住民族占了很大的部分。

談到階級結構的問題，我想起在八尺門工作期間發生了一件深刻影響我的事。當時我跟許多進港的朋友一起飲酒作樂，我忍不住問他們：「你們的手怎麼這麼粗糙？手指甲都有病變？」那朋友回說：「海上作業下網起網有時一搞三天，睡不到五小時。起網漁貨要立刻分類、分級、裝箱至冷凍艙。剛起網什麼都有，帶刺、帶菌、有些還有毒，

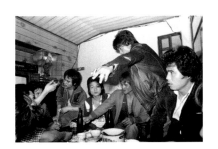

關曉榮與八尺門友人一同飲酒，融入其日常生活
關曉榮攝 / 1984
Guan Xiao-rong dining and drinking with friends at Bachimen as part of their daily life / photo by Guan

兩隻手即使戴手套也不免刺傷、刮傷，感染細菌，久而久之就變這樣，你看！每個人都一樣。」接著又說：「漁船結束作業回航跑水陸的時候，多半要到機房打盆水，兩隻手在熱水裡泡，老繭死皮泡軟了，才能用小刀刮掉。」

我問：「為什麼？」大家笑說：「哎呀！一個男人在海上，海船就像個牢房，待三、四個月，進了港，有人有老婆有人沒有，不管有沒有都有需要，你那雙手不刮要怎樣！」大家又一陣爆笑並且舉杯痛飲。過了一陣子後，坐在我身邊的朋友突然抓起我的手腕高舉說：「看！這是一個好命人的手！」雖然朋友只是出於直覺的反應。但在高風險、無保障、重勞動、低收入的漁業勞工，與拍照寫字就有好飯吃的人，「好命」與相對的「壞命」所指的就是階級差異與其矛盾。這就是階級，意思是說我的階級處境跟他們不一樣，這事件帶給我很大的教育，尤其是在拍與被拍的倫理上。

## 報導攝影的實踐與知識的重要性

沈：老師提到原住民族，我想回頭來談您的攝影實踐計畫，您是如何開始進行與現實主義密切相關的八尺門、蘭嶼等攝影計畫？

關：1979年的臺灣仍在戒嚴時期，很多知識被封鎖。我在當時看到四位西方攝影大師，包括亨利・卡提耶－布列松（Henri Cartier-Bresson）、尤金・史密斯（W. Eugene Smith）、理察德・阿維頓（Richard Avedon）還有愛德華・魏斯頓（Edward Weston）的作品集，我還記得那是大拇指出版社的黃金鐘發行的叢書，其中尤金・史密斯的攝影實踐給我最深刻的感動。

我的啟蒙是文學，早期就是亂讀一通，自己也寫些東西。離開《天下雜誌》以後，到了《時報雜誌》，認識我的朋友和當時主管大概知道我的狀況，知道我可以自己跑、可以寫、也可以拍，所以是這樣開始我的專題報導工作。

關曉榮於《時報周刊》工作時，赴日採訪國寶手造紙專題 / 雷驤攝 / 日本京都 / 1985-1986
Guan in Japan for the *Times Weekly*, interviewing for his story on Japan's national treasure, hand-made paper / photo by Lei Xiang / Kyoto, Japan

後來，有一個主要原因驅使我比較有意識地開始做八尺門專題報告。我覺得攝影雖然來自於西方，但做為一種記錄的工具或方法，必須通過記錄並揭露我們自己的社會現實，才能積累在紀實攝影領域的成績。做為承先啟後的一個起點——那個時候有這樣的願望。

1985年《人間》雜誌創刊前，也是解嚴之前，整個社會動蕩不安，各種社會運動的內涵充斥著各種衝突與矛盾，以及不平等、不公平的待遇。在那樣的情況下，我感受到社會的混亂，以及被壓迫、被剝削者的反抗。

1984年這一年就發生三次嚴重的煤礦礦災[3]，死難人數慘重，而且很多都是原住民。第一次海山煤礦的礦災在新聞上有一個統計數字，指出罹難的礦工裡面，阿美族裔超過半數。總礦工人數超過八百人，阿美族的礦工竟超過四百人，這就是我問題意識的源頭。

八尺門的專題報導標題，我用了「2%的希望與掙扎」，百分之二就是來自於原住民佔臺灣的總人口。但是在礦災，他們的犧牲超過百分之五十，這件事情讓我相當震撼。同時間，我覺得藝文採訪工作沒什麼挑戰性；我畢竟是藝專畢業的，雖然在繪畫上沒什麼作為，但是我吸收到的美學與藝術史，總是給我一些潛移默化的知覺與影響。比方說，梵谷的〈食薯者〉就帶給我很強烈的現實主義觸動，他描繪人的困境，也喚起了人的悲憫之心。相較來說，當時接觸到的藝術家創作實在沒什麼可看，可是他們投入很多的精力與藝文記者搞關係，我很看不慣這種狀態。

我想到攝影做為方法不可迴避的要通過自己社會的實踐才能打下基礎，讓後來的人踏著我們的肩膀繼續前進。所以面對當時的煤礦礦災，我決意離職，徒步環島；到花蓮時又驚覺有礦難，我就想我不是該去幹些什麼嗎？就是這個機會讓我前往八尺門一探究竟。

1987年我去到蘭嶼，這個計畫的執行跟在八尺門的蹲點，有一個比較大的知識上的差別。我在八尺門的工作，比較接近看見和直面苦與難

關曉榮〈2%的希望與掙扎〉
《中國時報》1985年9月24日
"Hope and Struggle of the Two Percent" written by Guan / *China Times, September 24, 1985*

《人間》雜誌第5期「關曉榮八尺門系列報導」完結篇 / 1986年3月
The concluding essay in the "Guan Xiao-rong Bachimen Report Series" in Vol. 5 of *Ren Jian* magazine / March 1986

的方式，我原先生活的世界裡的人們，好像日子都還過得去，但看到八尺門這群人生活得那麼艱難，我無權別過頭去，這種力量支撐著我想去不斷探索。

此外，我在八尺門的工作比較隨興、沒有計畫，但我知道這樣不夠，所以我開始閱讀，並前往臺大城鄉研究所等處找資料，那邊有些關於蘭嶼的專門研究報告，無論是自然環境、生物學、文化等等，之後的計畫就開始有這種知識上的充實。

沈：老師在攝影實踐中非常強調知識的重要性，但今天許多創作者還是很倚賴直覺，認為知識會箝制創作的自由與可能性。我好奇您怎麼看待創作與知識的關係？

關：前一陣子跟朋友聊到，在臺灣有一個侮蔑性的說法就是「拍照的人只有按快門的食指最發達」，反過來意思就是腦袋不行。我覺得這說法有一定來源，確實有一些拍照的人沒有意識到知識是非常重要的。

我在南藝大（國立臺南藝術大學）教學的時候，有時候跟年輕人聊長片、短片、長鏡頭、短鏡頭，也看他們拍的東西，我問他們說這叫做長鏡頭嗎？對我來說長鏡頭不是有聞必錄，從進廁所一直拍到出廁所就叫長鏡頭，長鏡頭很難拍的，尤其是紀實性的動態攝影。侯孝賢的長鏡頭是經過精密思考跟安排的，是非常大的一個挑戰，因為長鏡頭很容易就鬆掉了。

而短片並不是把長片剪短，就會自動變短片，它有不一樣的邏輯跟剪接節奏。所謂空景，也不是空空如也；空景在中國的繪畫裡叫留白，像音樂裡的餘音繞樑。一定是跟你創作的內容主題有內在的邏輯關聯性，那種留白才是真正的空景。所以，我覺得拍片並不能分開拍攝與剪輯，而是先有知識思考才去拍、再去剪接；拍與剪接只是製作時間線性上的先後，卻是創作上渾然一體密不可分的努力。對我來說拍紀錄片要有傻氣，但不能是個傻瓜。

## 攝影倫理的不斷反思

沈：除了更關注攝影或社會學的知識層面外，您同時也在意攝影的倫理問題。攝影史研究者陳佳琦在論文《再現他者與反思自我的焦慮——關曉榮的蘭嶼攝影》中提到您在拍攝工作上做為攝影者自省的焦慮，能不能請您談談這個關於倫理層面的焦慮？

關：你提到的那種焦慮，換個角度來看，不是那麼單面向的。拍與被拍之間，存在著作用和反作用的雙向動力，在這個動力的動態過程中，必須充分意識到在拍與被拍的交往中，雙方得共同面對背後的統治權力，也就是隱蔽在產、官、學複合體共謀的裁判權。正是這個統治權，製造了不平等的剝奪。而拍與被拍雙向的動力，是否存在揭發與對不平等剝奪的反抗，應該接受思想與理論的檢驗。如果我意識到拍與被拍的倫理觀是什麼，這也涉及「社會實踐」——把攝影做為方法，提問的方法，也是尋找答案的方法。所以說這種關係，來自你敏銳地感受到人與人之間的交往，不是從高處對待被攝者，而是你有一個強烈的企圖心，你想揚棄民族差別身分認同的政治正確禁區，平等地對待每一個人。

這個思想與理論是這樣教育我的，但實踐上你就會碰到具體的挑戰。當年我在蘭嶼紅頭村時，觀察到村民把傳統的小米祭想像成可以收費的活動。那個年代，臺灣很多攝影學會像軍隊一樣，帶著最先進的攝影器材，進入島上去拍穿著丁字褲的達悟族人。而原住民終於意識到，他們長期以來被觀光產業剝削，獲利的是觀光產業本身，他們是被消費的對象，卻沒有獲得什麼好處，所以他們開始想可以對攝影者獵奇的拍照收費。

在蘭嶼我一向都是帶著相機走走拍拍，我想記錄這種「觀光化的文化商品消費」的事件，對他們帶有被拍照獵奇的儀式排練卻沒有太大興趣。所以彩排進行之時，我揹著相機爬到紅頭國小的一間教室。那邊只有一樓，有一棵很老的榕樹，我爬上去看，結果下面在彩排的老人家當中，有一個人指著我，在議論什麼事情，好像是說「明天祭典要收費才能拍照，但是這人已經在拍照了，我們要不要跟他收費？」

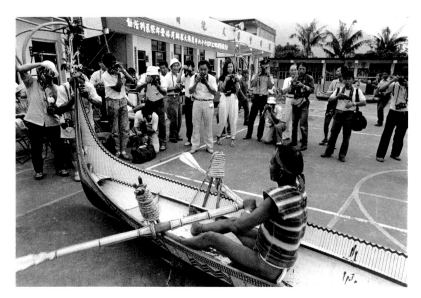

《蘭嶼報告》系列作品〈文化標本〉/ 關曉榮攝 / 1988-1989
"Cultural Specimen" from the *Lanyu Report* series / photo by Guan

沒過多久，我回到下面，他們內部已經化解對我也在拍照的質疑——意思就是「這個人跟明天要收費的人不一樣」。那個時候我已經在蘭嶼待半年左右，大概全村的人都知道我是誰，在幹什麼。

這事件將我推向一個問題：拍與被拍之間的倫理關係，經常是拍的人在追求探索時無從迴避所介入的雙向張力？後來我發現，這樣的議論來自於我們在這個知識權力與傳播權力裡面，處在不一樣的位階——我在拍，他們被拍。這樣的位置使我常常面臨到剛才所說的雙向張力。

拍與被拍的歷史、民族、文化、階級、社會等等差異一定存在，而我的工作最大的目標，就是突破不平等的視線。拍與被拍當中，拍攝者的最大誤區來自於不平等的視線，因為自認為我是研究你的，你是被我研究的。這件事情給我的教育以及收穫是，不是要在身分認同的認識論誤謬綑綁下變成他們以後，才具有正當性的完成，而是我必須努力學習：在階級與權力不平等的社會結構裡，什麼是平等的視線。

這個問題讓我想到，有一次和兩個跑到蘭嶼旅行的女生的對話，她們首先問我一個尖銳的問題：「聽你日常的言語，好像對觀光客有很多意見和批評？」我說：「是啊！」

她們繼續說：「我們三人其實都算觀光客，只是你比我倆待得久。」意思是，我批評觀光客也批評到他們，甚至是我自己。他們接下來對我的評斷，舉例不一定恰當，但我覺得滿有意思，她們說：「大家都是觀光客，我們是一百步，你是五十步。有一句古言：五十步笑百步。」我回應：「你覺得我在這文化主體外面五十步，你們距離較遠是一百步，所以我們之間的距離只有五十步。但事實上應該是一百五十步。因為我的五十步不是從主體外面邊界算起，而是以破解民族身分認同的理論誤區，追求民族別差異的交往、對話和認識的行動，進入族群文化體的範圍，向裡面推進的五十步。」

關於拍攝倫理，我在八尺門的書有述及一些思考點。事實上，這是一個拍攝倫理刀鋒上的挑戰；我們常常站在刀鋒上，一不留神就變成一種霸權觀看。這個刀鋒一直提醒我要自省，這不是一件容易的事情，時時刻刻都要將這把尺放在腳下的倫理刀鋒上，我有這種理解，因為漠視這刀鋒的話，很容易變成一種不平等對待而不自覺。

沈：在倫理問題上，除了拍與被拍的焦慮之外，我好奇老師如何看待自己身為一個漢人，卻幫原住民「代言」的問題？另外您又怎麼看待原住民族自己內部的發聲，跟你的報導實踐中幫他們發聲的差異？

關：我不否認把攝影、筆還有教育交給他們讓他們自己發聲的努力。

至於「代言」這樣的疑惑從哪裡來？我在南藝大開報導攝影課時，學生問我要拍什麼東西？我就給他們一些作業，我說：「學校旁邊的大崎村正在種植果樹，可以去瞭解一下。」

有個學生前往拍了一個老農夫專題，他在暗房沖片時選了七張老農民的人像照片，帶到我們的討論課上，他問我：「老師，這些照片沒地

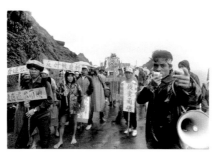

「蘭嶼大飯店」觀光巴士 / 關曉榮攝 / 1988-1989
An "Lanyu Hotel" tourist bus / photo by Guan

關曉榮以影像為蘭嶼居民發聲 / 1988-1989
Guan Xiao-rong's images speak for the people of Lanyu

方發表，就算發表了也不會改變這些老農夫的處境，我這樣拿著鏡頭對準他們，帶走他們的肖像，是不是也是一種剝削？」

我沒有正面回答，卻提了兩個問題給他。第一個問題：這樣子的攝影行為會把你推向剝削，是誰說的？一定有個聲音在那裡，鑽進你的腦子，你才會這麼想。你回去想一想這聲音從哪裡來。

第二個問題：你拍的是一個農人，他要種植果樹、要勞動，卻可能面臨市場上不等價交換的一些剝削，當你無法解決拍與被拍的焦慮的時候，放棄、退卻了，收起批判性報告的筆時，誰最高興？

他當下沉默許久，不發一語。我告訴他：「最高興的不一定是一個自然人，而是一個階級，或一個權力結構。」當你退卻，就像學界為加害者除罪化；身為知識分子，面對這樣的堅硬高牆，難道我找得到理由退卻嗎？所以那道牆不是一個自然人，是一整個階級、勢力，它就是要把你困住。你沒辦法改變弱勢者的處境，就解釋成你在剝削他，事實上是誰在剝削他？是那個集團，放出聲音的也是那些權力掌控者。

站在媒體人的角度，我揭發真相的工作是一個戰場，通俗一點來說，就是不平則鳴，因為感受到不公平，我必須在社會媒體上發聲。

前幾年，有人在蘭嶼放映我的紀錄片《國境邊陲：1997島嶼上的人類》。映後，在那邊工作的一名碩士生發問，質疑我憑什麼站在達悟族的角

度或立場，為他們代言或發聲？我當場回答他：當你質疑我工作位置的角度跟立場時，你是否知道有多少的媒體、學術界、官僚機構，赤裸裸地奴役、剝奪、鎮壓、侮蔑他們的歷史與現實，從來沒有停止過。

所以你應該要追問的是，他們為什麼不能發聲？而不是追問在特定的歷史條件下為他們發聲的人。在報導者替他們發聲前，你能不能理解他們是被什麼樣的力量所噤聲？我就是要揭露壓抑背後的權力，這是比我個人的報導更強大的權力。我報導的價值是在反抗這個權力，不是我個人成就的代言。當所有的聲音只有一個，且仍在粉飾問題時，當原住民沒有發言管道時，我當然選擇站在被剝奪被壓迫者這邊，而不是依附在剝奪者一邊以換取個人利益，這點我是義不容辭。

## 理想主義的回音

**沈：**經過那麼多年的抵抗，您這種理想主義的精神是否曾遭遇現實難以改變的困境而感到挫折？另外，像您這樣的精神又要如何傳承給後代？

**關：**年輕的時候，我試圖投入改造這個不平等社會的努力，那時候比較難體會改變需要時間，尤其需要具有中心思想理論指導實踐的行動組織。其實社會結構的變革是要經過漫長的世代交替、投入其中，不像生病吃藥，藥到病除。相對來說，結構性的東西——比方說黨派鬥爭、或所謂的民主選票制度，即使經過社會運動反覆地抵抗衝擊，也不會瞬間崩塌。甚至於有人率先進入權力結構試圖變革，但進去以後，多半只能複製出同樣的、前人的權力結構。

所以我們需要學習先人的遺產，雖然我們會被現實打倒，但可以從先人的精神跟智慧去尋找再度站起來的力量。

---

1  本文為專書主編沈柏逸2018/12/12、2019/1/6、2019/12/28於新店星巴克進行訪談後，彙整編寫而成。

2  天琴廳的經營者是當時臺北醫學院（今臺北醫學大學）的學生董世光，他也是「美的杏」（Medicine）畫社的社長，因為社團同學畫作無處展覽，於是興起開咖啡店做為展覽場地的念頭。天琴廳是當時藝文人士與作家聚會的場所。

3  1984年三次嚴重的礦災，發生於土城海山煤礦（6月20日）、瑞芳煤山煤礦（7月10日）、三峽海山一坑煤礦（12月5日）。

# Guan Xiao-rong Interview

## A Collision of Life Experiences: the Inspiration of Art and Literature

**Q:** You photograph and write about the status of the indigenous people of Lanyu and Bachimen, and many conversations and inspirations have been sparked through these works. When did you start to recognize the dignity and power of people who inhabit marginalized states?

**A:** In the 1970s, when I was teaching at Hengchun Junior High School, Taiwanese folk singer Chen Da became well-known, impacting the confused minds of society. Most of the people had no idea who they really were—they just listened to Western classical or pop music.

I'd heard Chen Da sing in the auditorium when I was teaching. Although I am originally from Guangdong and my mother tongue is Cantonese, the inherent spirit of Chinese culture in Chen Da's Taiwanese folk songs deeply touched and resonated with me. Many people were singing Taiwanese folk songs in those days, but their melodies were typically cheerful, smooth, and delightful—no one evoked the profound emotion he did.

The content of Chen Da's songs are similar to the lyrics of the travelling poets, which speak of the suffering in life, and that was quite different from Chinese pop, or Western rock n'roll, blues, etc. The ups and downs of his life not only resulted in his lyrics, but also transformed his body into a unique instrument that blended with his gekkin. From his voice, you could recognize the falsity of the "societal harmony" propagated by the New Life Movement. In comparison, the authenticity of Chen Da's folk songs penetrated  history as well as the aesthetics of the New Life Movement in the martial law period.

Because I had lived a poor life in a military village, I could sympathize with the messages of Chen Da's songs. Most of the kids from military villages fend for themselves. When I was young, I was not at all aware of the meaning of "repressed deprivation" ; however, upon hearing the stories told by Chen Da in his folk songs, I was able to connect my experiences of poverty with the hardships of the people about whom he sang.

**Q:** You wrote plenty of prose while teaching in junior high school, including a work you eventually published called Daughter's Afterbirth. How do you cultivate such accomplishments in writing and literature? And how do you relate these accomplishments to your photographic reports?

**A:** Shi Song had a strong influence on my literary tastes. Our relationship started back at the National Taiwan College of Arts (today the National Taiwan University of Arts). When I was a freshman, I frequented the "Tien Chin Hall," a coffee shop in Ximending where many young people from many walks of life gathered, including some kids from the Taipei American School.

We read, made friends, chatted, and fooled around; I became acquainted with Shi Song there. My thoughts and aesthetic appreciation came from literature, and Shi Song encouraged me to read Lu Xun, Shen Cong-wen, and some translated classic Western literature. I had read many novels during my student years, so I started to write and doodle when I became a teacher in an art school. It was quite conservative under the martial law, even in the art school. You could not draw the color red, as it stood for communism; no grey, as it stood for nihilism; and no black, as it stood for anarchism. Relatively speaking, the guys at the Tien Chin Hall were considered rebels at the time. However, their sense of rebellion originated from nihilism and self-exile, unlike those who protest on the streets these days.

It is not only intellectuals who feel a sense of alienation (e.g., writers expressing spiritual dilemmas and suffer-ing); the masses experience such feelings as well. Especially after WWII, people often faced issues of life and death, and the fact of the fragility of life. I believe that the work of Albert Camus and Jean-Paul Sartre appealed to Europeans because it resonated with their spirit. Sacrifice was not only for intellectuals, but for the broken families in general. These feelings were fertile soil for European literature.

The literary works I'd read while I was young influenced me greatly. The humanity in my documentaries or documentary photography is related to the insulting and damaging experiences of the protagonists in the novels I read. Essentially, I feel a connection with those injured people, and it stems from the disarray of my child-hood resulting from the Chinese Civil War. My empathy and ability to feel suffering are all related to my past personal experience.

## The Focus on Realism

Q: The "self-exile" and "nihilism" you mentioned seem related to the existentialism that was popular at the time. Your later works, however, focus particularly on realism. If existentialism focuses on solicitude for one's per-sonal spiritual state, political economics and critical realism focus more on social structure. How do you view the transformation of your thought from existentialism to left-wing realism?

A: The focus on realism came from the influence of Chen Ying-zhen, founder of Ren Jian Magazine. In 1984, when I dwelled in Bachimen, I didn't bring many books, but Russian anarchist Peter Kropotkin's Memoirs of a Revolutionist was one of them. After my report on Bachimen was done, I started to read China Tide, the publication for left-wing thought, theory, and social survey in the Dangwai (non-KMT) period; it was my window on political economics. The transformation you mentioned happened at that time. I began to learn Karl Marx's theories, and though I didn't study hard, I could still recognize the historical penetrability of Marx's analysis of political economics.

Spending time taking photos of Bachimen, I began to have questions concerning the coal mine disasters there: In such a dangerous occupation, why were indigenous people the majority? This problem came from my reali-zation of the producers' class position in the structure of society. A worker is not a "separate person." While an individual worker may be killed in an accident, the real issue is about the mine workers as an "exploited class" and the general class problem.

There are issues of alienation in each generation, but don't forget: You will also get old one day. While you're young, you need to realize that this social alienation probably comes from a crucial productive field. In Marxist theory, humans are the summation of the mode of production and the relations of production. The feeling of alienation occurs in the mode of production, and the latter comes from the relations of production. For instance, I am also viewed as a worker under the gaze of capitalists. You must understand such "alienation" consciously and rationally because feeling the nightmarish dilemma is not enough. If you want to be responsible for your own situation, and escape your plight, you have to find a solution.

I admire one sociologist very much—Chao Kang, from Tunghai University. He proposed the notion of the objectification of "I" in sociological studies. It might be difficult for "I" to escape from a lost state; however, by employing research methods that disengages the "I" from reality, "I" could engage with the vicissitudes of society and the times: How did I become "I" ? Why do I think this way? Why is my emotional projection in such a state? And why are my values like this?

When I approach knowledge methodically, and detach myself from a free state, I can view myself from a relatively objective angle. Consequently, I can begin to understand the social and historical factors behind my mis-takes and choices rather than thinking of them simply as natural occurrences.

Q: It is important to analyze the tactics of class structures in political economics. However, if we always view a person from the perspective of class, would it not be simplifying the individual's experience as well?

A: This is a major ideological issue, yet we cannot ignore the social facts of an oppressed class just because of the differences between individuals. The age of handicraft production is different from the age of socialized mass production. In socialized mass production, workers sell only their labor, from the perspective of political economics. I am not here to deny the character of individuals within the structure, but there is usually a statistical consistency in their respective characters. For instance, a person surely has insufficient cultural capital if he/she has a poor educational background and social capital. This personal existence is normally a condition resulting from the interweaving of individuals and the social structure.

The relationship between a group and an individual is dynamic. When we think about people in terms of class structure, the experience of a person may be reduced. However, if we look at ethnology, sociology and the post-war dependent development of the political economy, the truth is more concrete. These disciplines all emphasize the relationship between people and society, history, and the structure. From this point of view, the working class of production is sacrificed in the social development. In Taiwan, in the age of post-war modernized development, indigenous people have comprised a large part of the working class.

This issue of class structure reminds me of something that influenced me profoundly in Bachimen. I was drinking with some friends at the harbor. I couldn't help but ask them: "Why are all your hands so rough, your nails broken?" A friend answered: "It is the result of three consecutive days working at sea, and with less than five hours to sleep each day. The haul must be classified and packed in the freezer. With everything in the net, stuff with thorns, germs, and toxins, it's inevitable that we'll be stabbed, scratched, or infected even with gloves. That's why they become this way over time. Look! Everyone is the same." He added, "After getting back from fishing, we usually need to bring some hot water from the engine room to soak our hands in. Calluses can only be scraped off with a knife when they get soft." "Why do you need to do that?" I asked. Everybody laughed and said, "Alas, the boat is a cell for a man. It takes three or four months to get back to the harbor. Whether you have a wife or not, you still have the physical needs; what can you do with rough hands?" People laughed again and toasted each other. After a while, a friend by my side grabbed my wrists, raised them high and spoke: "See? These are the hands of a fortunate man." I know it was my friend's instinctive reaction, compare fishery laborers—whose work is hard, risky, insecure, and low-paying, —to someone who gets paid for photographing and writing. The state of being "fortunate" and relatively "unfortunate" points to the difference between classes and their conflicts. It taught me a great lesson, especially in terms of the ethics of documentary shooting.

## The Importance of Practice and Knowledge in Documentary Photography

Q: Speaking of indigenous peoples, I would like to come back to your photography projects. How did you begin your projects at Bachimen and Lanyu?

A: In 1979, Taiwan was still under martial law, and a great deal of information was censored. During that time, I saw the portfolios of Henri Cartier-Bresson, W. Eugene Smith, Richard Avedon and Edward Weston. I remembered that those series were published by Huang Jin-zhong from the publishing company

Big Thumb. Among them, W. Eugene Smith's photography practice had the greatest impact on me.

Literature enlightened me. Previously, I only read without context, and wrote some things myself. After I left Common Wealth Magazine, I went to China Times Magazine. My friends and my supervisor knew that I could write and shoot, and that I was mobile. That's how I started working on editorial coverage.

Later, there was a major reason that pushed me to start the report on Bachimen. Even though photography originated in the West, I believe that it is a tool or method of recording, and we must record and uncover our own social reality first before accumulating achievements in documentary photography. At that time, I wished to be the initiator in carrying on the heritage of the past and opening up the future.

In 1985, before the publication of *Ren Jian* magazine, and the lifting of martial law, the whole of society was turbulent and not peaceful. Various movements were filled with countless confrontations and conflict, as well as unfair treatment. In that situation, I felt the chaos of society, and the resistance of the oppressed and the ex-ploited.

In 1984, for instance, there were three serious mining disasters just that year. The people who suffered heavy casualties were for the most part indigenous people. According to the news, Amis people accounted for more than half of the dead mine workers in the first mining disaster, at the Haishan coal mine. Of over 800 coal mine workers, more than 400 were Amis. That became one of the sources for my project.

On the topic of the editorial coverage of Bachimen, I named it 2% Hope and Struggle because the proportion of indigenous people in Taiwan was two percent. However, in terms of the mining disasters, their sacrifices were more than fifty percent. I was terribly shocked at this. At the same time, I did not feel that there was any challenge to the task of art interviews. After all, I'd graduated from art school, and though I was not good at painting, the aesthetics and art history I had learned brought me a degree of perception and had an effect. For instance, The "Potato Eaters" by Vincent van Gogh gave me a strong sense of realism. He depicted the dilemma of the people, while also arousing the compassion of viewers. In contrast, the creations of the artists I met were actually not worth looking at; they poured all their efforts into building relations with art reporters. I despised this state of affairs.

For me, it is necessary to lay the foundation for photography as a method through our own social practice. Only then can the next generation have a basis from which they could go further. Thus, in the face of the mining disasters, I decided to quit my job and travel around the island on foot. When

I arrived in Hualien, I was surprised to hear the news of the mining disaster. I thought "Shouldn't I do something?" So I went Bachimen to investigate.

I went to Lanyu in 1987, and the execution of this project differed greatly from my stay in Bachimen in terms of knowledge. The work in Bachimen required me to face the pain and misery directly. Before I went to Bachimen, the world seemed tolerable for people; however, seeing the hard lives of the people in Bachimen, I felt that I did not have the right to turn away. It was a force pushing me to continue to explore.

The work I did in Bachimen was also more casual and unplanned, yet I knew it wasn't enough, so I started reading, and went to the Graduate Institute of Building and Planning at NTU (National Taiwan University) to look for information, and found some specialized research papers about Lanyu in the aspects of environment, biology, and culture, etc. Consequently, there was a greater application of knowledge in my later projects.

Q: **You emphasize the importance of knowledge in photographic practice, but creators today tend to rely on their instincts, thinking that too much knowledge might restrain the freedom and possibilities in the process of creation. I wonder how you treat the relationship between creation and knowledge.**

A: A while ago I was talking with a friend about a certain insulting phrase: "The shutter finger is the most developed organ of a photographer." In other words, the brain is deemed to be an undeveloped organ. I believe the saying came to be for a reason—some people do not realize the importance of knowledge when taking pho-tos.

When I was teaching at TNNUA (Tainan National University of the Arts), I talked about features, short films, long takes, and short takes with the young people, and also observed their work. I questioned them: "What is a long take?" For me, a long take doesn't mean you just shoot everything you see in front of you; it's really hard to do a long take, especially in documentary films. Hou Hsiao-hsien's long takes are meticulously arranged. That's a great challenge, for a long take can easily get out of hand.

And a short film is not just a short feature film; it has a different logic and rhythm of editing. A so-called "empty shot" is not merely a void. Emptiness here is like the blank space in Chinese painting, or the lingering sound in the air long after a note is played. There must be some logical connection to the theme of your creation; that is true emptiness. Therefore, I would suggest that filming and editing not be kept separate, but ongoing with your knowledge. Although filming and editing are processed in sequence by order of production, they are nevertheless inseparable efforts within the overall creation. In my view, you need to have a sense of caprice when shooting a documentary, but you cannot just fool around.

## Constant Reflection on the Ethics of Photography

Q: In addition to the aspects of knowledge of photography and sociology, you also care very much about the issues of ethics in photography. The photographic history researcher Chen Chia-chi mentioned your anxiety of self-reflection working as a photographer in her thesis: *The Anxiety of Representing the Other and Reflecting the Self: Guan Xiao-rong's Photographs of Lanyu.* Could you talk about this anxiety regarding ethics?

A: The anxiety you mention is not simply one-sided. Between photographing and being photographed, there are two-dimensional forces working against one another. In this dynamic process, one must fully realize the dominant power underlying the relationship between photographing and being photographed; that is, the concealed, conspiring jurisdiction of the complex of industry, government, and academics. It is precisely this kind of dominant power that creates unfair exploitation. The question of whether the two-dimensional forces of photographing and being photographed can uncover and revolt against unfair exploitation should be examined by means of thought and theory. Taking an ethical stand in terms of photographing and being photographed also involves "social practice,"  —using photography as a method to ask questions and seek answers. Consequently, an ethical relationship emerges from one's sensitivity in communicating with people, not disdaining them, but consciously attempting to treat them on an equal level.

I was educated this way through such thought and theory, yet there are specific challenges in the practice. During my years in Hongtou Village, on Lanyu, I noticed that the villagers were considering turning the traditional millet festival into a charged event. At the time, hordes of photography associations brought advanced devices to photograph the thong-wearing Tao people. Eventually, the indigenous people noticed that they were being exploited by the tourism industry, which only benefits itself. The indigenous people were always the consumed object, without any hope of profit. As a result, they started to think about the possibility of charging the inquisitive photographers.

I always walked around with my camera on Lanyu. I was trying to record this "tourism-driven cultural consumption," and I didn't have much interest in the rehearsals of the ceremony, the participants of which were aware of and indeed awaiting the cameras. I walked to Hongtou Elementary School as they were rehearsing. I climbed an old banyan tree, and an elderly man in the rehearsal pointed at me. They were probably saying, "Shall we charge the young man for photographing, even though the ceremony begins tomorrow?"

After a while, I climbed back down, and they had resolved the question of my action, concluding that "this guy is different from the people we are going to charge tomorrow." By that time, I had already lived on Lanyu for six months. Nearly all the villagers knew who I was and what I was doing.

This incident pushed me towards the question of the relationship between those who are photographing and those who are being photographed; that is, the inevitable two-way tension involved in the quest of a photographing someone. I then recognized that the discussion arose because we held different positions in terms of the power of knowledge and dissemination: I was photographing, and they were being photographed. Inhabiting such a position, I frequently faced the two-way tension I just mentioned.

There are the differences in history, ethnicity, culture, and sociality with regards to photographing and being photographed; the greatest aim of my job is to break through unequal viewpoints. In terms of photographing and being photographed, the photographers' biggest errors result from unequal viewpoints; photographers opinionatedly think they are the researchers, while you are the one being researched. For me, the lesson and the reward of this understanding is not so much about finding the legitimacy to finish my work by becoming them, but rather to strive to attain an equal viewpoint as the photographer.

This reminds me of a conversation I had with two traveling girls on Lanyu. They first asked me an incisive question: "We heard some of your words; you seem to have plenty of judgments and critiques for tourists?" To which I replied, "Yes!"

They went on: "We three are actually all tourists; you've just stayed longer than we have." By this, they meant that my critiques of the tourists were also against them and even myself. Although their judgement towards me was not exactly accurate, I thought it was interesting. They said: "We're all tourists; maybe we are one hundred paces from the culture, and you're fifty paces away. Like the Chinese saying goes, 'Those who retreat fifty paces mock those who retreat a hundred.'" I replied, "You think I am fifty paces from this cultural subject, and you're a hundred paces away, so the distance between you and me is merely fifty paces. As a matter of fact, our distance should be one hundred and fifty paces, for I am fifty paces within this ethnic cultural group."

Regarding the ethics of photography, I have mentioned some perspectives in the book on Bachimen. In fact, it is a challenge to photograph ethically; we often stand on the edge of a knife, and it can become a hegemonic view if we are not careful. This knife's edge always reminds me to be introspective; it is not an easy task. Always use this as a ruler for your actions. I have come to this understanding because, if you ignore this aspect, you can easily engage in unequal treatment without even being aware of it.

Q: As for the question of ethics, in addition to the anxiety of photographing and being photographed, I wonder how you see the question for Han people such as yourself "advocating" for indigenous people. Also, how do you see the difference between the voice of the indigenous people themselves and the voice of your reportorial practice?

A: I do not deny the efforts to provide the camera, the pen, and education to the indigenous people so that they can speak for themselves. But where does the term "advocate" originate? When I was teaching documentary photography at TNNUA, the students asked me what to shoot. I assigned them to take photos at the Daci village near the school, telling them, "Fruit trees are being planted at the Daci village. Maybe you can go and have a look."

One student did a project on an old farmer. He chose seven pictures he'd developed himself and brought them to the seminar. He asked me, "Professor, we don't have any place to show these pictures, and even we did, it wouldn't change the situation of the old farmer. I pointed my lens at him and took his portraits; isn't that a kind of exploitation?"

I responded to him with two questions instead of giving a direct answer. First: This action of photography makes you an exploiter…who says so? There must be a voice inside your brain, and you have to think about the origin of that voice. Second, you're filming a farmer who plants fruit trees and does his job, yet he may face the exploitation in the market. You decide to give up as you don't have the solution to deal with your anxiety in filming. Who will be the happiest once you withdraw your pen from the critical report?

The student stood silent for a while. I told him: "The one who is going to be happy about this is not necessarily a person, but rather a class, or a power structure." Your retreat resembles academia's act of decriminalizing the perpetrators. As an intellectual facing a high wall, do I have any reason to retreat? The wall is not a person, it is the whole class and power structure that tries to trap you. You are the exploiter in your own explanation, for you can't alter the situation of the vulnerable. But in fact, the real exploiter is the group, those who own the power and give voice to those in power.

Speaking from the position of a media worker, my job is a battlefield that aims to expose the truth. To put it simply, it is about sounding a defense against injustice: Whenever I feel the unfairness, I must spread my voice in the media.

A few years ago, some people screened my documentary, *At the National Frontier: Humans on an Island in 1997*. After the screening, a graduate student who worked there questioned my qualifications to speak for the Tao people. I answered immediately: "While you question my position, do you really understand how many people in the media, academia, and bureaucracy are nakedly and ceaselessly slaving, exploiting, suppressing and insulting the history and reality of the Tao community?"

What you should ask is why they can't make their voice heard, instead of questioning the people who speak for them in a particular historic condition. Before a reporter speaks for them, can you ever see the forces that have muted their voices? I am here to uncover the power behind the suppression, a power that is much more formidable than my personal coverage. The value of my coverage is to resist this power, not for my own achievement. When all the voices are trying to cover up the problems, and the indigenous people still have no room to speak up, it's obligatory for me to stand by their side.

## The Echo of Idealism

Q: In your years of resistance, have you ever felt frustrated in the face of a plight that you could not realistically do anything? Furthermore, how does one transfer such a spirit of resistance to future generations?

A: When I was young, I tried to participate in the effort to change unfairness in society. It was hard to realize that it actually takes time to make a difference. In fact, it requires long-term generational change and participation to transform the social structure. The process can never be compared to taking a pill to cure an illness. Relatively speaking, the structural aspects, e.g., partisan struggle or the so-called "democratic electoral system", would not instantly collapse even under the constant pressure of social movements. There are even people entering the structure of power with the purpose of altering it, yet most of them can only duplicate the same struc-ture within such a structure.

Therefore, we need to learn the heritage of our ancestors. Although we may be defeated by re0ncestors.

# 傳記式年表
Biographical Timeline————————

| 1949 | 國共內戰，中華民國遷都臺灣。時任中華民國臺灣省政府主席兼臺灣省警備總司令陳誠於5月19日頒布戒嚴令，宣告5月20日起臺灣省全境實施戒嚴。 |

在臺海政治動盪這年，9月7日關曉榮出生於中國海南島三亞市。父親是空軍，由於國民政府戰敗，襁褓中的關曉榮隨著家人搭機來臺。在臺南戰備機場落地後，母親帶著三個月大的關在臺南火車站月台等了三天，再轉乘牛車到一處美軍轟炸過的民宅暫居，之後全家人輾轉到臺中新社。

**1959**
**—**
**1962**

關曉榮小學三年級時，全家搬到一遇風災就淹水的板橋浮洲里，過著物質匱乏的眷村生活，顛沛流離的生命經驗與不安定的生活深深影響其性格。眷村裡，男生念完初中就進軍校，不像高層文官系統的家庭享有優渥資源；關幼時受壓抑的體驗間接影響到未來對人間底層的關注。

小學時期，曾瞞著家人挖取板橋大漢溪溪畔用來製作混凝土的碎石頭，以換取報酬。在夜色蒼茫中獨自面對天地，這是他第一次體驗到「獨處」的滋味。

**1968**

臺灣文學界發生「民主臺灣聯盟案」，陳映真等人被捕入獄。此外，臺灣第一部紀錄片《劉必稼》由導演陳耀圻在臺北文化圈發表後，被警備總司令部約談。這些白色恐怖時代的政治壓迫記憶，影響往後的關曉榮拍攝紀錄片《我們為什麼不歌唱》（2004）以及《冰與血》（2014），記錄政治受難者的處境。

**1969**
**—**
**1972**

關曉榮就讀國立藝專（今國立臺灣藝術大學）美工科。常到西門町的天琴廳與藝文領域的好友相聚，包括奚淞、阮義忠等人。此時開始大量閱讀翻譯文學作品如：杜斯妥也夫斯基傳記、《白鯨記》等。由於文學的陶養，文字成為他日後重要的創作基礎。

透過朋友介紹，首次接觸美國原版的《人類一家》攝影集。透過攝影之眼，觸動到影像有別於繪畫的歷史穿透力。

**1949** After the Chinese Civil War, the Republic of China government moves to Taiwan. Chen Cheng, leader of the Taiwan Provincial Government and Garrison Command, imposes martial law throughout Taiwan from May 20, 1949.

Guan Xiao-rong is born on September 7 in Sanya, Hainan Island. His air force father brings the family to Taiwan after the defeat of the Government of the Republic of China. Landing at an airbase, mother and baby wait three days at a Tainan railway station to take an oxcart to a bombed-out residence. The family later moves to Xinshe Township in Taichung.

**1959**
**|**
**1962** In third grade, Guan's family moves to Banqiao's Fuzhou neighborhood, which floods periodically, and live in poverty in a military village. Guan's unstable early life affects him deeply.

Children in military villages have to fend for themselves; boys enter military school after junior high. Families have fewer resources than higher-level civil servants. Guan's oppressive childhood shapes his concern for socially vulnerable groups.

In elementary school, he secretly earns money by digging stones for concrete beside Da Han River in Banqiao; working beneath the dark night sky gives him a taste of solitude.

**1968** Chen Ying-zhen and other literary figures are imprisoned in the "Union for a Democratic Taiwan" case. Chen Yao-chi, director of Taiwan's first documentary film, *Liu Pi-chia*, is interrogated by the Garrison Command's security division. Memories of political oppression during the White Terror influence Guan Xiao-rong's later documentary films, *Why We Don't Sing* (2004) and *Ice and Blood* (2014).

**1969**
**|**
**1972** Guan studies at the National Taiwan Academy of Arts (today's National Taiwan University of the Arts). He often meets friends with shared interests in Ximending, such as Shi Song or Juan I-jong. He reads literature in translation, such as Dostoevsky's biography and *Moby Dick*. Literary influences become important in his later creative work.

A friend introduces him to the American photographic collection *The Family of Man*, sparking an awareness of how photographic images and painting differ in historical influence.

| 1974 | 退伍，於臺中環山部落的水果農場打工兩個月。體會到勞動者所受的歧視，尤其是監工對懷疑偷吃水果的女工上下其手，讓他感到相當憤慨，並且意識到勞動者無從反抗的壓抑。 |

開始任教於屏東恆春國民中學。教書期間，遇到老友阮義忠，陪他到車城附近採訪，看到老友熟稔地運用相機，關曉榮開始思索自己也可以經由攝影傳達鄉下生活，以及身為小鎮國中教師的感觸。

與同校張老師共結連理。

關曉榮任教於中學時，利用餘暇抽菸看報紙
屏東恆春國中 / 1977
Guan takes a break from teaching
Hengchun Middle School, Pingtung

**1975 – 1976**

社會開始出現關懷臺灣本土的現實意識，關曉榮於此時接觸到不同於流行樂、也迥異於官方新生活運動宣傳的民間音樂，包括陳達的恆春民謠、李雙澤校園民歌〈唱自己的歌〉等，被他們的歌聲所感動。

1976年，兒子出生。

**1977**

關曉榮買了人生第一台相機以及放大機，並向阮義忠學習暗房的初步技法。用這台相機在彰化街口拍攝拉胡琴的老先生影像，收錄於張照堂《生活筆記》（臺北：景像出版社），這是關曉榮初次發表的報導攝影作品。

**1978 – 1979**

1978年，藝術家蔣勳回臺接任《雄獅美術》總編輯，隔年1月出刊的《雄獅美術》第95期收錄關曉榮散文〈陀螺〉，訴說在中學教書的生活點滴與心境。這是關的散文第一次被刊登在報章雜誌上。

關曉榮曾對學校把成績較差的學生，從升學班轉移至放牛班的做法不以為然，並在教務會議上提出討論，不料仗義直言的性格卻惹惱了校方。因為對長期教育體制感到失望與無力，遂於1979年辭去教職。開計程車為生。

1979年，女兒出生。

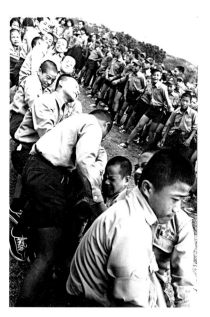

以影像記錄中學生的拔河比賽 / 關曉榮攝
屏東恆春 / 1979
Guan photographs a rope-pulling contest
photo by Guan / Hengchun, Pingtung

**1974**    After military service, Guan works at the Huanshan tribal fruit farm. He sees discrimination against workers there, including indecent treatment of women suspected of stealing fruit, and is angry that they are helpless against oppression.

Guan teaches at Pingtung's Hengchun Middle School. He meets his old friend Juan I-jong, and accompanies him to an interview. Seeing Juan use a camera, Guan thinks about using photography to depict rural life and his feelings about teaching in a small town.

Guan marries a young teacher surnamed Zhang at Hengchun Middle School.

**1975 – 1976**    Societal concern for Taiwan grows, and Guan enjoys folk music, such as Hengchun ballads or the campus folk song, "Sing Your Own Song." He finds it different from pop music or the official propaganda music of the New Life Movement.

Guan's son is born in 1976.

**1977**    Guan buys his first camera and learns basic darkroom techniques from Juan I-jong. He photographs an old man playing a Chinese fiddle at a Changhua street crossing. His first published work, it appears in Chang Chao-tang's *Notes on Life* (Jing Xiang Publishing).

**1978 – 1979**    In 1978, artist Chiang Hsun returns to Taiwan to become chief editor of *Lion Art*. The 95th issue of January, 1979 includes Guan's first published prose essay, "The Spinning Top," which describes the life of a middle school teacher.

Guan disagrees when his school transfers poor students from the college-bound class to the slow learner's class. He raises the matter at a teacher's meeting, not realizing it will anger the administration. Disappointed with the system, he resigns in 1979 and drives a taxi for a living.

Guan's daughter is born in 1979.

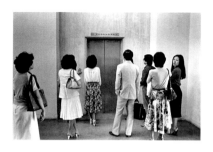

關曉榮上班前隨手拍攝等電梯的上班族，圖為當時天下雜誌所在的臺塑大樓 / 臺北 / 1981
A photo showing the Formosa Plastics Building, Taipei, location of *CommonWealth Magazine* offices
photo by Guan

**1980**

臺灣開始引進西方的攝影書籍。黃金鐘創立的大拇指出版社發行了國內第一套介紹國際名攝影家的專輯，收錄亨利・卡提耶－布列松（Henri Cartier-Bresson）、尤金・史密斯（W. Eugene Smith）、理察德・阿維頓（Richard Avedon）、安瑟・亞當斯（Ansel Adams）、愛德華・魏斯頓（Edward Weston）五位大師作品集。尤金・史密斯曾為了拍攝日本水俁的汞中毒事件，前後在當地住了四年多；他不當一個客觀的報導者，而是選擇與居民站在一起，還因此被資方派來的打手打傷——但這個系列作品發表後，成功引起全世界對公害的重視。尤金・史密斯的拍攝方式，深深影響關曉榮的報導實踐，也讓他意識到攝影與社會之間的關係，逐漸脫離知識分子對生活的單純感懷。

攝影家蘇俊郎於《婦女》雜誌發表文章，談到關曉榮的攝影，包括新竹三角公園中的客家老人及流浪者等作品。

**1981**

經作家黃春明與蘇俊郎推薦，關曉榮進入《天下雜誌》擔任專職攝影。

《天下雜誌》的影像呈現往往透過堂皇的辦公室、西裝革履的裝扮來突顯資本家的身分地位，和關曉榮關注民眾的美學信念有所衝突，因此離開《天下雜誌》。

關轉任《時報雜誌》，擔任文字編採與攝影工作。

**1983**

關曉榮於臺北爵士藝廊舉辦個人首次攝影展。照片內容有恆春半島的景象、臺北鐵工廠的工人、彰化的殘障學生、新竹公園的樂手、澎湖無人島的行訪以及華江橋下的豬販等。此次個展描繪了不同處境下的一群人，照片富含沉鬱與悵惘的氛圍。

參與雷驤製作的臺視電視節目，對基隆八尺門阿美族漁工的生存實況感到震驚，意識到原住民族的真實處境一直受到戰後「亞洲四小龍」榮景下的臺灣社會所遮蔽與漠視。

阮義忠於《中國時報》發表〈關曉榮的攝影之路是生活的片段，不是藝術的片段〉，提到關曉榮舉辦首次個展時的心聲：「希望能找一個個專題，好好地繼續拍下去。」似乎預告了未來的專題之路。

關曉榮首次攝影展邀請卡，圖為溪邊戲水的頑童，攝於苗栗獅潭鄉客家庄 / 1983
Guan Xiao-rong's first exhibition invitation card, showing a boy playing in the river at a Hakka Village in Shitan Township, Miaoli

**1980**   Western photography books find their way into Taiwan. Thumb Publishing, founded by Huang Jin-zhong, issues Taiwan's first books on Western photographers, including Henri Cartier-Bresson, W. Eugene Smith, Richard Avedon, Ansel Adams, and Edward Weston. Eugene Smith lived in Minamata, Japan, for four years to photograph its mercury poisoning incident. Instead of reporting objectively, he sided with the local people and was attacked by company-hired thugs, but his photos still aroused the world's concern about pollution. Smith's approach influences Guan's reporting, nurturing his growing awareness of the relationship between photography and society, and he gradually breaks away from the intellectual's aloof reflections on life.

Photographer Su Jun-lang mentions Guan Xiao-rong's work in *Women* magazine, including his photos of elderly Hakka people and vagrants in Hsinchu's Triangle Park.

**1981**   Recommended by writers Huang Chun-ming and Su Jun-lang, Guan joins *CommonWealth Magazine* as full-time photographer.

Images in *CommonWealth* often depict the social status of capitalists through their stately offices and suits and dresses. Guan Xiao-rong leaves *CommonWealth* since it conflicts with his ethos of concern for the general public.

Guan transfers to *China Times Magazine,* serving as text editor and photographer.

**1983**   Guan's first solo exhibition opens at Taipei's Jazz Image Gallery, with photos of the Hengchun Peninsula, Taipei steelworkers, disabled students in Changhua, musicians in Hsinchu Park, the uninhabited islands of Penghu, and hog dealers under the Huajiang Bridge. His depictions of people in different circumstances project a dismal and gloomy atmosphere.

Participating in a TTV program produced by Lei Xiang, Guan is shocked by the life of Amis fishermen in Keelung's Bachimen. He sees how Taiwan, one of Asia's "four little dragons," has ignored these indigenous people.

Juan I-jong writes a *China Times* essay, "Guan Xiao-rong's Photography — Pieces of Life, Not Art." A quote from Guan Xiao-rong at the time of his first solo exhibition indicates his future direction: "I hope to find a subject and continue to photograph well."

**1984**

關曉榮在工作過程意識到藝文報導的生態，如藝術家與雜誌的關係交攀、媒體充滿歌功頌揚的聲音等，讓他難以接受。此外，認為週刊的採訪節奏過於快速，無法長期深入地探討社會事件，因而離開《時報雜誌》，留職停薪。此時攝影風格從過往路上隨機的街拍，轉到跟被攝者有進一步關係的專題報導。

該年，土城海山煤礦、瑞芳煤山煤礦、三峽海山一坑煤礦等地接連發生礦災，原住民超過礦災總傷亡人數的一半，這成為關曉榮主要的問題意識——為什麼礦災犧牲的人大都是占臺灣人口少數的原住民？而接觸八尺門聚落所得知的原住民生活實況，也觸動了他年少時代對於勞動者受到不公平待遇時憤怒但走投無路的感受。

9月，赴基隆八尺門從事七個月的田野報告，探討阿美族漁業勞工之生活。在八尺門工作期間，閱讀俄國無政府主義者克魯泡特金（P. Kropotkin）《我的自傳》，這是他在戒嚴時期初步接觸到無政府主義的思想。

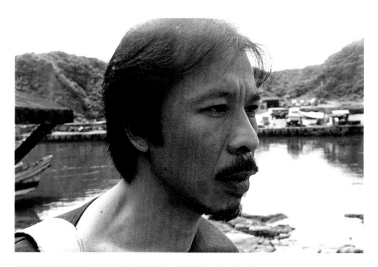

時報記者與美國記者至八尺門採訪關曉榮 / 蘇俊郎攝 / 1984-1985
China Times and American reporters interview Guan in Bachimen / photo by Su Jun-lang

1984   Guan dislikes the politics of arts reporting, including the way artists cultivate relations with magazines and the media's own gushing reports. He finds the weekly rhythm of interviews too fast for in-depth reporting, and takes a leave of absence from *China Times*. He switches from spontaneous street photography to special features and a closer relationship with his subjects.

This same year, three coal mine disasters occur in which indigenous people account for more than half of the casualties. Guan wonders why it is mostly Taiwan's minorities who sacrifice their lives; his awareness of indigenous people's living conditions at Bachimen village also reflects his earlier anger at the unfair treatment of laborers and their helplessness.

In September, Guan travels to Bachimen for extended reporting on Amis tribesmen laboring in the urban fishing industry.

While there, he reads *Memoirs of a Revolutionist*, the autobiography of Russian anarchist Kropotkin, his initial exposure to anarchist thought.

八尺門漁工出港前 / 關曉榮攝 / 1984
Fishermen preparing to leave Bachimen harbor / photo by Guan

**1985**

5月，關曉榮結束八尺門專題採訪，搬回臺北，著手沖洗照片，以及整理、編輯、寫作等工作。接觸《時代》（TIME）雜誌，進一步學習西方的報導攝影方法。

重回《時報》雜誌工作。

9月，於臺北美國文化中心舉辦「百分之二的希望與掙扎」個展。《中國時報》人間副刊於9月23、24日連載「2％的希望與掙扎——八尺門阿美族生活報告」上下兩篇。《人間》雜誌創辦人陳映真經朋友引介該展覽，故於雜誌創刊籌備期間，到訪關曉榮家中觀看並討論八尺門照片及專題報告。陳映真決定邀約關曉榮在《人間》雜誌發表〈八尺門專題〉。

11月，《人間》雜誌創刊號發行，封面選用關曉榮拍攝的阿美族青年高昌隆，成為《人間》現實主義的風格基底。以「人間封面報導」專欄收錄關曉榮「八尺門專題」，並刊登陳映真訪問關的報導工作紀錄。「關曉榮八尺門連作」專題共於《人間》連載五期：

第1期〈百分之二的希望與奮鬥〉（1985.11）；

第2期〈船東・海蟑螂和八尺門打漁的漢子們〉（1985.12）；

第3期〈老邱想哭的時候〉（1986.1）；

第4期〈失去了中指的阿春〉（1986.2）；

第5期〈都是人間的面貌〉（1986.3）。

1980年代中期，黃才郎於行政院文建會（今文化部）發起「百年臺灣攝影史料整理」工作，該計畫曾邀請關曉榮加入，但關想在臺灣實踐西方報導攝影的方法，並未參與，從而進行自己的專題計畫。

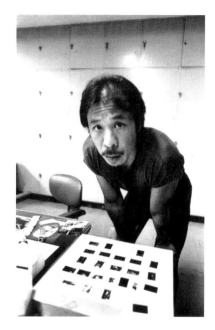

「八尺門攝影展」前，關曉榮正在看印樣照片
臺北大理街時報雜誌社辦公室 / 1985
Guan views a contact sheet prior to the "Bachimen" photo exhibition. / China Times Magazine offices, Dali Street, Taipei

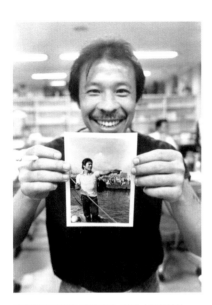

關曉榮展示拍攝阿春的照片 / 臺北人間雜誌社
1985
Guan holds a photo of Ah-Chun
*Ren Jian* magazine, Taipei

**1985**

In May, Guan concludes interviews at Bachimen and returns to Taipei for the writing and editing. He reads *Time* magazine to learn more about reportage photography in the West, then returns to work at *China Times*.

In September, Guan holds "The Hope and Struggle of the Two Percent" exhibition at the American Culture Center in Taipei. The *China Times* Literary Supplement runs a two-part essay, "The Hope and Struggle of the Two Percent — A Report on the Amis Tribespeople at Bachimen." Chen Ying-zhen, founder of *Ren Jian* magazine, visits Guan Xiao-rong at home to see his photos and discuss the Bachimen report; he invites Guan to publish a "Bachimen" feature in *Ren Jian*.

The first issue of *Ren Jian* in November, with a cover featuring Guan's photo of Amis youth Gao Chang-long, establishes the magazine's realistic style. The "Ren Jian Cover Report" column includes Guan Xiao-rong's "Bachimen" feature and Chen Ying-zhen's interview with Guan. "Guan Xiao-rong's Continuing Bachimen Feature" is published over five issues of *Ren Jian*:

Vol. 1, "The Hope and Struggle of the Two Percent" (November 1985);

Vol. 2, "Shipowners, Woodlice, and the Men Who Fish at Bachimen" (December 1985);

Vol. 3, "When Old Chiu Feels Like Crying" (January 1986);

Vol. 4, "Ah-Chun, Who Lost His Middle Finger" (February 1986);

Vol. 5, "All Are Faces of Humanity" (March 1986).

In the mid-1980s, Huang Tsai-lang invites photographic experts for a project "One Hundred Years of Taiwan Photographic History," at the Council for Cultural Affairs (now the Ministry of Culture). Guan is invited, but instead concentrates on developing Western-style reportage in Taiwan and his own feature stories.

1986　　　1月，《時報雜誌》在發行第320期後停刊，關曉榮轉任《時報新聞周刊》。

受淡江大學攝影社邀請，進行八尺門專題講座分享。

該年下旬，關預定進行蘭嶼專題計畫，執行動機源起於新北土城發生的一起原住民鬥毆事件。當年6月，蘭嶼青年蘇光明被砍殺兩刀致死；由於蘇家無法負擔龐大的費用，未能遵守達悟族亡者多得歸葬故鄉的傳統，蘇父迫於無奈只能遠渡臺灣，將兒子安葬於土城的荒郊墓地。關曉榮報導蘇光明事件期間，認識蘭嶼知識青年施努來（夏曼·藍波安），施不顧達悟族迴避喪事的禁忌，仍於妻子懷孕時協助蘇光明的喪事。從上述兩起事件，關曉榮感受蘭嶼青年在臺灣生存的不易，意識到他們缺乏資源的困境，以及不得不違背傳統習俗的無奈，因此投入「蘭嶼報告」的專題報導攝影工作。

為了不被官方說法所蒙蔽，企圖瞭解原住民弱勢的現況始末，關曉榮開始進行蘭嶼報告的前行研究，前往國立臺灣大學建築與城鄉研究所大量閱讀相關資料。

於淡江大學演講八尺門專題，學生拍攝的關曉榮
新北淡水 / 1986
A student's photo of Guan at his Tamkang University
lecture on Bachimen / Tamsui, New Taipei

1987　　　關曉榮離開《時報新聞周刊》，前往蘭嶼展開「蘭嶼報告」之文字與攝影工作。

7月15日，臺灣戒嚴時期結束，由時任中華民國總統蔣經國宣布解除戒嚴令。

10月10日，蘭嶼十人舟漁團成員首次入山，為取造船的龍骨揮出第一斧。關曉榮自清晨便與10位成員一同步行上路，開啟為期132日的造舟過程。

12月9日，蘭嶼開始反核廢料運動的第一次行動。機場抗議事件後，在地青年郭建平等舉辦反核廢運動說明會，讓族人認識到核能的可怖。身在蘭嶼的關曉榮參與其中，用相機記錄一幕幕的真實場景。

**1986**    In January, *China Times Magazine* ceases publication and Guan transfers to *Times News Weekly*.

Guan is invited by Tamkang University to lecture on Bachimen.

Late in the year, Guan plans to work on the Lanyu project, which grew out of a fight involving indigenous people in New Taipei City. In June, Su Guang-ming, a Lanyu youth, is stabbed and killed; his family can't afford to return his body for burial according to Tao tradition, and he is buried in a desolate cemetery in Tucheng, New Taipei City. In his reporting, Guan meets Shi Yulai, a young intellectual from Lanyu who, against Tao taboo, assists with Su Guang-ming's funeral during his wife's pregnancy. These incidents show Guan the difficulties Lanyu youths face in Taiwan, how they are often forced to violate their own traditions. He therefore throws himself into photography for the "Lanyu Report." He prepares by reading and attending classes at Taiwan University, so as to understand relevant circumstances without being influenced by official public statements.

**1987**    Guan leaves the *Times News Weekly*, then begins writing and photography for the "Lanyu Report."

President Chiang Ching-kuo announces martial law will be lifted on July 15.

On October 10, a tree is felled in the mountains for the keel of a ten-person boat. Guan Xiao-rong accompanies the men throughout their 132-day boat-building process.

On December 9, Lanyu holds its first anti-nuclear waste rally. Following protests at the airport, local youth Guo Jian-ping holds a briefing to inform local tribesmen of the dangers. Guan Xiao-rong takes part and photographs numerous scenes.

| 1988 | 2月18日，刻繪完成的十人舟，在儀式中下水。 |
|---|---|

2月20日，舊曆年假期間，許多青年返回蘭嶼，和族人一同集結成反核廢抗議隊伍，向蘭嶼核廢料貯存場前進。關曉榮鏡頭下青年領袖郭建平在驟雨中的宣言、長老們在貯存場內「驅逐惡靈」等畫面，展現族人堅毅對抗的精神。此後，關曉榮也持續追蹤蘭嶼反核事件。

結束蘭嶼專題報導的工作後，關曉榮搬回臺灣，整理「蘭嶼報告」之照片，並進入自立報系從事專題報告採訪工作。

9月，臺大攝影社與時報廣場合辦「臺大攝影社四十周年攝影展系列講座」，邀請關曉榮主講〈從八尺門到蘭嶼──談報導攝影〉。

解嚴後開放兩岸探親旅遊，關首次到中國四川成都，觀察當地社會現代化的階段性發展實況。

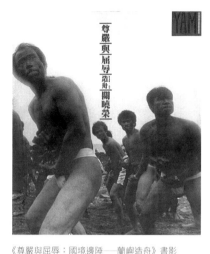

《尊嚴與屈辱：國境邊陲──蘭嶼造舟》書影
1991
Cover of *Dignity and Humiliation: At the National Frontier —Lanyu: Boat Building*

| 1987 – 1988 | 陸續在《人間》雜誌發表「關曉榮蘭嶼紀事系列」： |
|---|---|

第18期〈孤獨傲岸的礁岩──蘭嶼報告〉（1987.4）；

第19期〈飛魚祭的悲壯哀歌〉（1987.5）；

第20期〈文明，在仄窄的樊籠中潰決〉（1987.6）；

第21期〈塵埃下的薪傳餘燼〉（1987.7）；

第23期〈酷烈的壓榨，悲慘的世界〉（1987.9）；

第24期〈觀光暴行下的蘭嶼〉（1987.10）；

第26期〈一個蘭嶼能掩埋多少「國家機器」？〉（1987.12）；

第28期〈漢化主義下的蘭嶼教育〉（1988.2）；

第30期〈被現代醫療福祉遺棄的蘭嶼〉（1988.4）；

第33期〈流落都市的雅美勞工〉（1988.7）；

第36期〈十人舟下水儀典〉（1988.10）。

**1988**  On February 18, a launching ceremony is held for the completed carved boat.

On February 20, young people return to Lanyu for the lunar new year, join other villagers, and protest at the Lanyu nuclear waste storage site. Guan captures their determined resistance; youth leader Guo Jian-ping speaks in the rain while his elders "expel evil spirits." Guan later continues to follow Lanyu anti-nuclear events.

After finishing the Lanyu report, Guan moves back to Taiwan to sort through his photos, and conducts interviews for Independent Evening Post feature stories.

In September, the National Taiwan University Photo Club organizes a lecture series for its 40th anniversary. Guan Xiao-rong gives lecture, "Reportage Photography — From Bachimen to Lanyu."

When martial law ends, Taiwanese can visit relatives in China. Guan travels to Chengdu to better understand their social modernization and rural poverty.

**1987**
 |
**1988**
The "Guan Xiao-rong Lanyu Chronicle Series" is published in *Ren Jian*:

Vol. 18, "The Proud and Lonely Reefs — Lanyu Report" (April 1987);

Vol. 19, "Elegy for the Flying Fish Festival" (May 1987);

Vol. 20 "Civilization Collapses in a Narrow Cell" (June 1987);

Vol. 21, "Dying Embers Under the Dust" (July 1987);

Vol. 23, "Brutal Exploitation, Tragic World" (September 1987);

Vol. 24, "Lanyu and the Atrocities of Sightseeing" (October 1987);

Vol. 26, "How Many 'State Apparatuses' Can an Island Bury?" (December 1987);

Vol. 28, "Sinicization and Lanyu Education" (February 1988);

Vol. 30, "Lanyu Abandoned by Modern Medical Welfare" (April 1988);

Vol. 33, "Yami Workers Stranded in the City" (July 1988);

Vol. 36, "The Ten-Man Boat-Launch Ceremony" (October 1988).

**1989**  Guan leaves the Independent Evening Post.

Economic pressures force *Ren Jian* to cease publication after its 47th issue.

| 1989 | 關曉榮從自立報系離職。 |
|---|---|
| | 出版47期的《人間》雜誌,因不敵現實的經濟壓力而停刊。 |
| 1990 | 關曉榮重回自立報系。年底,因故離職。 |
| | 基隆市政府在八尺門原址擬定「海濱國宅」興建方案。 |
| 1991 | 2月20日,蘭嶼反核廢料抗議隊伍再次出動,向自行政院原子能委員會手中接管「蘭嶼核廢料貯存場」的台電公司抗議。 |

| 1991 — 1994 | 時報文化出版關曉榮蘭嶼專題叢書: |
|---|---|
| | 1991年,《尊嚴與屈辱:國境邊陲——蘭嶼造舟》; |
| | 1992年,《尊嚴與屈辱:國境邊陲——蘭嶼主屋重建、飛魚招魚祭、老輩夫婦的傳統日作息》; |
| | 1994年,《尊嚴與屈辱:國境邊陲——蘭嶼1987》。 |
| | 依序探討蘭嶼十人舟的榮耀、主屋重建、飛魚招魚祭、老輩夫婦的傳統作息、漢化教育、戰後的青年勞工、觀光暴行、現代的醫療衛生、反抗核能廢料等11個主題。關曉榮將一半的版稅捐出,歸屬致力於達悟族反核廢料運動的組織。 |
| 1993 | 時報文化出版《女兒的胞衣》散文集,內容集結關曉榮從1979年起創作刊登於《雄獅美術》、《聯合文學》、《中時晚報》、《中國時報》與《民眾日報》副刊等之散文創作。 |
| | 八尺門聚落發生一場無名大火,焚毀多處住房後全面拆除,不留痕跡。 |
| 1995 | 國民大會通過修憲,正式以「原住民」取代「山胞」的稱呼。 |
| | 在藍博洲的文字報導專書《幌馬車之歌》的影響下,侯孝賢執導電影《好男好女》,但認為僅以這部劇情片仍不足以面對白色恐怖的歷史,便找關曉榮拍攝《我們為什麼不歌唱》史實紀錄片。該片曾受邀於「臺灣紀錄片雙年展」播映。 |

《尊嚴與屈辱：國境邊陲——蘭嶼 1987》書影 / 1991
Cover of *Dignity and Humiliation: At the National Frontier —Lanyu 1987*

1990　Guan returns to the Independent Evening Post, but leaves at year's end.

The Keelung City Government plans "seaside public housing" at the former Bachimen site.

1991　On February 20, Lanyu people protest against the Taiwan Power Company, which took over the nuclear waste storage site from Taiwan's Atomic Energy Commission.

1991
|
1994

Guan Xiao-rong's series of books on Lanyu are published by China Times Publishing:

In 1991, *Dignity and Humiliation: At the National Frontier —Lanyu Boat Building*;

In 1992, *Dignity and Humiliation: At the National Frontier — Rebuilding the Main House on Lanyu, the Flying Fish Festival, Traditional Work and Lifestyle of a Senior Couple*;

In 1994, *Dignity and Humiliation: At the National Frontier —Lanyu 1987*.

The series explores nine themes, including the ten-person boat, traditional house rebuilding, the "Flying Fish Festival," the traditional lifestyle of a senior couple, Sinicized education, post-war youth labor, tourist atrocities, modern medicine, and nuclear waste protest. Guan Xiao-rong donates half of the royalties to the Tao tribe's anti-nuclear waste campaign.

1993　China Times Publishing issues Guan's prose collection *Daughter's Afterbirth*, bringing together writings published since 1979 in the supplements of Lion Art, the UNITAS literary monthly, the *China Times Express, China Times*, and *The Commons Daily*.

An unexplained fire breaks out in Bachimen, burning and destroying a number of houses.

1995　The National Assembly amends the Constitution, changing "mountain compatriots" to "indigenous peoples."

Hou Hsiao-Hsien directs the movie *Good Boy, Good Girl,* influenced by Lan Bo-Chow's book *Song of the Covered Wagon*. Believing it does not sufficiently convey the White Terror, Hou invites Guan Xiao-rong to film *Why We Don't Sing,* which is later shown at the Taiwan Documentary Film Biennial.

1996　關曉榮重回基隆八尺門。原地已改建為「海濱國宅」，共190戶五層樓房，其中110戶為原八尺門住戶，阿春一家人住在其中一戶。

關依據11年前蹲點工作留下的生活筆記，與重新整理、挑選、編輯的照片，集結成《八尺門手札》，由臺原出版社出版。作品以「環境」、「村民生活」、「人物」（阿春與邱松茂的個別專題）形成主題系列。

台電運送核廢料的船隻，被十餘年反核廢運動所凝聚的力量阻擋在小蘭嶼海域，無法進港後，原船返回臺灣，核廢料運儲蘭嶼的作業被迫停止。

1997　關曉榮執導紀錄片《國境邊陲：1997島嶼上的人類》，由侯孝賢電影社出資製作。侯孝賢支持該作是因為他認為用文字以外的自然影像拍攝法，才能讓該議題的知識拼圖更齊全。

1998　關擔任國立臺南藝術大學音像紀錄與影像維護研究所教授（1998-2012）。

2001　關擔任921大地震後成立的原住民族部落工作隊機關刊物《原住民族》月刊主編（2001-2003）。

蘭嶼鄉公所原住民族山地保留地「土地審查委員會」決定不續租「蘭嶼放射廢料儲存場」給台灣電力公司。

8月，台電將蘭嶼儲放核廢料的補償金撥交蘭嶼鄉公所，發放給每一位蘭嶼達悟族人。

2002　5月，台電遷廠跳票，蘭嶼人發起全島反核大遊行。經濟部與蘭嶼反核自救會達成協議，承諾將成立「遷廠推動委員會」。

12月24日《中國時報》頭版新聞刊登行政院公告：核能廢料終極處理場址排除蘭嶼。

重訪八尺門，從和平島上看望改觀後的地景
關曉榮攝 / 1996
A changed landscape on Guan's return to Bachimen,
seen from Heping Island / photo by Guan

**1996**　Guan returns to Bachimen; the original site has become "seaside public housing." Five-story buildings there hold a total of 190 households, including 110 Bachimen families, among them Ah-Chun's family.

Based on notes from his field work 11 years earlier and a new selection of photos, Guan writes *Letters from Bachimen*, issued by Taiuan Publishing. It focuses on the environment, village life, and individual life stories (with special features on Ah-Chun and Chiu Sung-mao).

A Taiwan Power Co. ship carrying nuclear waste is blocked by the protest movement near Lesser Lanyu. The ship returns to Taiwan, and nuclear waste storage in Lanyu is halted.

**1997**　Guan directs the documentary, *At the National Frontier: Humans on an Island in 1997*, funded by Hou Hsiao-hsien. Hou believes images provide a more complete picture than words alone.

**1998**　Guan teaches at the Tainan National University of the Arts' Graduate Institute of Studies in Documentary and Film Archiving (until 2012).

**2001**　Guan is chief editor (until 2003) of the Indigenous Peoples Tribal Task Force monthly journal, established after the September 21, 1999 earthquake.

An indigenous people's land review by Lanyu Township refuses to renew Taiwan Power Company's lease for the radioactive waste storage site.

In August, Taiwan Power Company gives compensation for nuclear waste storage to the Lanyu Township Office, for distribution to the Tao tribe.

**2002**　Taiwan Power Company fails to move its storage site, sparking island-wide protest. Taiwan's MOEA and Lanyu's Anti-Nuclear Self-Help Association reach an agreement on a "Relocation Action Committee."

On December 24, China Times announces the Executive Yuan decision to exclude Lanyu as a nuclear storage site.

<table>
<tr><td>2004</td><td>侯孝賢電影社出品、人間學社發行關曉榮拍攝的紀錄片《我們為什麼不歌唱》。</td></tr>
</table>

2004　侯孝賢電影社出品、人間學社發行關曉榮拍攝的紀錄片《我們為什麼不歌唱》。

臺北市立美術館典藏關曉榮「蘭嶼雅美族十人舟造舟工藝與社會組織系列」十二件。

國立臺灣美術館典藏作品〈製舟前上山取材〉、〈雨中扛米的八尺門男子〉。

2006　關曉榮回到蘭嶼於「夏潮報導文藝營」播放紀錄片《國境邊陲：1997島嶼上的人類》。該作藉由達悟族人的處境，直揭資本主義商品體制下環環相扣的問題——達悟人世居的蘭嶼家鄉成了核廢料的儲存場；整個族人居於臺灣的政治、經濟、文化弱勢；年輕族人為了謀生、被迫流離於異鄉臺灣；飛魚文化的泯喪——與全球化潮流下第三世界國家淪為強權國家掠奪性政策的輸入國，是同時發生的。

由張正霖策展之「人間雜誌回顧展」於臺中東海大學藝術中心舉行。

2007　蘭嶼達悟族反核廢料運動進入第二十年；人間出版社發行《蘭嶼報告1987-2007》。

人間學社發行《國境邊陲：1997島嶼上的人類》紀錄片，並於光點臺北之家放映。

2010　任職於「基隆市原住民會館」的阿美族青年董安妮讀到《八尺門手札》，有感於八尺門報告的歷史意義，初次與關曉榮聯繫。

2011　董安妮再次聯繫關曉榮，啟動「八尺門原住民生活攝影特展」計畫。

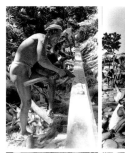
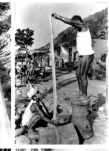

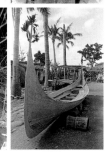
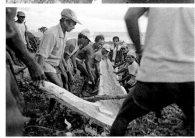

北美館典藏的《蘭嶼報告——造舟》系列作品
Photos from the *Lanyu Report: Boat-Building* series in the Taipei Fine Arts Museum collection

2004　*Why We Don't Sing*, produced by Hou Hsiao-hsien, is released by the Ren Jian Society.

Taipei Fine Arts Museum acquires 12 photos from Guan's "Lanyu Tao Tribe Ten-Man Boat Building and Social Organization" series.

National Taiwan Museum of Fine Arts acquires "Felling Boat Timbers in the Mountains" and "Bachimen Men Carrying Rice in the Rain."

2006　Guan shows his film "At the National Frontier: Humans on an Island in 1997," at the China Tide Association Reportage Arts Camp on Lanyu. It reveals the problems of capitalism for the Tao people: how their home became a nuclear waste site; how the tribe is disadvantaged in Taiwan's politics, economics, and culture; how its young people had to move to Taiwan to make a living; how it lost its flying fish culture; and how predatory policies of powerful countries are imported into the third world.

A "Ren Jian Magazine Retrospective Exhibition" is held at Tunghai University.

2007　The Tao's anti-nuclear waste movement enters its 20th year; Ren Jian Public Publishing publishes *Lanyu Report 1987—2007*.

The Ren Jian Association releases *At the National Frontier: Humans on an Island in 1997*, showing it at the SPOT Taipei Film House.

2010　Dong An-ni, an Amis youth at Keelung's Indigenous Cultural Hall, reads *Letters from Bachimen*, and understanding its historical meaning, contacts Guan Xiao-rong.

2011　Dong An-ni again contacts Guan to initiate the "Photo Exhibition of Indigenous People's Life in Bachimen."

《蘭嶼報告 1987-2007》書影 / 2007
Cover of *Lanyu Report 1987 – 2007*

阿春斷指住院，出院後立即至基隆原住民文化會館「八尺門專題展」看 27 年前的照片 / 關曉榮攝 / 2012
Ah-Chun views photos from 27 years earlier at Keelung City Indigenous Cultural Hall, after leaving the hospital due to another hand injury

**2012**　基隆市政府與基隆市原住民文化會館合辦「八尺門原住民生活攝影特展」，展出關曉榮自1984年起拍攝的「八尺門專題」系列作品。關曉榮於該展見到54歲的阿春；當年，阿春再次因為工傷斷指住院，不過出院後還是立即前往會館看展。而關曉榮也在此展拍攝許多八尺門居民觀看過去照片的身影，照片收錄在2013年出版的《八尺門：再現2％的希望與奮鬥》。

蘭嶼居民發起第四次於核廢料貯存場前的「驅逐惡靈」行動。

**2013**　在臺灣政黨輪替、民進黨上台執政之際，做為「轉型正義」的政策環節，當局規劃籌備成立國家人權博物館，並投入大量資源於口述歷史工作，留下紀錄文字。關曉榮從政治受難人互助會處得知，這些歷史調查在結案歸檔時，很多敏感內容仍遭篡改壓制；因而在互助會的期待下，義不容辭接受國家人權博物館籌備處委託，參與政治受難人影像紀錄專輯拍攝案系列：1950年代政治受難人（陳水泉、陳棠黎、黃至超、蔡再修）四人計畫案。

7月，南方家園出版《八尺門：再現2％的希望與奮鬥》。

「再現2％的希望與奮鬥──關曉榮攝影巡迴展」於烏來泰雅民族博物館（7/18-9/8）、臺北紫藤廬（8/10-8/25）、新竹縣縣史館（9/13-10/6）、新北中和國立臺灣圖書館（10/8-10/27）、國立清華大學（11/5-11/24）等地展出。

「再現 2%的希望與奮鬥——關曉榮攝影巡迴展」
書卡資訊
Bookmark info on "Return to the Hope and Struggle
of the Two Percent—A Guan Xiao-rong Touring
Photo Exhibition"

**2012** Based on Guan's photography for his "Bachimen features" since 1984, Keelung City and its Indigenous Cultural Hall organize the "Bachimen Indigenous People's Life Special Photography Exhibition" at the Indigenous Cultural Hall. Guan Xiao-rong sees 54-year-old A-chun, who visits the exhibition despite having just been hospitalized for yet another hand injury. Guan Xiao-rong photographs Bachimen residents looking at their past photos in the exhibition. Those photos are included in "Bachimen: Return to the Hope and Struggle of the Two Percent," published in 2013.

Lanyu islanders stage the fourth "Expulsion of Evil Spirits" at the waste storage site.

**2013** A new political party takes power, and the Democratic Progressive Party plans a National Human Rights Museum as part of their "transitional justice" policy. It invests in creating a written archive of oral histories. Guan Xiao-rong learns from the Association for Political Victims Mutual Aid that previous historical records have been tampered with; responding to the Association, he feels obligated to assist the Preparatory Office of the National Museum of Human Rights in making video records of four political victims from the 1950s (Chen Shui-chuan, Chen Tang-li, Huang Chih-chao, and Tsai Tsai-hsiu).

In July, Homeward Publishing releases *Bachimen: Return to the Hope and Struggle of the Two Percent.*

"Return to the Hope and Struggle of the Two Percent—A Guan Xiao-rong Touring Photo Exhibition" appears at the Wulai Atayal Museum, Wistaria Tea House in Taipei, Hsinchu County Archive, the National Taiwan Library in Zhonghe, and National Tsing Hua University in Hsinchu.

**2014**
「再現2%的希望與奮鬥──關曉榮攝影巡迴展」至桃園縣政府文化局展出（2/19-3/16）。

文化部主辦圖書大獎金鼎獎頒獎典禮，關曉榮以《八尺門：再現2%的希望與奮鬥》獲得非文學圖書獎。「八尺門」三個大字的筆劃，源自《尊嚴與屈辱：國境邊陲──蘭嶼1987》中，一幅拍攝蘭嶼民宅屋前貼有「死囚」字樣的影像。

國家人權博物館籌備處（今國家人權博物館景美園區）發行由關曉榮拍攝的《冰與血》紀錄片。

小孫子出世，新生命的誕生帶給關曉榮許多提醒、啟發與歡喜。

**2016**
「原住民族歷史正義與轉型正義委員會」成立。

《人間》雜誌創辦人陳映真過世。關曉榮以〈嚴厲的鞭子與腳前的提燈──永誌不忘陳映真〉為題撰文悼念陳映真，收錄於2017年遠景出版的《遠行的左翼戰士：悼念陳映真文集》。

**2017**
國立臺灣博物館典藏關曉榮《八尺門》系列三十件、《蘭嶼造舟》系列三十五件。

關曉榮參與國立臺灣美術館「危觀風景─原住民族文化與空間部署」特展。

國美館典藏《蘭嶼報告──反抗核能廢料》系列。

**2019**
關曉榮籌劃建立「人間學社」網站，架設完成前，暫時使用臉書粉絲專頁，公開曾拍攝的影片、圖片、書寫文字等資料，希望喚起大眾對公共議題的關注。

計畫重回蘭嶼，展開「蘭嶼報告」三十餘年後的訪查紀錄。預期以影像筆記探討蘭嶼老中青三代在社會變遷中的生命史。

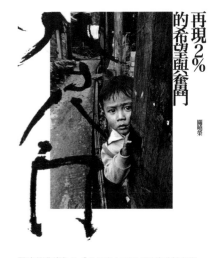

關曉榮獲獎作品《八尺門：再現 2%的希望與奮鬥》書影 / 2014
Cover of Guan's prize-winning book, *Bachimen: Return to the Hope and Struggle of the Two Percent*

「人間學社」粉絲專頁 / 2020.7.23
Fan page for the Ren Jian Association

**2014**   "Return to the Hope and Struggle of the Two Percent—A Guan Xiao-rong Touring Photo Exhibition" appears at the Taoyuan County Government Cultural Affairs Bureau.

Guan Xiao-rong wins a Ministry of Culture non-fiction book award for *Bachimen: Return to the Hope and Struggle of the Two Percent*. The Chinese words "ba" "chi" "men" on the cover are from Guan's photo of the "condemned man" slogan painted on a Lanyu house in *Dignity and Humiliation: At the National Frontier — Lanyu 1987*.

The National Museum of Human Rights Preparatory Office releases Guan's documentary *Ice and Snow*.

Guan begins to care for his newborn grandson, who brings him inspiration and joy.

**2016**   The Indigenous Historical Justice and Transitional Justice Committee is established.

Chen Ying-zhen, *Ren Jian's* founder, passes away. Guan pens "A Stern Whip and a Guiding Light—the Unforgettable Chen Ying-zhen" as memorial. The essay appears in *The Expedition of the Left-Wing Soldier: Mourning Chen Ying-zhen*, in 2017.

**2017**   The National Taiwan Museum acquires 30 works from Guan's *Bachimen* series and 35 from his *Lanyu Boat-Building* series.

Guan participates in the National Taiwan Museum of Fine Arts' "Landscape of Crisis: Indigenous Cultures and Dispositif of Modern Space."

The National Taiwan Museum of Fine Arts acquires the *Lanyu Report—Resisting Nuclear Waste* series.

**2019**   Guan plans to establish a Ren Jian Association website. Prior to completion, he uses a Facebook fan page to publish videos, photos, text and other materials, hoping to raise awareness about public issues.

Guan plans to return to Lanyu for a new "Lanyu Report" 30 years on, to explore in photos the effects of social change on three generations in Lanyu.

# 關曉榮簡歷

1949 年出生於海南島，中國
現居住於新北新店，臺灣

## 個展

2013-2014 「再現 2％的希望與奮鬥—關曉榮攝影巡迴展」，烏來泰雅民族博物館、臺北紫藤廬、
新竹縣縣史館、國立臺灣圖書館、國立清華大學、桃園縣政府文化局，臺灣

2012 「八尺門原住民生活攝影特展」，基隆市原住民文化會館，基隆，臺灣

1985 「百分之二的希望與掙扎」個展，臺北美國文化中心，臺灣

1983 「關曉榮攝影展」，爵士藝廊，臺北，臺灣

## 聯展

2017 「危觀風景—原住民族文化與空間部署」特展，國立臺灣美術館，臺中，臺灣

2006 「人間雜誌回顧展」，東海大學藝術中心，臺中，臺灣

## 作品典藏

2017 《蘭嶼反核》系列兩件，國立臺灣美術館，臺中，臺灣

2017 《八尺門》系列三十件、《蘭嶼造舟》三十五件，國立臺灣博物館，臺北，臺灣

2004 《蘭嶼造舟》系列十二件，臺北市立美術館，臺北，臺灣

2004 〈製舟前上山取材〉、〈雨中扛米的八尺門男子〉，國立臺灣美術館，臺中，臺灣

## 重要著作

2013 《八尺門：再現 2％的希望與奮鬥》

2007 《蘭嶼報告 1987-2007》

1996 《八尺門手札》

1994 《尊嚴與屈辱：國境邊陲——蘭嶼 1987》

1993 《女兒的胞衣》

1992 《尊嚴與屈辱：國境邊陲——蘭嶼主屋重建、飛魚招魚祭、老輩夫婦的傳統日作息》

1991 《尊嚴與屈辱：國境邊陲——蘭嶼造舟》

## 紀錄片

2014 《冰與血》

2007 《國境邊陲：1997 島嶼上的人類》

2004 《我們為什麼不歌唱》（拍攝於 1995 年）

# Guan Xiao-rong

Born in 1949 in Hainan Island, China
Living in Xindian, New Taipei, Taiwan

## Solo Exhibitions

| | |
|---|---|
| 2013-2014 | "Return to the Hope and Struggle of the Two Percent—A Guan Xiao-rong Touring Photo Exhibition," Wulai Atayal Museum, Wistaria Tea House in Taipei, the Institute of Hsinchu County History, National Taiwan Library in Zhonghe, National Tsinghua University in Hsinchu, Taoyuan County Government Cultural Affairs Bureau, Taiwan |
| 2012 | "Bachimen Indigenous People's Life Special Photography Exhibition", Indigenous Cultural Hall, Keelung, Taiwan |
| 1985 | "The Hope and Struggle of the Two Percent" solo exhibition, American Culture Center, Taipei, Taiwan |
| 1983 | Guan Xiao-rong solo photo exhibition, Jazz Gallery, Taipei, Taiwan |

## Group Exhibitions

| | |
|---|---|
| 2017 | "Landscape of Crisis: Indigenous Cultures and Dispositif of Modern Space," National Taiwan Museum of Fine Arts, Taichung, Taiwan |
| 2016 | "Ren Jian Magazine Retrospective Exhibition," Tunghai University Art Gallery, Taichung, Taiwan |

## Public Collections

National Taiwan Museum of Fine Arts, Taichung, Taiwan

National Taiwan Museum, Taipei, Taiwan

Taipei Museum of Fine Arts, Taiwan

## Books

| | |
|---|---|
| 2013 | Bachimen: Return to the Hope and Struggle of the Two Percent |
| 2007 | Lanyu Report 1987-2007 |
| 1996 | Letters from Bachimen |
| 1994 | Dignity and Humiliation: At the National Frontier —Lanyu 1987 |
| 1993 | Daughter's Afterbirth |
| 1992 | Dignity and Humiliation: At the National Frontier —Rebuilding the Main House on Lanyu, the Flying Fish Festival, Traditional Work and Lifestyle of a Senior Couple |
| 1991 | Dignity and Humiliation: At the National Frontier —Lanyu Boat Building |

## Documentary

| | |
|---|---|
| 2014 | Ice and Blood |
| 2007 | At the National Frontier: Humans on an Island in 1997 |
| 2004 | Why We Don't Sing |

散文《女兒的胞衣》章名頁
時報出版 / 1993
Chapter title page from Guan's book,
*Daughter's Afterbirth*
(China Times publishing)
P.45

散文《女兒的胞衣》內頁 30-31
Pages 30-31 of Guan's book,
"Daughter's Afterbirth"
P.45

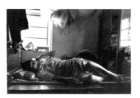

關曉榮的阿公
屏東恆春 / 1979
Guan Xiao-rong's Grandfather
Hengchun, Pingtung
P.46

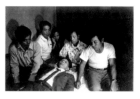

關曉榮岳父（右）與彌留的阿公
屏東恆春 / 1979
Guan's father-in-law (right) with his
dying grandfather
Hengchun, Pingtung
P.47

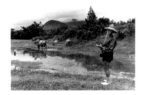

恆春古城東門外崩塌的城垣
屏東 / 1978-1979
Collapsed city wall outside the East
Gate Hengchun, Pingtung
P.48

恆春核三廠建廠用地外
屏東 / 1978-1979
Outside the Maanshan Nuclear Power
Plant building site
Hengchun, Pingtung
P.49

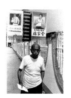

臺北南京東路 / 1981-1982
Nanjing E. Rd., Taipei
P.50

昔日麥克阿瑟公路南松山路橋下
臺北南京東路四段 / 1981
Beneath the South Songshan Bridge
on the former MacArthur Thruway
Sec.4, Nanjing E. Rd., Taipei
P.51

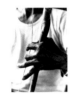

《早期攝影》街頭演奏者
彰化 / 1983
*Early Photographic Works*,
A street musician / Changhua
P.52

魯凱族豐年祭及運動會
屏東霧台 / 1983
A Rukai Tribe bamboo swing
competition / Wutai, Pingtung
P.53

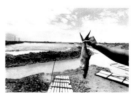

九三大水災後的魚塭
臺南 / 1981
A fish pond after
the great flood, Tainan
P.54

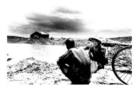

九三大水災後的魚塭
臺南 / 1981
A fish pond after
the great flood, Tainan
P.55

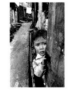

《八尺門》母親外出交代看家的男孩
1984
*Bachimen*, A little boy looks after the
home while mother is away
P.57

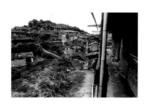

兩座小山向東的一個山坡頂最高的住戶
1984
The highest residence on the eastern-
facing slopes of two hills
P.58-59

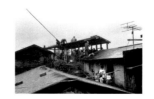

阿美族人在移居地求生存保留了傳統
助工、換工的社會凝聚力
1984
Amis tribe members in a new
settlement retain social cohesion,
helping and exchanging labor
P.60-61

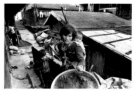

丈夫出海未歸的婦女
1984
A wife waits for her husband at sea
P.62-63

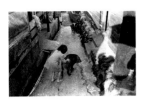

被捕獲帶回飼養的小山豬
1984
A small boar captured to be raised
at home
P.64-65

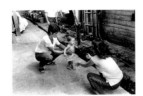

剛學走路的孩子
1984
A child taking his first steps
P.66

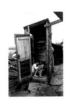

哨所般的小公廁
1984
A watchhouse-style public toilet
P.67

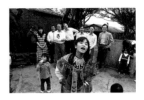

國外參訪者到來，學童從學校被叫回來
跳迎賓舞。中央為領唱的女孩李惠美
1984
Children called out from school sing a
greeting song for a foreigner. At center is
lead singer Lee Hui-mei
P.68

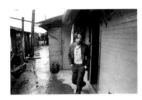

往朋友家借錢未果的青年
1984
A youth after failing to get a loan
from a friend
P.69

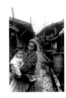

年輕的母與子
1984
A young mother and child
P.70

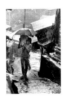

林明發扛著故鄉臺東的米袋
1984
Lin Ming-fa carries a bag of rice
from his hometown of Taitung
P.71

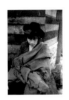

高昌隆，1985 年《人間》
雜誌封面人物
1984
Gao Chang-long, cover photo subject
for 1985 Ren Jian magazine
P.72

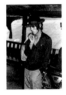

阿杉出海前
1984
Ah-Shan before going to sea
P.73

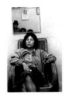

照顧弟弟、同時育養
三個小孩的阿杉大姊
1984
Eldest sister of Ah-Shan, caring for her
younger brother while raising three
children
P.74

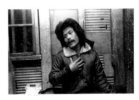

來找邱松茂的朋友向關曉榮吐露心事
1984
A friend, coming to see Chiu Sung-
mao, shares his troubles with Guan
Xiao-rong
P.75

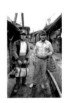

阿春與父親出港前在家門口
1984
Ah-Chun and his father at the door of
their home before heading
to the harbor
P.76

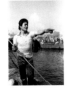

這一趟出海，阿春擔任大副
1984
On this trip, Ah-Chun is first mate
P.77

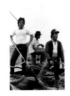

阿春、阿杉與馬各
1984
Ah-Chun, Ah-Shan and Ma Ge
P.78

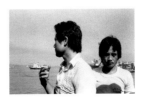

阿春（左）與馬各即將出港
1984
Ah-Chun (left) and Ma Ge about
to leave the harbor
P.79

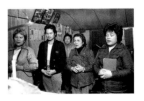

斷指歸來後，阿春母親與教友
在家裡禱告
1984
After Ah-Chun loses his finger, his
mother prays at home with
church members
P.80-81

阿春在作業中被繩索絞斷中指
1984
Ah-Chun loses his middle finger,
catching it in a rope while working
P.82

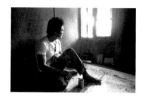

受傷斷指前，在關曉榮房裡的阿春
1984
Ah-Chun in Guan Xiao-rong's room
before his injury
P.83

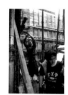

八尺門的阿美族漁工都已下船，
在建築工地做板模工
1996
The Amis fishermen of Bachimen,
no longer on their boats, now work
setting construction forms
P.84

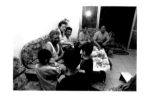

阿春已婚，有了兩個兒子，
一家人在國宅
1996
Ah-Chun, married with two sons, and
family in their apartment
P.85

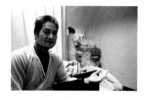

阿春工傷斷指出院前
基隆長庚醫院 / 2011
Ah-Chun prior to leaving hospital after
second hand injury / Keelung Chang
Gung Memorial Hospital
P.86

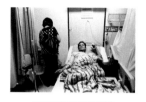

阿春工傷斷指出院前
基隆長庚醫院 / 2011
Ah-Chun prior to leaving hospital after
second hand injury / Keelung Chang
Gung Memorial Hospital
P.87

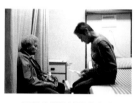

母親來醫院接阿春出院
基隆長庚醫院 / 2011
Ah-Chun's mother comes to take him
home from the hospital / Keelung
Chang Gung Memorial Hospital
P.88-89

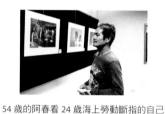

54 歲的阿春看 24 歲海上勞動斷指的自己
基隆原住民會館 / 2011
54-year old Ah-Chun, after losing a finger
at sea, gazes at his 24-year-old self
Keelung Indigenous Cultural Hall
P.90-91

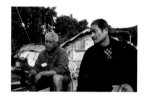

剛收到喜帖的邱顯德（左）與阿春
2011
Chiu Xian-de (left), with Ah-Chun, has
just received a wedding invitation
P.92

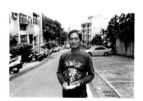

不作態不迴避不言語的賴福春
2011
Lai Fu-chun (Ah-Chun) – direct,
unaffected, quiet
P.93

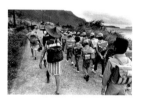

《蘭嶼報告─反核》清晨前往田園工
作的婦女與上學的孩童
1987
Lanyu Report: Anti-nuclear, Women
leaving for the fields and children
going to school early in the morning
P.95

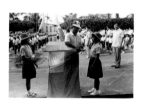

國旗下的漢化學校教育
1987
Sinicized education at school under
the Republic of China (ROC) flag
P.96

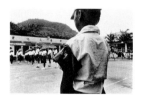

紅頭國小校園裡的糾察隊
1987
Hongtou Elementary School class
monitor
P.97

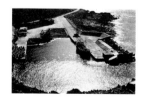

蘭嶼的核電廢料卸運碼頭
1987
Lanyu nuclear waste unloading dock
P.98

在蘭嶼龍門碼頭裝卸的核電廢料
1987
Unloading nuclear waste at Longmen
Wharf, Lanyu
P.99

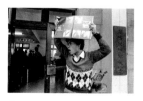

蘭嶼反核行動「機場抗議事件」
1987
"Airport protest event" during Lanyu
anti-nuclear campaign
P.100

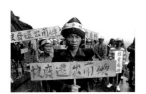

反核廢料抗議隊伍集結
1988
The anti-nuclear protest group gathers
P.101

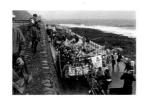

反核隊伍行經「蘭嶼核廢料貯存場」圍牆外
1991
Anti-nuclear protesters march around
perimeter wall of the Lanyu Nuclear Waste
Storage Site
P102-103

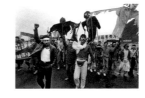

遊行隊伍進入核廢料貯存場
1988
Marching protesters enter the nuclear
waste storage site
P.104

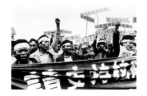

核廢料滾出蘭嶼
1988
"Nuclear waste out of Orchid Island!"
P105

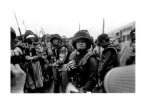

「驅逐惡靈」的長老們
1991
Elders "expelling evil spirits"
P.106

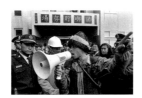

核廢料貯存場轉給台電後，抗議行動
中的郭建平
1991
Kuo Jian-ping during protest
movement, after nuclear waste site is
turned over to Taiwan Power Company
P.107

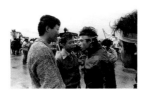

反核廢料運動青年領袖郭建平質問
核廢料貯存場場長
1988
Young protest leader Kuo Jian-ping
confronts head of nuclear waste
storage site
P.108-109

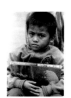

剛進入國小一年級的達悟男孩農農，
在「機場抗議事件」現場
1987
Nong-nong, Tao tribe boy just entering
first grade, at the airport
"protest event"
P.111

《蘭嶼報告—造舟》
漁人部落造舟出發前的清晨
1987
The Lanyu Report: Boat Building,
Early morning, before the fishing tribe
sets out to build a boat
P.112-113

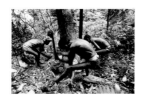

利用熱帶雨林樹木的板根，取製龍骨
彎曲部分的材料
1987
Taking the lateral buttress root of a
tropical rainforest tree to make the
curved keel of the boat
P.114

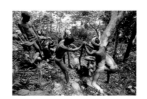

樹木連根挖起
1987
Tree and root are dug out together
P.115

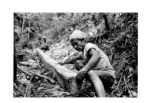

龍骨中段直幹的製材工作
1987
Cutting the straight plank for the keel
P.116

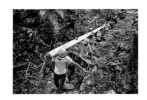

扛運沉重的龍骨中段直幹
1987
Carrying the heavy straight plank for
the keel
P.117

造舟是民族智慧和藝能的傳承積累，
也是生產工具製作的團結勞動
1987
Boat-building requires both
knowledge and energy
P.118

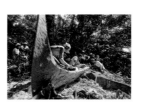

助工族人展現技能與體力
1987
Workers demonstrate skill and strength
P.119

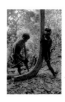

伐木現場完成曲狀龍骨結構
1987
Completing the curved keel plank at
the logging site
P.120

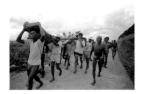

薄暮時分搬運船板下山
1987
Keel planks come down the mountain
at sunset
P.121

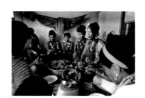

漁團成員的妻子們祈禱神祇庇佑
1987-1988
Wives of the fishing expedition pray to
the gods for divine protection
P.122-123

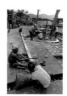

在龍骨中段直幹兩端鋸出凹槽
1987-1988
Notching the ends of the straight
keel piece
P.124

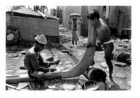

在龍骨的結合處打鑿榫洞
1987-1988
Chiseling a mortise where the keel
sections meet
P.125

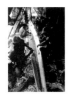

緊接龍骨的第一層船板完成接合
1987-1988
The first set of hull plates being
attached to the keel
P.126

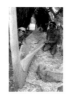

第二層船板結合前的修整
1987-1988
Preparing to attach the second set of
hull plates
P.127

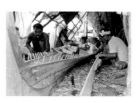

第三層船板結合前的修整
1987-1988
Preparing to attach the third set
of hull plates
P.128

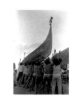

雕刻彩繪前眾人練習拋舟
1987-1988
Practicing tossing the boat prior to
carving and painting
P.129

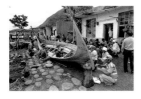

雕刻與彩繪舟體
1987-1988
Carving and painting the body
of the boat
P.130

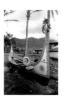

雕刻彩繪完成的十人舟
1987-1988
The 10-man boat after carving
and painting
P.131

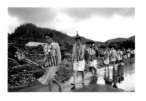

漁團成員個別家庭的婦女前往芋田採收禮芋
1987-1988
Women representing individual families
of the fishing expedition going to harvest
ceremonial taro
P.132

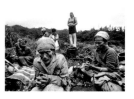

採收禮芋前婦女在田邊禱告驅邪
1987-1988
Women pray beside the fields
to expel demons prior to harvesting
ceremonial taro
P.133

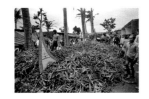

十人舟下水祭典前，帶梗的禮芋覆蓋
在無梗的禮芋上面
1988
Before the launching ceremony for
the 10-man boat, taro, with stalks, are
placed on top of ceremonial taro roots
P.134

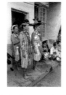

盛裝參與十人舟下水祭典的婦女
1988
Women dressed in special attire for the
10-man boat launch ceremony
P.135

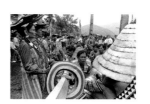

漁團成員男子坐在舟內，女子立於舟
側，繼續與來客對唱
1988
The men of the fishing expedition sit in
the boat while the women stand at the
side and sing with guests
P.136

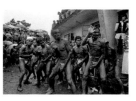

驅除 anito 惡靈儀式
1988
Ceremony to expel evil "anito"
spirits
P.137

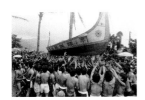

群眾將十人舟拋向空中
1988
A crowd tosses the 10-man boat into
the air
P.138-139

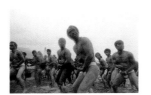

青年們在灘頭驅除 anito 惡靈
1988
Young men on the shore, expelling evil
"anito" spirits
P.140-141

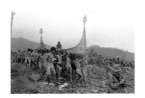

協力舉舟即將到達漁人部落灘頭
1988
Working together to carry the boat to
the shore
P.142

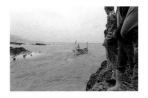

十人舟下水祭典首航歸來
1988
Returning from the maiden voyage
after the boat launching ceremony
P.142-143

# 女兒的胞衣

文／關曉榮

十三年前，冬至過後第二天，曙光猶自黑暗中摸索的時辰，女兒來到人世，比她的哥哥小了三歲。

十餘年來，身為人父，卻過著輾轉荒誕的浪遊生涯。如今再次賦閒，重返海島邊陲，瑣務家事之餘，嘗遁入寂夜獨飲的世界。年少時與友人閒話，曾提及我所目擊的一名工人模樣的中年父親，置身於簡陋而嘈雜的小攤獨飲，酒液有若安靜無言的心事，深深地沉入生命的內裡，還諸歲月與人事造次的天地，這獨飲的中年人與生命之孤單廝守的情景，給我莫名的感動。友人笑說：怕你也將變成這樣的一個父親吧！證諸今日的情境，確乎被他言中，只是無關幸與不幸而已。生活中如若沒有孤寂獨飲的餘裕，佐以深沉無告的心事，祭於荒野的殿堂，生命恐將更為寒涼冷厲吧！

長子出世，時值七月底的酷暑，我的教員生涯將進入第三個年頭。若非政府驟然將舊有的六年國教延長為九年，掀起一陣國民中學教師荒的風暴，我或不致在這亂流中輕易地捲入教員的行業。為了使這些非法定資格的教員合法化，當局在全國最高的師資養成學府，開辦「補修教育學分」的暑期業務。這一年暑期，我正在此接受為期兩個月的速成研習。由於時間短促，為人師表的課目龐雜，遂使每週一至週六，每日從早到晚，密不透風地排滿十二堂課。來自全省各地的學員們的集體生活，比諸充員戰士入伍訓練時「連大便的時間都沒有！」猶有過之而無不及。至於教育概論、教學原理、教育心理學、教材教法……等深奧的學問，自然只能生吞活剝了。

當初親手把兒子接來世間的人，乃是數十年前生下妻子的丈母娘。她在日據時間末，受過助產與護理訓練，任職於小鎮衛生所，是一位經驗老到的助產士，人們仍習稱她產婆玉蘭桑。妻子懷孕期間的各種檢查，都由丈母娘負責，預估的產期正值我受訓期間，但似乎沒有值得憂愁掛慮的情況。

準教師所組成的學員，本是經由同一個教育制度養大的成人，對於密集而呆板的大小考試，應是沙場老將。但或因這種經歷並未造成人的解放，反倒成了終生的焦慮烙印。尤其這次考試涉及終生不破的鐵飯碗，這種焦慮遂變成羣體生活的主要情調。學員們在這盛夏的酷刑裡，乖順地按時到堂，絕不敢輕忽缺課。各個班級不約而同地，推舉出深諳人情禮尚老成持重的人，做為班級的代表。當選者常懷愛國的凝重面色，以審慎的措詞，向學員暗示：期末對各教授獻禮的重要意義，因而必須循往例收取經費。除去功課的研習之外，班代表還得負責多方面打探各教授的習僻與行情，好像一個缺乏自信的考生，耽於歷年考古題的追索研究。

學府老舊的校園裡，遍生綠蔭濃密的大樹，夏日的蟬噪像催眠的耳鳴，揮之不去。巴夫洛夫的狗的心理實驗，英、美、法、日諸國學制的演變與特色，日內瓦學派兒童心理學大師皮亞傑，如何製訂教材與學習結果評量表，制約與反應……彷彿來自另一個世界的聲音，如蟬鳴般忽遠忽近似真如幻。「妻子預產的日子快到了！」這樣的念頭，屢次在腦袋裡不經意地一閃而過，卻每次都只是「妻子預產的日子快到了！」如此而已，從來都不勾起更進一層的將為人父的聯想。青年時期曾罹患肺結核，第一次咳血後，鼻腔與喉頭的黏膜永遠存在著揮之不去的血腥味，它具有撕裂生命的悚慄，也有存活的興奮，與他人無涉卻與我的呼吸同在。經由這血腥的黏膜，我進入一個孤獨生命的思維世界。亡父不治的病痛及死亡，於我的生命是一種斷裂，子嗣延續的想像亦無法縫合，生命好像一則彷彿確鑿但又不完全透悉其真相的啞謎。切身與不切身，現實與非現實，在日子裡反反覆覆顛倒錯置。彷彿心理學家實驗對照組的籠中，因過度刺激而喪失了選擇反應的茫然動物。

「妻子懷孕之前，幾位友輩先有了他們的子嗣。轉眼間，戰後的一代進入了偶配婚生的動物性熱潮，生活裡總也不缺有關懷胎與生產的話題。有的人在受孕之前，有的在確知受孕之初，切切地打聽、比較、整理、求證並傳遞著各種訊息。醫院、婦科大夫的手藝與聲名、產婦床位的價格、名醫紅包的行情、超音波檢查、羊膜刺穿術、帝王切開術等等，不一而足。傳聞中，尚有知名的影星、貴婦，為了產後美姿，或為了逃避生產的劇痛，執意剖腹取嬰。更有甚者，有些產婦，為了恐懼生命中偶爾卻屬必然的乖違，尋訪知名的相士，推算胎中生命在相學中的降世良辰，據此與名醫切結，務必依相士所見，或早或遲，自母胎中剖出小生命，藉以改造生命的無常。

這類聽來奇異無稽的行徑，在安排好名醫名院的友婦口中，竟興味盎然，並掩不住沾沾自喜的神色，一時間蔚成一股流行的風潮。生命延續本身的自然完成，一夜間變成可鄙而落伍的事情，使我心生荒謬之感而緘默。

暑修，在艱苦中踱著緩慢沉悶的步子。任課的教授們，大多是學問與人品概無嚴重瑕疵，卻也不頂有趣的人。其中僅有兩位，給我鬱悶的生活，帶來某種人物觀察的興味。

一位別號「雷公」。從班代表口中，學府大學部的學生，與前期的學員，不僅傳來他的別號，同時也傳來「雷公」當人不留情面的貫耳聲名。他約莫五十歲出頭，不苟言笑，花白的短髮，剪著彷彿永不長長的陸軍頭。目光如炬的雙眼，嵌在潔淨而略泛油光血色的臉龐上。他只穿白襯衫配黑灰色系西褲，件件白襯衫都是平擺的式樣，穿著時一概放在褲腰外面，好像一種刻苦、律己的制服。「雷公」講課極其認真，言而有物，每堂授課的內容，雖不看書，卻講得有條不紊。學員們因為恐懼被當，常裝出專注且饒有興味的樣子。其實，他的嚴厲縱有專業的實才，卻是多了點退職軍官檢查內務的習慣罷了！而他所傳授的，都是建檔備查塵埃落定的庫存知識，少有思想觀念的觸發與啟蒙。

另一位別號「神經的」，是位留美的心理學博士。他的身材高大，卻非虎背熊腰，反而略駝著背脊。形影相隨地提著沉重的黑色手提包，長年在知識的桌椅間埋身挖掘，塑造了他落坐與行走的姿態。他答覆問題或與人交談，總是一直思索著，輕聲細語，彷彿任何問題都沒有標準答案，甚至答案裡也還埋藏著問題。他說話時，習慣性地騰出一隻手半掩著嘴，如果碰上他的腋下夾著手袋容納不下的書本，他則與對話者保持較遠的距離。好像他的學生生涯，曾被教師的唾餘噴濺，一直沒能洗去那骯髒的印象，而深自戒慎。「神經的」講起課來，天馬行空，從榮格到史金納的行為學派，以及許多無從記憶的心理學家，倏忽不定。講解常常觸發了他的新思維，既有的知識爆發了新生的精力，不甘於主人腦海裡歸檔的所在，使勁蹦出來相互切磋一番。學員們對他的課束手無策，只有拚死記筆記，但是記完之後，卻無論如何也看不懂記了些什麼，因為少有人能及時掌握課中思想與觀念的激盪與啟發。因此，學員們恐慌怨怪，議論紛紛，最後總有人嘆著氣說：別緊張！聽說「神經的」沒當過人……。

在這兩位截然不同的教師風格之間，學員們的愚昧日漸暴露著求知的淪喪。為了謀職的單一目的，無所選擇地承受這暑修的酷刑，雖然可憫，卻使我跌入不堪與索然的苦悶，生命的價值糟蹋在無謂的生活裡，致使生命與生活之間的鴻溝愈深，唯有寂寞中孤單的思緒作伴。「妻子預產的日子就要到了……。」這預告的聲音倏忽與蟬噪俱在。

丈母娘自二十出頭，開始從事接生的工作，到如今已三十多年歲月。不捨寒暑不分晝夜的操勞，為她一頭花白髮絲的容顏，留下罕見的風霜與沉著所糅合的堅忍神情，正是她內在人格的具體寫照，她有一口鋁合金的手提藥具箱，尺餘見方的箱子裡，區分成幾個大小不一的空格，紅汞水、碘酊、藥棉、鑷子、剪刀等必備的接生什物，全部有秩地放在裡頭。外加一只狀如小唧筒，上有扣環下有彎鉤的拉稱。這口藥具箱還是日據時期的產物，沿用至今，已然成為產婆玉蘭桑的一部分。箱子的外表，早就磨盡了金屬的表面處理，卻因為常年不斷的觸摸，免去了氧化物的留存，隱隱地透著宜人的銀灰色澤。經驗所及，岳母應產家催請出診的次數難以算計。更深人靜，她以方巾包頭，提著藥具箱，因厚重的衣履與抵禦寒風的姿勢，向著日益蒼老的身體，隨傳喚著急步遁入風緊的寒夜，引致一陣陣寂巷隆冬的犬吠。常與白日出診時，特具時代殊相的街景大異其趣。彷彿有某種關於生命的古老真相，在寂夜中穿透了時代的侷限，如同一則自古不變的啞謎謎底，似真似幻地，遺落在老邁的接生者火急赴事的細碎步履之中……。

日子挨過一天又一天，一節又一節。我逐漸陷落於自閉的苦悶，與荒誕的思維之中。幻想著無數個小人，爭先恐後各具招式，踢打拉扯相互踐踏，在蛆蟲般的人堆裡蠢然蠕動，朝著一只巨大而黯然無光的鐵鑄飯碗，掙扎前進……。生命果是珍貴無匹的嗎？人的生命是否能夠沒有生活而就這樣存在？如果生活正是生命的具體表現，何以生活慣於與珍貴對立而割裂？是生命的無能遭致生活的遺棄放逐嗎……。

預產的日子竟被遺忘了一個早上，在燠熱無風的午後校園，打電話回家。妻子產下一個男嬰。母子平安的消息，從丈母娘口中傳來。對於自己的生命驟然起了角色的重大轉換，一時之間感到陌生而遙遠，卻又近似耳際的蟬鳴。腦子裡一片茫然的空白，過去對於誕生的想像，此刻顯得浪漫無知。對於身為人父的事實，我所有的感受只是訝異，事不關己而已！

幾天後，收到嬰兒入浴的黑白照片，稍減我心中的遲疑。然而，幼嬰在羊水中孕育的浮腫未消，五官尚不十分明確成形，有著小猴兒般的軀體。身長、體重的數字，在二乘四的照片裡，總無法從中掌握具體的真實。我需要屬於嬰兒本身的接觸，或者嬰兒直接接觸所留下的痕跡；一股氣味、一個聲音、亦或一個拓印……。

研習接近終結的考試，課業日形繁重無趣，學員們相互傳染著熱病似的緊張，與作弊的準備。我想，通過考試應無問題，但是對於做為一個教師卻喪失了敬意。班代表最後一回催繳酬師禮金的時候，我平靜地表示拒絕，他瞬間數變的表情，使我畢生難忘。

家人寄來以橘色水彩拓取的嬰兒手腳印，有些因水份過多而模糊，重印的結果，共有九個手腳印。印得好的可辨認掌紋脈絡，這簡單的生命實體的印記，成為我抵擋苦悶生活的想像羽翼……。

告別了暑期進修，重投教學生活不久，學校的文書先生，送來一紙正式教師證書。然而面對艱難的教育工作，並不因資格的合法化，而具備更有效的對策。國中一年級課業成績低落的新生，並非只怪資質愚鈍。其實，問題出在他們對求知的價值並無認識，加上基本的學習方法與態度，並未在國小教育中養成。做為一個導師，我夾纏於一定的課業進度，學生的個別差異與學習的基本動作矯正之間。腹背受敵，異常吃力而成效不彰。國家軍事戒嚴控制體制的教師動員月會裡，校長已經多次在百餘位教職員工面前，點名要我修剪過長的頭髮。對於

我提出的升學班每班三十四人，教室有電燈有電扇，永遠派給更新的桌椅；而我的放牛班多達五十九人，教室無燈無扇，課桌椅缺腳斷腿等一干問題的質疑，校長先生充耳不聞……。

夜闌人靜，因飢餓而哭鬧的兒子，在奶後逐漸安睡於我的懷中。我深深地嗅著他身上，奶食與汗漬混合的襁褓氣味。首次想像到；亡父在數十年前的某個深夜，在那因戰爭而離亂飄泊的某個屋頂的庇護下，或也在失眠的疲憊中，做著與我相同的事情。如果，幼稚的生命理當接受教育的啟蒙，進而發展內在的潛能，使生命俱有淋漓的光采。那麼，在一個蠻橫粗暴而不公的制度之下，身為一個教師，多半只是個脆弱有限的無能共犯。正因為如此；這學校的暴力機器才得以不停地運轉……。幼兒安詳的睡臉，使我感到嬰兒的生命並不像我這樣，存在著生命與生活的割離所致的永恆鬥爭。深夜寂巷的犬吠裡隱含著一種祥和，給我溫暖與慰藉。也給我疲倦與深沉的沮喪，我正捲入職業去留的躊躇中難以自拔。

妻子懷了第二胎，預產的日子逼近了。按照吩咐，上街剪了塊一米見方的塑膠布，買便兩張牛皮紙。子夜時分，我在隆冬的強勁季風中，抵達丈母娘家裡。她從容地著裝提起那口箱子，我略略落後半步，緊隨她身側前進。勁風一陣緊過一陣，颳得樹木劇烈地搖擺擺，也颳得我們必須不時地停下腳步來頂撞強風。呼呼的風號裡，只有二人細碎急促的腳步聲。

產房正是我們的臥室，三年前兒子出生的所在。榻榻米上業已鋪好塑膠布，上敷牛皮紙，旁邊擺著拆開的整包衛生紙。丈母娘在妻子陣痛的乾號聲中，安靜沉著地打開工具箱，消毒雙手後檢查產道張開的幅度，暈黃的室燈照著她花白的髮絲。年久而鬆動的木窗，在強風中相互撞擊，發出陣陣空隆空隆的聲音。毛玻璃上樹影幢幢，偶爾，幾枝長樹枝鞭打著窗櫺，戶外的風勢呼天搶地，臥室裡只有妻子因陣痛而扭曲的臉龐。

逐漸加劇的陣痛，已使妻子的髮絲散亂，汗水使它們無章地黏附在她的臉頰。她無助卻又克制地承受著來自軀體深處的痛苦，一會兒雙手緊抓著床褥，一會又伸出其中的一隻，曲張著五指在空中顫抖。我想去握住那手，但是已被丈母娘緊握，我無用地猶豫著舉著相機，試圖紀錄這動人心魂的一刻，卻因老是抓不住焦距感到十分苦惱。分不清經過多久無言的等候，丈母娘吩咐我下樓準備嬰兒淨身的熱水。

嬰兒的頭顱，在一陣持續的劇痛中出現，血漬與黏液使胎髮緊貼在顱頂，羊水濕透了墊上的衛生紙。妻子屈弓著叉開的雙腿，好像急欲掙脫又像是最後的挽留，女陰緊緊地含著嬰兒的頭顱，股與腿間的筋腱賁張，有如承受開天闢地萬鈞之勢的撐持。原本平躺的上身，因最後的搏鬥而挺昂，雙眼圓睜又復使勁緊閉，張口如圈。生產中的女陰，褪去了性的勾引挑逗與亢奮歡愉的情色，顯露著極為原始的蠻荒表情。彷彿古老混沌的黏膜，因誕生的衝突而崩裂出來的門戶。成形的新生命，正自緩慢但堅決地擠過這道門扉，就像精蟲埋頭鑽進卵子的球膜。求偶與交配的溫情，兩性恆常的鬥爭與妥協，從這道混沌的裂罅進出它的子實。

剎那間，噗地一聲！一團混著血水的小小肉體，快速地在失算的預期中衝跌而出，丈母娘險些錯失了接勢，嬰兒躺在血水裡。緊接著，如腸的臍帶拉扯著血淋淋的胎盤，脫離了婦女的產道，在血水中隨勢溜滑攏向嬰兒的軀體。這時，彷彿連嬰兒自己，都被這最後衝刺的速度吃了一驚，沾著血浮腫而醜怪的臉蛋擠皺成團，哇哇地放聲哭喊起來！丈母娘說：是個女兒！

剪斷臍帶、消毒、包紮、淨身、度量身長體重。紀錄出生時辰……。一陣忙碌過後，曙光中傳來悠長的雞啼，窗玻璃已不見翻騰的樹影，風卻還一陣陣颳著。天已大亮，女嬰在母親懷裡，安穩地吮著母乳。屋裡洋溢著一股妊娠、哺乳與床褥、藥水糅合的氣味。丈母娘收拾停當臨去之前，將密裹在牛皮紙、塑膠布裡，以細繩綑紮的女兒的胎盤，交在我手中，要我尋個地方掩埋。

我肩著鋤頭，提著女兒的胞衣，出門迎向強勁的季風，風勢一鬆一緊，彷彿大地在呼吸吐納。我的軀體與行進中的腳步，在風的擺佈下停停走走，時而必須立定，抓緊鋤頭柄，低頭弓腰使勁抵抗猛撲的強風。緩慢地穿過宿舍通往田野的小徑，來到圍牆外，開闊的田野空曠而渺無人蹤。幾畝未開花的洋葱地，在寒風中鮮綠盎然，遠處的田壠間栽著一排排防風的木麻黃。廣闊的休耕地，蔓生高高低低或疏或密的各種雜草。更遠的小丘，可見小鎮居民安息的墓園。天空的雲，淡如絲縷，在急風中快速移動飄散。蒼穹有如一只巨大的鼓風爐，又如一只無匹的共鳴箱。在風的吐納中嗡嗡地鳴響，相互激盪共震。聲音有如來自遙遠的天外，又如來自深沉的地底。俱有某種無法測度，為人力所不能發出的深廣與強度，雄渾悠然地在曠野徘徊，震動我的肺腑。我的腳步被野草掩蓋的泥坑絆跌，衣角翻飛，褲管沾滿野草附著的種子，跌跌撞撞地找尋適當的掩埋地點。

終於，我決定避開休耕卻不知何時要復耕的土地，選擇一處建於清末的古城牆牆腳，擱下包裹揮鋤掘地。牆下的土地乾涸堅硬，並雜有石頭與城牆崩塌下來的硬塊，城牆長出來的銀合歡在風中劇烈地搖擺，成熟為深褐色的繁多果莢相互摩擦，幾隻小蟲在開掘的土縫中驚慌走避。我將包裹置於坑中就要掩土，又覺不妥。憂慮著土坑的深度不足，胎盤恐為野狗挖食，又擔心牛皮紙塑膠布，將阻礙胞衣溶入大地。再次深掘後，我解開包裹，小心地將胞衣血水倒入土坑，一陣勁風捲起滾涎的血水沾上我的臉頰。軟滑的胞衣沿乾澀的坑壁向洞底蠕去。好像還有知覺，了然自己的去處。風中的髮，絲如飛蓬，風號鑽進耳鼓，我安靜地注視著濃稠的血水爬過乾硬的泥土，沾著塵灰，一點一點地緩緩滲入土石。屬於母女生命的漿液，就將要與土地結合為一體……。

荷鋤，兀立在空茫無問的曠野，我不禁抬手，輕觸頰上業已乾涸的血漬。女兒出世於教員生涯的第五個年頭，生命與生活的裂痕總也無法縫合，挫折已達飽滿，對苟延退休的日子，恐懼日甚。常態分班的新生，經過一年的苦鬥，連功課最差的孩子，都逐漸萌發了學習的芽苞。及至狹隘的升學分班後，被打散到放牛班裡的學童，在開學之初，孤單地佇立於新班級的門口，惶恐而迷惘地與我隔空對視，我已無力面對那種失落的眼神。辭去教職，依然在生命與生活的擺盪中顛簸，轉眼十三個年頭。

昨晚，將夜飯的炊具碗盤洗淨後，枯坐於光線昏黃的後屋獨飲。洗衣機規律的攪拌聲，翻動著日常的思緒；如果太累不想晾衣，至少別忘了女兒的運動裝一定得晾，明天要穿。冰箱裡的牛肉是否已冷凍過久？為什麼冷凍庫裡老是有凍了半年以上的東西？明天的飯盒要帶什麼菜？多日前要修的紗門還要再拖嗎？破了幾個小洞的那扇紗窗，是否一起換新呢……。曾經激盪我的生命情熱所追尋的古老啞謎，而今何似？生命本是也正是如此的生活？亦或不是……。

不意間，妻子悄然來到身畔，輕聲告訴我：女兒的初潮來了……。

# 參考書目

## 一、中文專書

1. 台灣攝影年鑑編輯委員會編，《台灣攝影年鑑綜覽：台灣百年攝影~1997》，臺北：原亦藝術空間，1998。
2. 林志明、蕭永盛，《台灣現代美術大系：報導紀實攝影》，臺北：藝術家，2004。
3. 亞瑟·羅特施坦著，李文吉譯，《紀實攝影》，臺北：遠流，2004。
4. 奚淞，《姆媽，看這片繁花！》，臺北：爾雅，1996。
5. 茱蒂·巴特勒著，何磊譯，《戰爭的框架》，鄭州：河南大學出版社，2016。
6. 陳映真，《孤兒的歷史·歷史的孤兒》，臺北：遠景，1984。
7. 張照堂，〈光影與腳步──臺灣寫實報導攝影的發展足跡〉，《映像與時代──中華民國國際攝影藝術大觀：攝影藝術研討會論文集》，臺中：臺灣省立美術館，1992。
8. 郭力昕，《製造意義：現實主義攝影的話語、權力與文化政治》，臺北：影言社，2018。
9. 關曉榮，《尊嚴與屈辱：國境邊陲──蘭嶼造舟》，臺北：時報，1991。
10. 關曉榮，《女兒的胞衣》，臺北：時報，1993。
11. 關曉榮，《尊嚴與屈辱：國境邊陲──蘭嶼1987》，臺北：時報，1994。
12. 關曉榮，《八尺門手札》，臺北：臺原，1996。
13. 關曉榮，《蘭嶼報告1987-2007》，臺北：人間，2007。
14. 關曉榮，《八尺門：再現2%的希望與奮鬥》，臺北：南方家園，2013。
15. 蘇珊·桑塔格著，黃燦然譯，《論攝影》，臺北：麥田，2010。

## 二、中文期刊論文

1. 《人間》雜誌第1期至第47期，1986-1989年。
2. 朱雙一，〈臺灣左翼報導文學的理論傳承和創作經驗──以《人間》作家關曉榮、鍾喬為例〉，《中國現代文學》21（2012.6），頁23-42。
3. 陳德馨，〈光明與真情的瞬間：鄧南光與《台灣攝影》雜誌〉，《藝術學研究》20（2017.6），頁93-154。
4. 須文蔚，〈報導文學在臺灣〉，《新聞學研究》51（1995.7），頁129-130。
5. 關曉榮，〈追究記憶、創造現在──「國境邊陲」十年後出土的思考〉，《藝術觀點》32（2007.10），頁57-59。
6. 關曉榮，〈想念大陳、再現《人間》〉，《文訊》287（2009.9），頁70-73。
7. 關曉榮，〈留長髮、搖滾樂、反「新生活」規訓體制──《八尺門》社會報告的1980年代〉，《藝術觀點》44（2010.10），頁17-21。
8. 關曉榮口述，錢怡安、李威儀整理，〈影像的左與右──從我的攝影工作與左翼認識談起〉，《攝影之聲》15（2015.6），頁28-39。

## 三、博碩士論文

1. 陳佳琦，《再現他者與反思自我的焦慮──關曉榮的蘭嶼攝影》，國立成功大學藝術研究所碩士論文，2002。
2. Ma Kuo-An, *Visualizing the Human World: Another Look at Renjian Magazine and Documentary Photography in 1980s Taiwan*, University of California, Berkeley, MA thesis, 2010.

## 四、其他

1. 趙剛，〈這些船不知道消失在哪兒了──讀關曉榮的《國境邊陲》〉，《國際邊緣·名家專欄》（2019.3.22），網址：http://sex.ncu.edu.tw/column/?p=822。
2. 關曉榮，《我們為什麼不歌唱》紀錄片，臺北：侯孝賢電影社出品、人間學社發行，2004。
3. 關曉榮，《國境邊陲：1997島嶼上的人類》紀錄片，臺北：人間學社，2007。
4. 關曉榮，《冰與雪》紀錄片，臺北：國家人權博物館籌備處，2014。
5. 顧爾德，〈離開人間的巨大身影〉，《端傳媒》（2020.2.27），網址：https://theinitium.com/article/20161128-opinion-guerde-chenyingzhen/。

臺灣攝影家 Photographers of Taiwan

# 關曉榮 Guan Xiao-rong

研究主編兼主筆｜沈柏逸
專文｜馬國安

指導單位｜文化部
出 版 者｜國立臺灣美術館
發 行 人｜梁永斐
編輯委員｜梁晉誌 汪佳政 蔡昭儀 黃舒屏 薛燕玲 蔡雅純
　　　　　林晉仲 周益宏 劉木鎮 張智傑 楊媚姿
審查委員｜沈昭良 林文玲 林建享 侯淑姿 張蒼松 曹良賓
　　　　　黃寶琴 簡榮泰
英譯審稿｜李欣潔
執行編輯｜吳欣潔
地 　 址｜403 臺中市西區五權西路一段2號
電 　 話｜04-2372-3552
傳 　 真｜04-2372-1195
網 　 址｜https://www.ntmofa.gov.tw

編輯印製｜左右設計股份有限公司
編輯顧問｜翁國鈞 張國權 張宏聲
專書審訂｜孫松榮 陳佳琦
英文翻譯｜William Dirks（杜文宇） 蕭鈺
英譯審稿｜T. C. Lin（林道明）
影像提供｜關曉榮
總 　 監｜施聖亭
執行編輯｜蘇香如 張欣宇
美術設計｜孫秋平 吳明黛
影像處理｜翁國鈞
地 　 址｜106 臺北市大安區仁愛路3段17號3樓
電 　 話｜02-2781-0111

初 　 版｜2020年11月
定 　 價｜980 元
GPN　1010901500
ISBN　9789865321536

國家圖書館出版品預行編目資料

臺灣攝影家：關曉榮 / 沈柏逸、馬國安撰文. -- 初版.--
臺中市：臺灣美術館，2020.11
208 面；21.5 × 27.1 公分
ISBN 978-986-532-153-6（硬殼精裝）
1. 關曉榮 2. 攝影師 3. 攝影集
959.33　　　　　　　　　　　　　109015488

展 售 處

國立臺灣美術館精品商店
403535　臺中市西區五權西路一段2號
04-2372-3552

國家攝影文化中心－臺北館
100007　臺北市中正區忠孝西路一段70號

五南文化廣場
400002　臺中市中區中山路6號
04-2226-0330

國家書店
104472　臺北市松江路209號1樓
02-2518-0207